Gift of
Fellow Students
In Memory Of
DERRICK N. SCOTT
1964 - 1985

WORLD OF CULTURE

BOWMAN LIBRARY'
MENLO SCHOOL AND COLLEGE

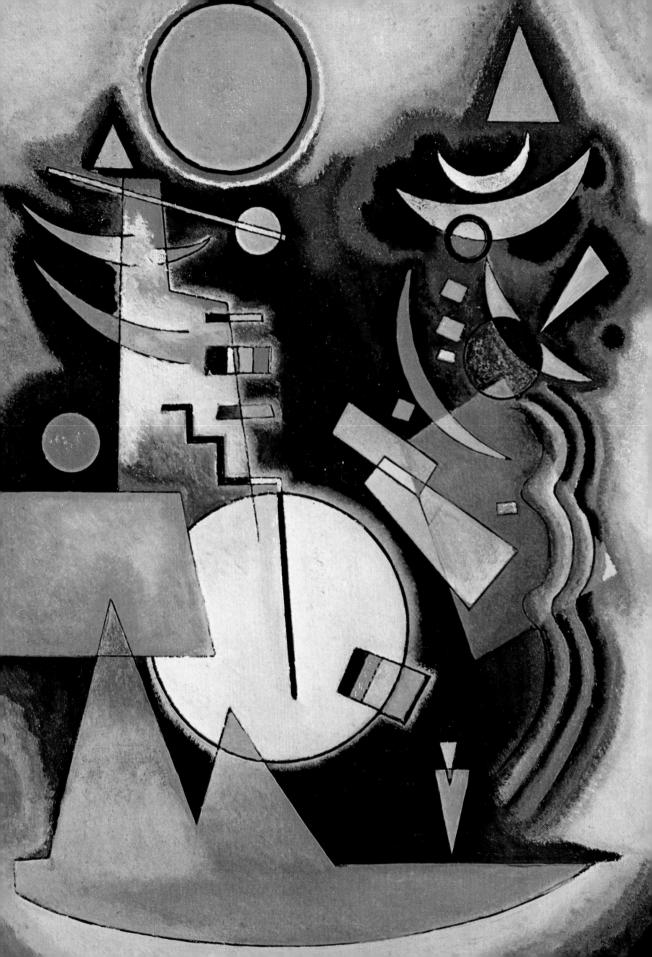

MODERN PAINTING

From 1800 to the Present

by Gaeton Picon

Newsweek Books, New York

NEWSWEEK BOOKS

Joseph L. Gardner, Editor

Janet Czarnetzki, Art Director Jonathan Bartlett, Associate Editor Judith Bentley, Copy Editor Ellen Kavier, Writer-Researcher Mary Ann Joulwan, Designer

S. Arthur Dembner, President

Frontispiece: Double Ascension by Wassily Kandinsky

Gäeton Picon's text has been translated from the French by Henry A. La Farge

Grateful acknowledgment is made for the use of excerpted material on pages 154–179 from the following sources:

The Autobiography of Alice B. Toklas by Gertrude Stein. Copyright © 1933 and renewed 1961 by Alice B. Toklas. Reprinted by permission of Random House, Inc. The Complete Letters of Vincent van Gogh. Vol. I. Copyright © 1958 by the New York Graphic Society. Reprinted by permission of The New York Graphic Society.

Concerning the Spiritual in Art by Wassily Kandinsky. "Documents of Modern Art," Volume 5. Copyright © 1947 by Nini Kandinsky. Reprinted by permission of George Wittenborn, Inc., Publishers.

"Retrospects" by Wassily Kandinsky. Reprinted from the original 1913 *Der Sturm* edition of *Kandinsky*. Copyright © 1945 by the Solomon R. Guggenheim Foundation. Reprinted by permission of the Solomon R. Guggenheim Foundation.

Letters of the Great Artists. Edited by Richard Friedenthal. Copyright © 1963 by Thames and Hudson, Ltd. Reprinted by permission of Random House, Inc.

"Notes of a Painter" in *Matisse From the Life* by Raymond Escholier. Translated by Geraldine and H.M. Colisile. Reprinted by permission of Faber and Faber Ltd.

Memoirs of the Life of John Constable. Edited by C.R. Leslie. Reprinted by permission of John Lehmann Ltd. Noa Noa by Paul Gauguin. Translated by Jonathan Griffin. Reprinted by permission of Bruno Cassirer Ltd. Outline; an autobiography and other writings by Paul Nash. Reprinted by permission of Faber and Faber Ltd.

ARNOLDO MONDADORI EDITORE

Giuliana Nannicini, Editor

Mariella De Battisti, Picture Researcher Marisa Melis, Editorial Secretary Enrico Segré, Designer Giovanni Adamoli, Production Coordinator

Paul Cezanne Letters. Edited by John Rewald. Reprinted by permission of Bruno Cassirer Ltd.

Paul Klee by Felix Klee. Translated by Richard and Clara Winston. Copyright © 1962 by Diogenes Verlag AG. Reprinted by permission of Diogenes Verlag AG. Plastic Art and Pure Plastic Art and Other Essays. Piet Mondrian. Copyright © 1945 by Harry Holtzman. Reprinted by permission of Harry Holtzman.

Theories of Modern Art. Edited by Herschel B. Chipp. Copyright © 1968 by the University of California Press. Reprinted by the permission of the University of California Press.

A statement by Willem de Kooning first published in What Abstract Art Means to Me. Bulletin of The Museum of Modern Art, New York, Volume XVIII, No. 3, Spring 1951. All rights reserved by the Museum of Modern Art and reprinted with its permission.

Reproductions on pages 61, 62, 63, 66, 67, 83, 84, 85, 88, 90, 92, 93, 107, 108, 110, 111, 112–113, 114–115, 116, 117, 119, 120, 140–141 have been reprinted with the permission of S.P.A.D.E.M. Copyright © 1974 by S.P.A.D.E.M.

Reproductions on pages 2, 71, 89, 94, 95, 98, 100, 106–107, 110, 118, 122, 123, 124, 125, 138, 139, 144, 147, 151 have been reprinted with the permission of A.D.A.G.P. Copyright © 1974 by A.D.A.G.P.

ISBN: Regular edition 0-88225-113-9 ISBN: Deluxe edition 0-88225-114-7

Library of Congress Catalog Card No. 74-83889 © 1974 Europa Verlag. All rights reserved. Printed and bound by Mondadori, Verona, Italy.

Contents

MODERN	PAINTING by Gäeton Picon	
1	Bridge to Modern Painting	7
2	English Landscapes and French Romanticism	23
3	The Realist Moment	39
4	Impressionism	55
5	The Logic of Color	73
6	New Directions: From Cubism to Surrealism	91
7	Masters of the New Techniques	109
8	Action Painting and Beyond	133
THE PAINTER'S VISION		153
A CHRONOLOGY OF MODERN PAINTING		180
SELECTED BIBLIOGRAPHY		185
PICTURE CREDITS		185
INDEX		188

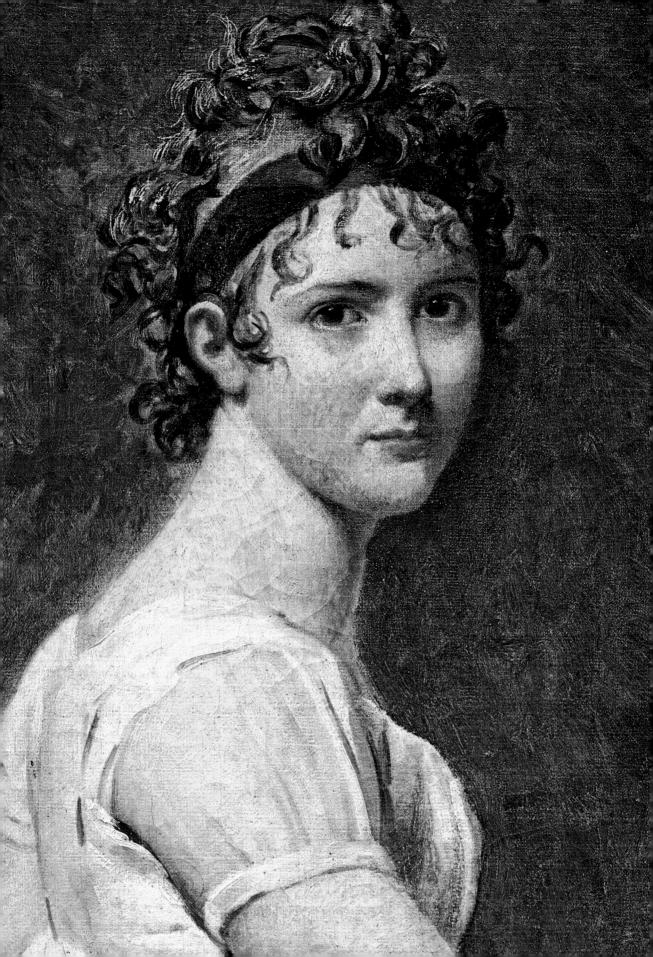

1

Bridge to Modern Painting

The starting date for a history—or a museum—of modern art is one that is constantly being adjusted. Modern painting, it has been said, began with Manet, with Cézanne, Picasso, Kandinsky, or Marcel Duchamp. But this variety of starting points derives from the use of the word "modern" in too narrow a perspective. If a sufficiently comprehensive period of time is included, if modern art is spoken of in the same way as medieval or ancient art, then there is little doubt that the beginning of our time—our society as well as our art—is to be found in the years just before and just after the French Revolution.

Paradoxically, what was first expressed in the ideas and forms of that era is something with which we no longer have any affinity: the Neoclassic movement, which took the ancient world as its model. Nothing could be further removed from us now than that concept of form, that style inspired by ancient statuary and bas-reliefs, that insistence on bold outlines and somber tones, all founded on subjects taken from history or ancient fable. We have also come a long way from the conviction that art is identified with beauty and the belief that there is a canon of beauty and that art can be classified into a hierarchy of importance, with historical and allegorical painting at the summit followed in descending order by the depiction of manners, portraiture, landscape, and still life.

But just where did Neoclassicism come from? Its dogma was defined in 1764 by Johann Joachim Winckelmann in his *History of Ancient Art*, and interest in it, at first anyway, was provoked by archaeological discoveries—in 1711 digging began at Herculaneum—and by Giovanni Piranesi's prints, which were acquainting a wide audience with the monuments of ancient Rome. It was not just knowledge of the ancient past that was of interest, however, but knowledge of every aspect of the past. The Age of the Museum was born. In 1791 Alexandre Lenoir founded the Musée des Petits Augustins, where medieval sculpture, pillaged during the Revolution from châteaus, churches, and convents, was given refuge. Then in 1795 the Louvre began assembling the spoils of war, which included not only ancient art but also works of the Italian Renaissance.

Deeper analysis reveals that Neoclassicism was an answer to a new consciousness of the function of art. It was a refusal to accede to prevailing taste, personal preference, or force of habit; it was to become a

In his portrait of Madame Récamier (detail at left), Jacques Louis David exemplified the Neoclassic tradition. Placing his subject in classic pose, he garbed her in the loose, flowing robes of antiquity and placed a fillet around her brow.

reaction to eighteenth-century rationalism and critical reasoning and at the same time a reaction of critical reasoning against historical development, remaining flexible but defining itself, for the first time, in terms of the events of the day. Neoclassicism's aim was to found aesthetic structure on indisputable truths-as in science-based on experience and history and encompassing a plurality and diversity of styles.

What then constituted beauty, since it was evident that it existed in different kinds of art? Before replying that beauty is where you find it, one must realize that formerly attempts had been made to establish a standard of beauty and that the definition of beauty had been sought in a sort of rational critique. No longer could it be found in perfection of technique or craftsmanship, especially in view of the disappearance of the traditional atelier, where the master transmitted his craft to the artisan. Under professors in the academies, teaching became all the more rationalized in that it consisted of copying and studying masterpieces of different schools. The day had passed when the master told his pupil, "Do as I do." Between the manual tradition and the advent of the machine there came a time for intelligence, for a system of knowledge and judgment. Paintings ceased to be ordered by a client familiar with the skill and style of a particular workshop but were subjected to confrontation with the public in exhibitions, where a premium was placed as much on orginality as on style.

The depiction of a contemporary history echoing the events of a glorious past subsequently became the primary motivation of painting. Delacroix said that Jacques Louis David, the best-known Neoclassic artist, had brought back to simplicity and greatness the degenerate art of the Rococo era. The new age could no longer countenance the frivolous, disquieting trappings of the eighteenth century. An epoch that was establishing itself on new foundations compatible with the cult of reason and demanding sacrifices from every citizen needed an art that was at the same time austere, grandiose, and universal. Prerequisite to a return to great history was a return to grand style, ignoring everything that had happened in the intervening centuries. The Revolution and the empire were filled with grandiose events-but epic greatness requires a heroic community as well as individual heroes. Exemplary Plutarchian lives join in a sort of lay sermon addressed to each individual, uttered by all. Jean-Baptiste Greuze's pictures of individual morality and sensibility gave way to images of civic morality. David spoke to the people; Fran-

cisco de Goya revealed them.

But that which justified a return to antiquity was soon to become an academic imitation and lose its meaning. For David antiquity provided the language that conveyed contemporary events, the reportorial style for the thing seen. But the value of his approach was canceled out at the same time. If there is grandeur in the event itself, why have recourse to such a formal style of representation? From his famous Oath of the Horatii to the Distribution of the Eagles, David passes from an image inspired by a famous episode of Roman history to one of the contemporary world modeled on antiquity. In Marat Assassinated, still later, all reference to antiquity is excluded, even in the style of representation. Similarly, by the time J.M.W. Turner completed the Battle of Trafal-

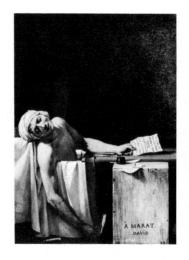

All the panoply and pomp of Neoclassic grandeur pervade David's monumental Coronation of Napoleon (detail at right). When the same artist painted his Marat Assassinated (above), however, he stressed only essentials; by stripping his art of the trappings of the past, he endowed the painting with the immediacy of a news flash while retaining the "noble simplicity" that had been insisted upon by Neoclassicism's arbiter, Johann Joachim Winckelmann.

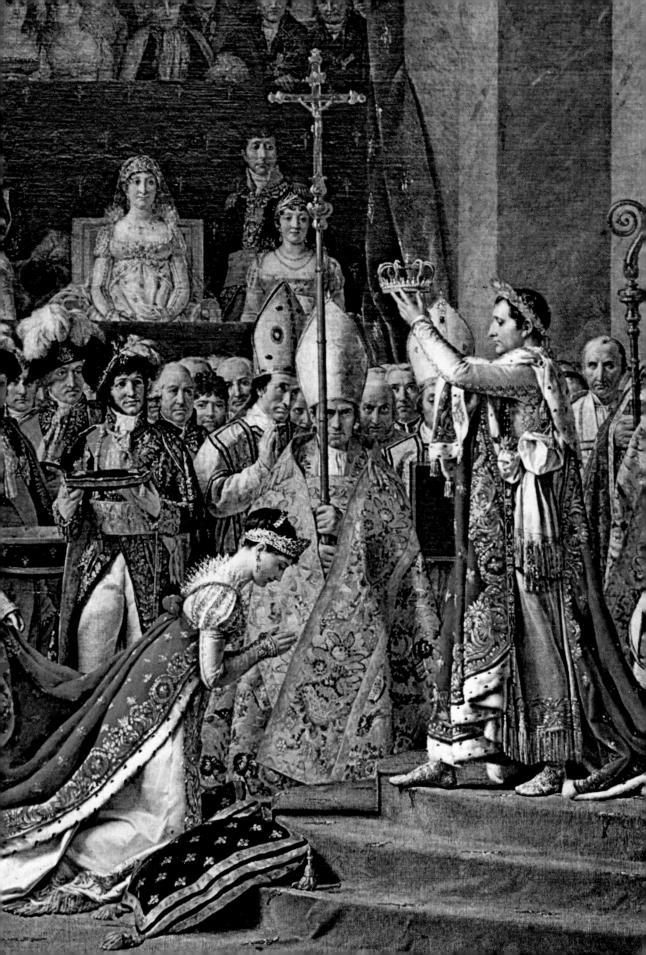

gar in 1825, nothing remains from his Carthage theme-except the grandeur. Goya, on the other hand, always seized grandeur at first hand, in

the pulsing life of actuality.

Thus, under the most anachronistic appearances, Neoclassicism discovered contemporary history as a subject for art. Marat, Napoleon, the Days of May, 1808, all gave meaning to the Brutuses and the Battles of Thermopylae but ended by eliminating them. History by then had accelerated and expanded; it henceforth concerned itself with individual lives (it is not accidental that the two greatest artists of the period, David and Goya, both died in exile). But an event in history actually represents something more far-reaching, namely experience itself. Thus Neoclassicism opened art to contemporary actualities-to sensation, perceived reality, even to dreams. It also proved the futility of formal criteria and revealed the value of experimentation-of whatever kind. Neoclassicism corresponded to a brief moment when a new, violently experienced life sought to clothe itself in traditional guise. The dress was appropriate for a short time-the epic moment-and might have lasted longer had the empire lasted, for it reflected a dream that was shared alike by artists and statesmen.

It was natural that Neoclassicism should have found its major expression in France-then the theater of epic action convulsing the worldin the commanding personality and art of Jacques Louis David. Founder of a movement, "official" artist, organizer of the great festivals of the Revolution, and originator of monuments it intended to erect, David dominated the period by expressing its contradictions: the aspiration toward tradition and toward origins but also the sense of the actual and the immediate; the desire to reach grandiose perfection, dogmatism, and intellectual intransigence but also an awakening, a receptiveness to reality. A Parisian, pupil of François Boucher and Joseph-Marie Vien, David described his early work as marked by what he called "the wretched style of the French School." It was in Italy, where he went to study in 1784 as a winner of the Prix de Rome, that he found the antidote to those early influences. "The power and the richness of tone of the old masters made a deep impression on me . . . ," he later recalled. But even greater was the revelation of Classical sculpture: the insubstantiality and delicacies of the eighteenth century were soon forgotten before the austerity and spare grandeur of Classical reliefs, in which heroic action takes place in closed space, in perfect frontality and theatrical solemnity, where form is vigorously defined by shadow, where the vertical folds of drapery harmonize with the columns of temples, and where the nude serves throughout as the measure and standard of beauty. This style from the remote past seemed the perfect vehicle to express a reality that had rediscovered greatness.

At first it was through myth or some event of antiquity that David spoke of his time: The Lictors Bringing to Brutus the Bodies of His Sons (1789) and The Oath of the Horatii (1784)—pages of Roman history—are lessons in civic courage in the face of compelling events. But at the outbreak of the Revolution, to which he gave himself unreservedly, his Marat Assassinated (1793) and Joseph Bara (1794) required neither imaginary nor formal mediation to convey feelings of

Although a pupil of David's and standing very much in the Neoclassic tradition, Antoine Jean Gros also anticipated the vigor and passion of Romanticism in such paintings as Napoleon Among the Plague-stricken at Jaffa (detail below).

tragic terror and pity. Then, after remaining faithful to the Republican austerities during the diversions of the Directory (his imprisonment after Thermidor, which witnessed the fall of Robespierre, was the occasion for his only landscape, the Luxembourg Gardens viewed from his cell), he devoted himself to the return of grandeur with Napoleon. Once more his sole inspiration, the contemporary epic, filled his work. Bonaparte appeared to him "as noble as the Ancients"; he painted his portrait in 1799. The Oath of the Army after the Distribution of the Eagles (1810) maintains the rigorous standard that marked his Horatii, but the miraculous élan of the intersecting flags anchors the tranquillity of the eagles and gives a timeless stability to the figures—a return once more to the bas-reliefs of antiquity. But in the Coronation of Napoleon (1805) the drama and realities of contemporary life can be seen, without any loss of theatrical majesty, in all those eager, bewitched participants. David's acuity and directness of observation are evident in the individual portraits, which are among the finest of the century, even though portraiture was not his specialty. Before his death in Brussels, where the Restoration had banished him for having voted for the death of Louis XVI, he sought to return to the charms of the eighteenth century—in vain. His last canvas depicts Mars Disarmed by Venus and the Graces (1824)—but it is David himself who is disarmed.

In the spirit of his time, David clothed contemporary greatness in classic dress, but today this aesthetic dogma and technique put us off. His theories belong to the history of ideas, yet the best of his work possesses a vividness we can still enjoy. Bara's adolescent body cut down in the flower of youth and especially Marat's corpse in his bath, which Baudelaire called that "unusual poem," have lost none of their immediacy. They are examples of a kind of beauty that comes not from ideal form but from an inherent intensity. The event that has just taken place—as indicated by the date on the inscription—this piece of frontpage news, flashes in the light of eternity. *Marat* is one of the canvases that opens the field to modern painting—on the same plane as Goya's *Second* and *Third of May*, 1808.

Antoine Jean Gros was a pupil of David's but one of whom the master said: "He widened the range of my ideas." Napoleon appointed him to supervise the selection of works of art in Italy and even preferred him to David. Gros painted the contemporary epic completely free of the Neoclassic idiom. He painted what he saw or remembered having seen: the battles and the moments of glory such as Napoleon at the Battle of Arcole (1796) and The Battlefield of Eylau (1808). But he also painted moments of suffering and compassion: in an 1804 canvas Napoleon is shown comforting the plague-stricken of Jaffa, and what is striking in the Eylau canvas is the suffering of the fatally wounded and the sadness of the emperor. Gros, who had no interest in classic formalism, lit the first flames of Orientalism and, quite simply, romantic color: the scarlet of uniforms flashes out from the morning mists and artillery smoke. Under the Restoration, however, he remained aloof and forgotten. He was criticized for having lacked style and having painted soldiers and not heroes. He attempted to gain favor by painting his Farewell to Louis XVIII, but its admirable Veronese color was over-

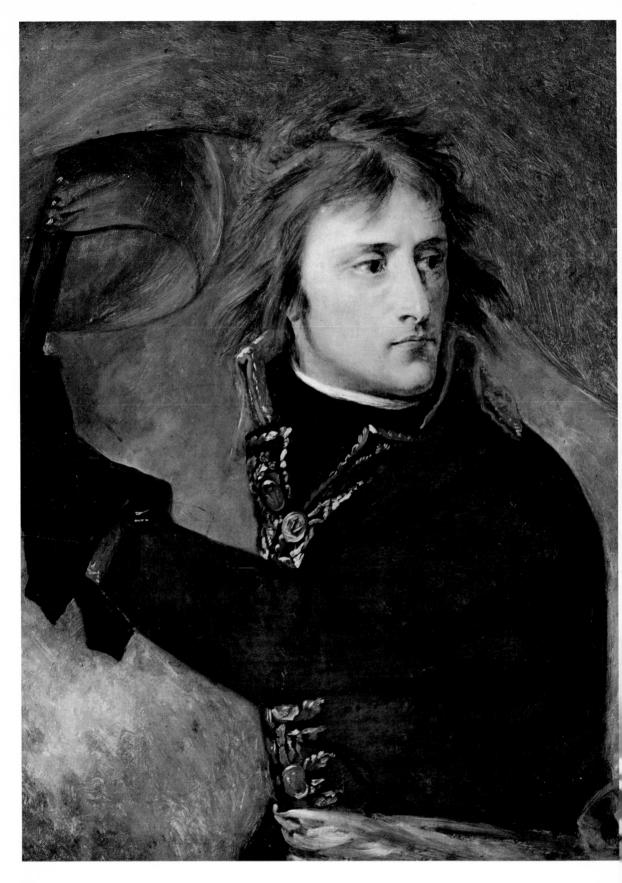

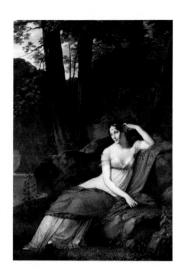

The air of detached melancholy on the face of the Emperor in Gros's Napoleon at the Battle of Accole (detail at left), and the languid sensuousness of Prud'-hon's Empress Josephine (above), are further evidence of the changes that were taking place as Neoclassicism gave way to the more subjective Romanticism.

looked; no one was as moved by it as by Horace Vernet's *Farewell* (to Napoleon) *at Fontainebleau*. Gros committed suicide in 1835, finally caught up in a lost generation of numberless victims.

David and the Davidians abhorred Pierre-Paul Prud'hon, but Delacroix was to render him homage. He was an exquisite and singular painter in whom the charm of the eighteenth century lived again in a proto-Romanticism reminiscent of the rejected regime. He traveled in Italy, copied Pietro da Cortona's ceiling in the Barberini Palace, revered Leonardo da Vinci, and has been compared to Correggio. In subjects borrowed from classical mythology-Venus at the Bath; Psyche Abducted by Zephyr (1808)-his canvases swarm with small angels, celestial apparitions, and floating draperies. But the importance he gives to line harks back to the seventeenth century and is more Greek (even Hellenistic) than Roman. In the elongation and sinuosities of his figures he even evokes the Mannerism of the School of Fontainebleau and anticipates Ingres. Thus he is a painter saturated with culture, in whom many strains can be discovered; but fundamentally he possesses a noble sensitivity, a pure feeling for feminine beauty, and a sort of precision and acuity in etherealism. His official portraits (for instance, the beautiful portrait of the Empress Josephine, 1805) are marked with interior life and a somewhat languid reverie. Yet this sensitive personality was also a man of the Revolution-he was a friend of the terrible Saint-Just. He is a bridge between a nostalgic past and a future in which color was to project its own thoughts and dreams. In The Happy Mother (1810), he fused fiery color and the delicate line of a bare arm into a combination of elements that Delacroix and Ingres were to explore along separate paths. His most famous canvas, Divine Justice and Vengeance Pursuing Crime (1808), is notable for the freshness of its allegory, its grave sensuality, its purity of form (with profiles like cameos), and a delicacy of touch evoking avenues of reverie.

Outside France—whose dominating political situation explains its artistic supremacy (and the concomitant awakening of national feelings against it and the Neoclassicism it incarnated)—English painting was the only great school, Goya the only great artist. Italy produced the sculptor Antonio Canova, the perfect example of a Neoclassic artist, but no great painter. Although Germany was the breeding ground of Neoclassical theory, the Nazarene movement that arose there was set against the school of Winckelmann. Its leader, Friedrich Overbeck, was influenced by the Romantics Friedrich and August Wilhelm von Schlegel and sought a national, Christian art. And it was in Rome, not Germany, that he attempted to bring together a mystical and artistic community. There was in this kind of premature Pre-Raphaelitism an element of Neoclassicism, since it constituted what has been called an attempt to "baptize Greek art." Intellectually, the movement is not without interest, but artistically it is limited.

Just before making its important contribution to landscape painting, England experienced in its visionary art a combining of elements of Neoclassicism with those of nascent Romanticism. This happened in other parts of Europe, but in England its sources were very different, mixing elements that elsewhere remained separate. England's tradition was the Bible, Shakespeare, and Milton rather than strictly Greco-Roman Classicism. The latter was not entirely absent, however, for it was in England that Piranesi's admirers were most numerous. Drawing on this heritage the sculptor and designer John Flaxman copied the designs on Greek vases and illustrated Homer and then Dante. But the classical elements that appear everywhere in his work do not constitute an independent aesthetic. The tradition of line and sculpturesque form in Flaxman's work refers more directly to Michelangelo than to classical antiquity. What we find in his pure and simple line is a very free rein given to the imagination; he makes no attempt to set modern art against ancient form but—on an entirely different plane—substitutes vision for sight.

England produced three artists of the imagination thus defined: their modernity consists of the faculty to treat traditional subjects with an entirely personal vision. If the great painters of the time are illustrators, devoting less effort toward intrinsic painting than toward developing a given subject, these three are visionary illustrators expressing their most secret obsessions (which their French contemporaries had not yet attempted) in compulsive statements often having to do with conflicts of puritan morality with faith or with sensuality and

individual liberty.

One of them is John Martin, who gained early successes but was soon completely forgotten, to the extent that in 1835 his three vast compositions of The Last Judgment were sold for seven pounds and have only recently been rediscovered. Most of his work consists of immense biblical scenes (The Flood, The Destruction of Sodom) in a chaotic, awesome world of inordinate architectures-pillars, columns, towers, battlements, marble stairs-dreams of antiquity borrowed from Piranesi and Claude Lorrain. It all reflects an obsession with the end of the world, universal conflagration, celestial punishment—a cataclysm in which everything proudly erected by man founders, in which a diminutive human being is seen clinging to the summit of a cliff or disappearing into a ravine. The elements of fire against water, and shapelessness and gigantism against orderly form, are found in constant confrontation, in a style of painting in which such structures as the outline of a rocky ridge or the fluting of a column are meticuously delineated. Compositions like the Great Day of His Anger (c. 1853) evoke Hollywood spectaculars swarming with crowds in limitless settings.

The chimerical Johann Heinrich Füssli was born in Zurich and remained more Germanic than English, although most of his life was spent in England. (His name is often Anglicized to Fuseli.) He was a follower of the philosopher Rousseau, an occasional clergyman (he gave only one sermon), and a friend of the mystic and physiognomist Johann Lavater. His work is the most singular expression of oneiromancy (divination by dreams), which was then just beginning to be studied. His most famous canvas, *The Nightmare* (1781), is a depiction of the macabre, in which a hideously grimacing gnome squats on the chest of a woman lying in a sleep akin to death. Despite the explicit autism of Füssli's world, it is full of cultural references and derivations; his titanic anatomies come from Michelangelo, his *Nude Listening to a*

Although he is best known for his macabre canvases, the Swissborn mystical painter Johann Heinrich Füssli also executed paintings in the classical style, as in his Charon (above). His contemporary and fellow mystic, William Blake, preferred biblical subjects such as Elijah (right).

Harpsichordist (1800) derives from Titian's famous treatment of the theme, and there are numerous subjects from Shakespeare, such as the series on Titania illustrating A Midsummer Night's Dream. "Nature puts me out," he once said, so much so that in his adjustment to it, space and scale are feverishly distorted. In Titania, Bottom and the Fairies, for example, miniaturized personifications the size of insects flit around giant figures, and certain nude figures are in bizarre contrast to the costume and headdress of others.

The greatest visionary of all was the poet and painter William Blake. The son of a London shopkeeper, he had experienced mystic visions (angels walking in wheatfields, for example) from childhood. A reader of Swedenborgian and Böhmian mysticism, he developed an idiosyncratic philosophy based on the idea that creation is evil and life sinful. In the Creation of Adam (1795), he depicts a cruel Assyrian deity; Urizen Creating the World evokes another evil demiurge, applying a compass to the face of the moon. From this prison of the compass we are called upon to liberate ourselves, for in our world desire is good and faith is evil. There is a sort of puritan anarchism in this mystical pessimism. Everything visible is a sign, every creature a spirit that must be revealed. The Phantom of a Flea (1820) offers frightening evidence of this. Anyone unable to see beyond what is visible to the eye is evil -the Venetians and the Flemish are demons-for Blake sees conflict between good and evil where others see culture. But this ardent spirituality becomes incarnated in his line, which reveals his being, while his imagination invents forms more concise and solid than any seen with the eye. Blake's mystical forms invest his esoteric symbolism with a sculptural style in which Michelangelo's musculatures mingle with intimations of Pre-Raphaelite delineation. It is a thoroughly strange style,

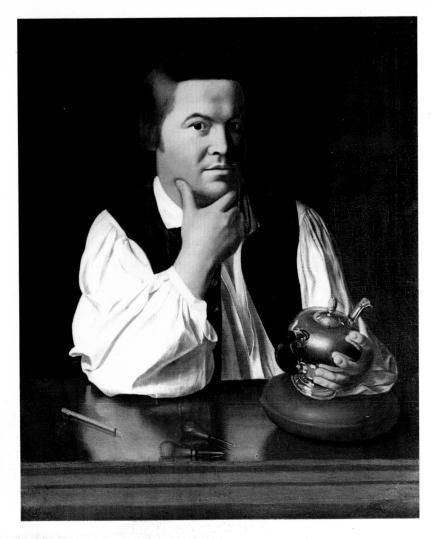

Late eighteenth-century American painting was noted for its portraits, including John Copley's Paul Revere (left) and Gilbert Stuart's Mrs. Richard Yates (below). Charles Willson Peale also favored trompe l'oeil, as in his Staircase Group (right).

Overleaf: Prior to 1800, when The Family of Charles IV was painted, portraits of royalty had always been romanticized and ennobled. It took Goya to depict with devastating accuracy Spain's vapid king with his strong-willed but no-more-intelligent consort and their vacuous family.

conforming to no known canon—one might say almost tainted with awkwardness. How great was Blake as a painter? Working almost exclusively in watercolor, he produced color that has a fleeting transparency with delicate iridescences. What counts is his vision, which in a good reproduction is as conducive to dreaming as in the original.

Although most American painters of this period studied in England, their work bears little relation to this visionary art. They descend from English eighteenth-century portrait painters, notably from Joshua Reynolds, and even before David they were influenced by the latent Neoclassicism on the Continent. Toward the end of the Colonial period and during the Federal era, in a time of growing optimism for the future of the new nation, art as an accomplishment beyond any practical application was limited for the most part to portraiture, notably in John Singleton Copley's extraordinary record of leading citizens and Benjamin West's heroic compositions. Copley moved to England at the outbreak of the Revolution, following West who was already established in London with an influential studio. Even before David, West was painting Roman subjects clearly enouncing civic virtues. But in 1771, a theme of contemporary history surfaced in his Death of General Wolfe. Copley likewise turned to actuality in his dramatic Watson and

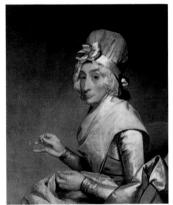

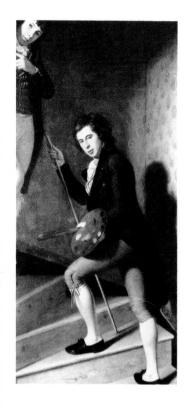

the Shark (1778), based on a real incident—an attack by a shark on a fourteen-year-old youth off the coast of Cuba in 1749. In his *Death of Major Pierson on the Isle of Jersey* (1783), he painted part of a minor battle that had occurred between the French and the British in 1781.

John Trumbull undertook a vast series on the Revolution, traveling everywhere to portray the exact locale of battles and other historic events of the day. The numerous portraits of Washington remain the legacy of Gilbert Stuart and Charles Willson Peale. Peale named his children, themselves destined to become painters, after the artists he most admired—Raphael, Rembrandt, and Titian. For the inauguration of the Philadelphia Columbianum (an artists' association) in 1795, he painted *The Staircase Group*, so successful in its *trompe l'oeil* that Washington is alleged to have bowed politely before it, taking the figures represented for real personages. Mention should also be made of the portraits of Ralph Earl and the paintings of Thomas Sully, such as *The Lady with a Harp* (1818), which were already showing the influence of the romantic imagination.

The greatest painter of the period-Francisco de Goya-belongs to a country that had produced no great master since Velázquez and was to have no other until Picasso, a country on the decline in political power and deserted in artistic glory-Spain. Like David, Goya had to break loose from the eighteenth century (though only from its charms and not from any classicizing mythology), and the slowness of his development indicates the difficulty and depth of his rupture. Born in 1746 near Saragossa a few years before David, Blake, and Flaxman, learning his craft in local studios, failing his examinations for the academies of Madrid and Parma, then called by Anton Raphael Mengs to work in the Royal Spanish Tapestry Manufactory, he first produced charming but rather uninspired works, including hunting scenes and a few religious paintings (for example, a Crucifixion dating from 1780). Between 1775 and 1792 his tapestry cartoons for the royal palaces became increasingly brilliant in execution, extending the Rococo pastoral tradition in audacious scenes of daily life. In the limpid color of the Madrid Fair, the Picnic on the Banks of the Manzanares, and the Meadow of San Isidro, popular gatherings are magically transfigured by a play of light and color that anticipates Impressionism by almost a century.

But Goya was not to remain merely a painter of happiness and the good life. In 1790, following the accession of Charles IV, Spanish liberals were persecuted under suspicion of being in sympathy with the French Revolution. Goya then withdrew from court life and in 1793, during a trip to Cadiz, fell seriously ill and became deaf. From then on he was motivated solely by his own "caprice and invention." More concise brushstrokes, heavier impasto, somber values, and the complete absence of the decorative appeared in his work. With the exception of a few portraits that are miracles of limpidity and silver-gray harmonies, he turned his whole attention to a pitiable throng, faces of torment, insanity, and every conceivable form of tragedy and cruelty. Not without equivocation he titled one of the plates of his Caprichos (the series of etchings published in 1799) In the Name of Reason and another The Sleep of Reason Wakens Monsters.

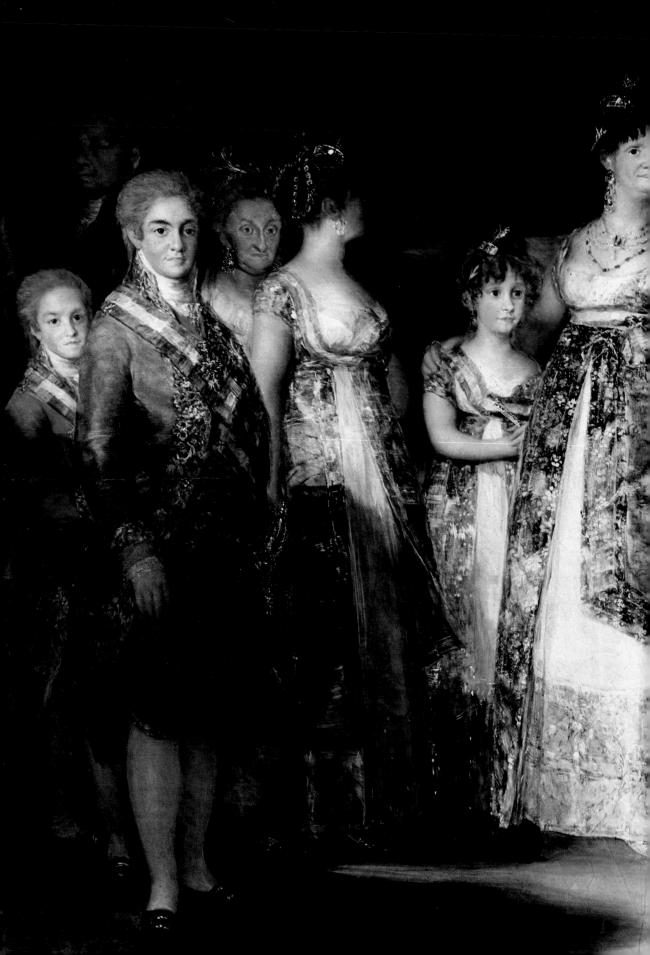

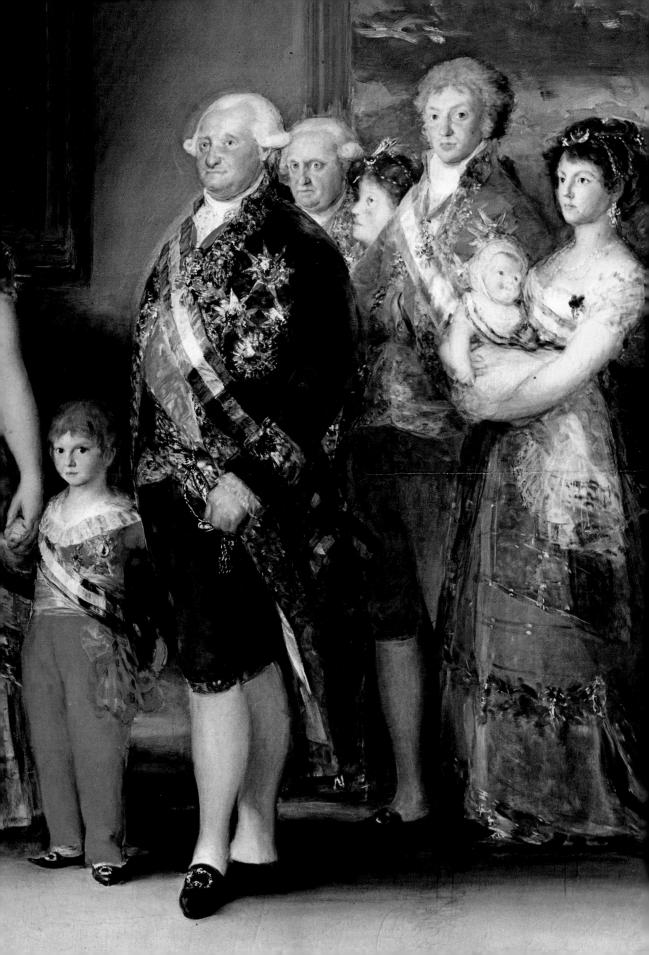

There is no denying that there is serenity and refinement in many of Goya's portraits, sensuality in the two majas, the *Clothed Maja* and the *Naked Maja* (1800), and in one of his last canvases, *The Milkmaid of Bordeaux* (1827), an exquisite freshness. The frescoes for the Hermitage of San Antonio de la Florida in Madrid (1798) are marvels of clarity and bravura, breaking with all the laws of religious painting: the thirteenth-century saint performs miracles in the midst of an eighteenth-century crowd of participants forcing their way around a circular balustrade from which they peer down, the cupola of the dome being no longer reserved for angels and clouds but for a contemporary mob.

But indictment remains the chief theme of Goya's work: indictment of the ruling class in the vacuity of royal and princely faces in the Family of Charles IV (1800), the first demystified portrait of royalty; indictment of despotism in the anger and horror at the tragic events depicted in the two famous canvases, The Second of May and The Third of May, 1808 (painted in 1814), which celebrate the revolt of the Spanish people against Napoleon's troops. Therein the heroic composition of axes and pyramidal lines of force are eschewed in favor of an indiscriminate heap depicting what really happened: the advent of terror and faceless cruelty in darkness punctured by the glare of a large

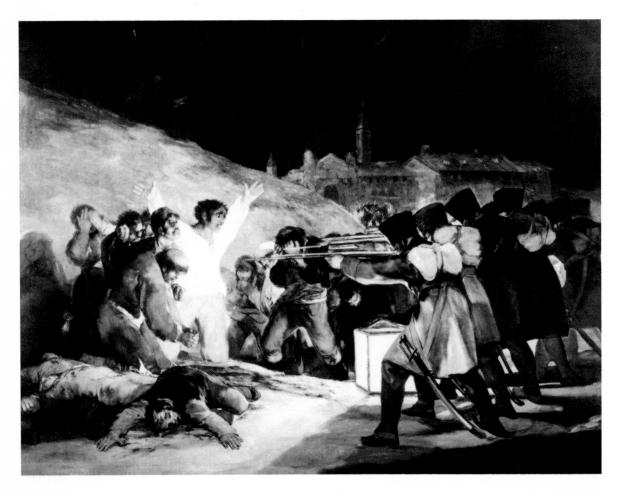

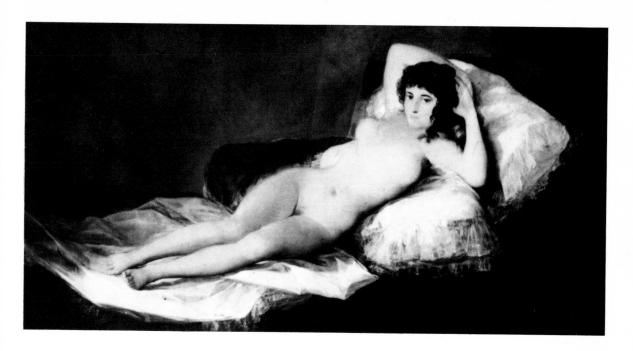

Goya's extraordinary ability to express extremes of emotion is shown here in the contrast between the transcendent serenity of The Naked Maja (above) and The Third of May, 1808 (left). The horror of the latter painting, recording the Napoleonic invaders' nocturnal executions of Spanish prisoners, is heightened by flanking the present victims with the recent dead (left) and with prospective victims (on the right), who huddle in terror as they wait their turn.

yellow lantern. The engravings of the *Disasters of War* contain an indictment of all the monsters that devour us but which perhaps we cherish—madmen, the plague-stricken, the prisoners in the darkness of vaulted dungeons, the outcasts (of another race?), and the tortured. On the walls of the Quinta del Sordo, the country house Goya bought when he was seventy-two, he painted sinister scenes of nocturnal revels, sneering hags, skeletons of old men eating their soup, and the head of a dog coming out of its grave. This is the domain of Saturn, the monster devouring his own children, symbol of man bent on self-destruction.

Goya, having chosen exile at the advent of the despotic repressions of 1824, died in Bordeaux in 1828, leaving no followers worthy of the name. The master was an overwhelming force on the threshold of the new era, far ahead of his time, retaining nothing of the past, and too strange to have been understood immediately. The interest of the Romantics in Goya was limited to preference for the chiaroscuro of his engravings; but Daumier and Manet understood him better, and Baudelaire with deep insight said he was "full of unknown things." Today, these unknown and singular things have become matters of common occurrence. He was the first painter to show the bestiality and sadism of naked humanity, in images that the horrors of the twentieth century no longer permit us to deny. In his art alone is found almost everything that determines the main lines of modern art: the decisive divorce of art from beauty, an approach that until then had been practiced only by painters specializing in the grotesque and the fantastic; the subjection of painting to interior vision, which dictates nonobjective colors, sometimes very bright, sometimes totally somber; and the special importance given to contemporary events, things actually witnessed ("I saw that" is the caption of one page of the Disasters of War). This new vision, whether of an historic event or simply an item of everyday news, led painters to give importance to the recording of a rapid impression. From this came an easel painting graced with light touches, an art full of spirit and dash, to take the place of traditionally balanced composition.

English Landscapes and French Romanticism

THE INFINITELY WIDENED SCOPE of tradition in the first quarter of the nineteenth century—encompassing the Bible, the Middle Ages, Shakespeare, Masaccio's Italy, Venetian and Flemish painting-was further augmented by the development of individual sensibility in art. The great exemplars of this many-faceted past, still nourishing an imagination eager to develop vast compositions, were simultaneously motivated by the desire to record immediacy and actuality—the observed event. The result was that the sketch, the study of the passing incident, began to compete with slowly meditated, thematic compositions and color became more important than drawing. Not only did the study of humankind in myths and revealing actions become the subject of painting but so did a passion for external nature, for landscape. Passion, vigor, and enthusiasm but also nostalgia, restlessness, and disquietude: so many conflicting tendencies came together in that moment called Romanticism that it is almost impossible to define the movement. Yet, between the dying Neoclassicism and the Realism to come, it is possible to trace the limits within which this diversity developed.

The sculptor Canova, who had based his categorical Neoclassic style on Roman copies, abandoned it in London in 1815 when he discovered a living Classical art in the Elgin Marbles, newly arrived from Greece. Ancient models were not thereupon completely discarded—they simply ceased being the sole source of form and inspiration. Classicism became one style among others, and copying it became less important than creating a new living style. In France, where awareness of national origins was still lively, the nearer past—documented in the Museum of French Monuments—became the inspiration for a whole new generation. Elsewhere, in Spain and Germany, there were parallel developments, chiefly motivated by reaction to French political domination. Awareness of the moment and of contemporary mores and events henceforth seemed more natural, and Baudelaire—an important art critic as well as poet—challenged painters to depict modern man complete with necktie and polished shoes.

Yet the artist Baudelaire named "the painter of contemporary life" was a draftsman of secondary importance, Constantin Guys. He reserved his real admiration for Delacroix, whose nostalgic ideal rejected bourgeois Paris—which disgusted him—for the Bible, the legends of the past, and the Orient. Romanticism is not represented by the

"The first requirement of a painting," wrote Delacroix in his journal, is that it be "a feast for the eye." The artist embellished his feast by drawing on his exceptional gift of color and by setting his paintings in exotic locales. His Women of Algiers (detail at left) is set in North Africa, a hitherto mysterious region that in Delacroix's time had recently been opened to European travel.

often admirable portraits commissioned from outstanding artists by the bourgeoisie, or by Delacroix's *Liberty on the Barricades* of 1830; its essence is found in paintings like his *Death of Sardanapalus* (1827) and Ingres's odalisques. Romanticism made no attempt to take stock of the bourgeoisie; it was to be an art of the imagination projecting shadows and flames in great compositions seeking to reveal humankind in decisive, sublime situations. These situations were not those of history in the making but those of a yesterday or an elsewhere—or a time that never was. Romanticism was a form of pessimism toward contemporary life, and that made it fundamentally an escapist art. Napoleon is still a subject but less a conqueror than a fallen Icarus. If antiquity no longer furnished a grammar of style, it was undoubtedly because a number of new languages had been learned and also because reality had ceased being a chapter out of Plutarch.

The two great schools of the period-the English and the French -confront each other: landscape painting is opposed to the painting of ideal human action. England, unlike France, had no urge to cloak itself in a dream of historic grandeur. France was unable immediately to replace its civic art with landscape painting. Between David's Coronation of Napoleon and a hay cart a transition was necessary, one fulfilled by such paintings as Delacroix's Entry of the Crusaders into Constantinople (1840). Nevertheless, the two schools were part of the same moment, in which free, untrammeled inspiration replaced dogmatism. "Beauty is everywhere," declared Delacroix; "not only does every man see it, but each must depict it absolutely in his own way." After having been almost exclusively portrait painting throughout the eighteenth century, then becoming visionary at the turn of the century, English painting of the Romantic era was to be almost entirely landscape. And through landscape both the aim and the technique of painting itself became modified.

From the beginning there was a traditional school, headed by John Crome, which descended from seventeenth-century Dutch landscapists, notably from the work of Meindert Hobbema: landscapes with majestic trees in the foreground against distances in progressively graded tones. Then came the watercolor school, born of the English love of nature and taste for ruins, predilections that were more highly developed in England than anywhere else. A Watercolour Society, formed in 1804, introduced clear color: watercolor lends itself to the expression of atmospheric transparency, the mobility of light, and instant perception.

It was John Constable who fulfilled the promise of the watercolorists in full-scale canvases. His sole aim was to paint what he saw before him, at the moment of vision. The words "sincerity" and "natural" occur frequently in his letters. Like the casual traveler, he had no interest in the art of museums, and he was probably the first modern painter to paint without any dependence on them. Constable was the first to create a style based uniquely on direct observation, regardless of the subject; he denied that there was any distinction between what is beautiful and what is ugly. And yet he was not without preferences. Born near the banks of the Stour River, he felt out of his element in London and missed his native soil—"every stile and stump, and every lane in the

A deep-seated love of nature is apparent in the clear color and monumental form of Francis Towne's Source of the Arveiron (above). The full flowering of the works of Towne and other English watercolorists was to come with the oil paintings of John Constable, whose The Hay Wain is shown at right.

village." He chose to see and to paint what he had always seen, the places of his childhood, not the distant views or gradation of things in space but the clump of trees before him, the river at his door, the soft earth under his feet.

One might say that Constable's greatness is contained within narrow limits. The smallest canvases are adequate for some of his most complex scenes, such as A Shuice on the Stour (c. 1830–36), which measures only 8 % by 7 % inches. His touch is as important as his sight. He had an original way of drawing, developing form by counterpoising—the juxtaposing of robust, liberally applied strokes. The greatness of his revelation of the universal in that countryside, the vital sap spreading everywhere in the earth and foliage, is transmitted to us by the unwonted weight of painting in those modest, sparingly dimensioned canvases. But this visible world also relates to an impalpably invisible one. Constable speaks of textures and surfaces, but he also seeks to paint what has not been seen, to record what is not readily visible: "breezes, dews, fresh efflorescences," a sign of renewal, the murmur of a spring. Those ephemeral outcroppings at the surface of the dense earth in that rugged countryside appear only in his sketches, which he never exhibited. It is these sketches that appeal to modern taste, views of the Stour sometimes almost a monochrome bluish white-despite the dominant green of

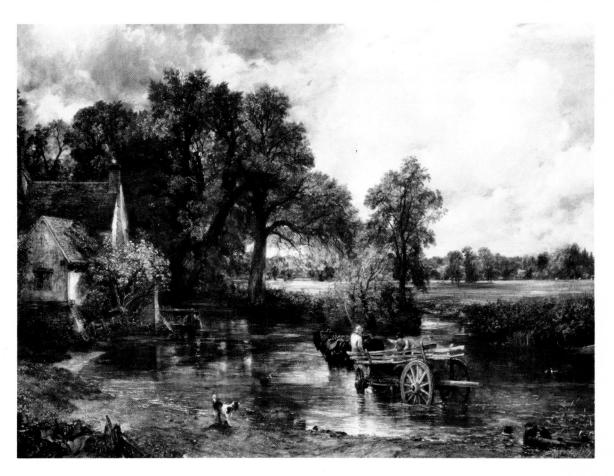

most of his canvases-or his studies of clouds, such as the Cirrus of

1821, illuminated by a blaze of pink and blue.

Constable was criticized for his realism. Confronted by a Constable sky, Füssli declared that he looked for his umbrella. Such accusations are blind to the underlying lyricism, the miracle of evanescent solidity, and the weight given to the imponderable. Actually, the real shock in Constable's canvases comes mostly from his technical innovations and, more than from his clear color—which has tended to be associated with chiaroscuro—from a proto-Cézannian structure of touch, a sort of granulation of broken color anticipating Pointillism, a structure that owes nothing to line, culminating in a kind of majesty that emerges from the humble haphazardness of everyday life.

In 1832, J. M. W. Turner, exhibiting alongside Constable, inserted a dab of brilliant red lead on a gray sea in his canvas, thus eclipsing the vermilions and purplish reds that Constable had used to heighten the tone of his painting, which included a ship with flags. In violent contrast to Constable, color takes on the effect of a conflagration in Turner's work. Turner is more an "eye," whereas Constable can be said to be more a "hand." Turner is the painter of distances, of open skies, of space, atmosphere, and water rather than of the earth. He was excited by sights of bursting magnificence and by cataclysms of nature—

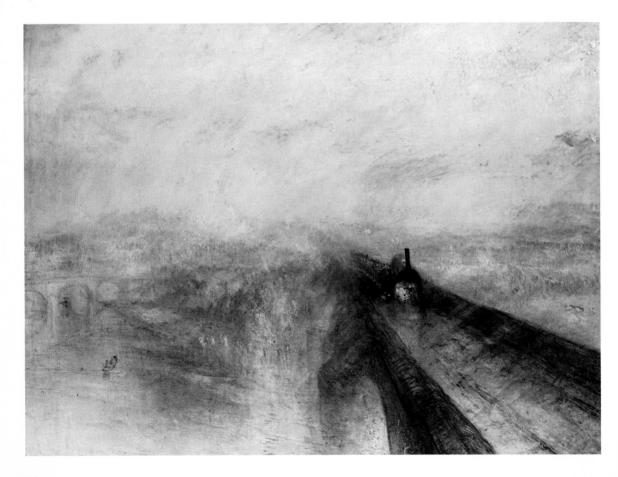

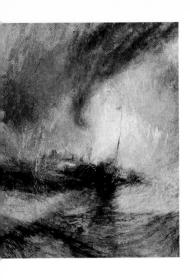

The bursting magnificence of Turner's broken-color technique helped pave the way for the abstract artists of a later age. In Rain, Steam, and Speed (left) Turner captured a locomotive speeding along the Great Western Railway; in his Snowstorm (detail above) he depicted the relentless fury of a blizzard at sea.

storms, tornadoes, fire over water, and snow falling over waves (as in his *Snowstorm*, 1842). Linked to tradition, to the art of museums, he retained for a long time the idea of the relative importance and rank of different kinds of painting. He had predilections for certain classic themes—an attraction to Poussin and especially to Claude Lorrain, notably to canvases in which the radiance of the sun and the sea are the setting for epic actions. Indeed, his will stipulated that one of his canvases should hang alongside one by Lorrain in the National Gallery, a desire that was respected.

A number of Turner's paintings, by virtue of their grandeur and their mythical allusions (such as the Landing of Aeneas and The Plagues in Egypt) reveal him as a master of Neoclassicism, a sort of fulfilled John Martin. Nor is the link between ancient and contemporary grandeur lacking: Turner's Hannibal Crossing the Alps (1812) belongs to a series of subjects inspired by the fall of Carthage, obviously identified with the France of Napoleon. But can his Ulysses Deriding Polyphemus (1829) be called historical painting? A contemporary critic saw in it only "frenzied color" and likened it, quite rightly, to a kaleidoscope or a Persian rug; for the vessel, the galley, the sailors climbing the masts or plying the oars, even Ulysses waving his coat, all blend indiscriminately with the reflections of the sinking sun on the gold, the blue, the rose, and the red of the sea. For the first time color annihilates subject and effaces form.

Ever present in the period of Turner's historical paintings are the fogs of London, lit by the reflections of the sun, as in *The Sun Rising through Vapor* (1807). Then in 1820 Turner discovered Italy, less the Italy of its art than of a hitherto undiscovered light, especially the dappled light of Venice. Suddenly everywhere in his canvases there appears a unique lyrical substance indistinguishable between gold, mahogany, velvet, and fire. The vision comes from the splendor of the thing observed with which Turner attempts to identify himself: he has himself tied to a mast to study a storm at sea or he leans out of the window of a moving train in the rain, whence comes his *Rain*, *Steam and Speed* (1844) in which a locomotive rushing head on seems to explode a universe of fiery substances. Such a painting reveals a widening vision from the expanding world of science and industry.

It was also in landscape that American painting produced its best work of the period—with Thomas Doughty and especially Thomas Cole, who were major figures of the Hudson River School. Cole introduced ancient ruins he had seen in Italy into representations of the wilderness, and his series titled *The Course of Empire* (1833–36) is without precedent in depicting the same site at different historical moments. Albert Bierstadt was to become the painter of the Rockies, the prairie, and the Indians; and Frederick Edwin Church was to combine Bierstadt's influence with Cole's. But there was also a folklorist tradition of mostly anonymous painters who worked predominantly with landscape. The Pennsylvania Quaker Edward Hicks, in his detailed and sometimes allegorical depictions of farm life and animals, is an outstanding exponent of this naive art.

In Paris, the Salon of 1819 showed Géricault's Raft of the Medusa,

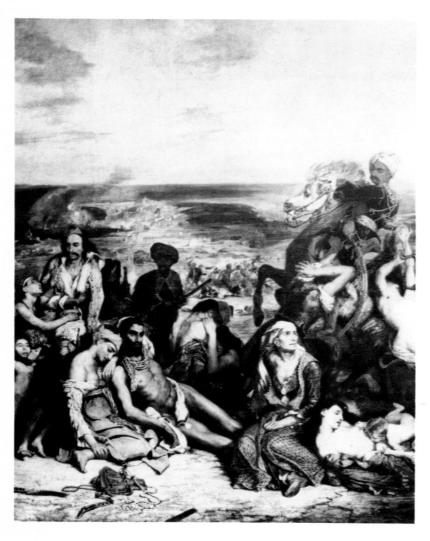

As subject matter became more topical, painters took up new themes ranging from Géricault's mundane Epsom Derby (below, right) to Delacroix's mordant Massacre at Chios (left), which symbolizes all the atrocities that marked Greece's bitter struggle for independence from Turkey. At right, a study of a horse by Géricault.

which later made a triumphal tour of England. Then the Salon of 1822 showed Delacroix's *Dante and Virgil in Hell*; and in 1824, his *Massacre at Chios* (the sky of which he repainted after having seen some Constable skies) and Ingres's *Vow of Louis XIII*. These are the three great names dominating the Romantic era, the complexity of which is illustrated by their divergences.

On his deathbed in 1824, Théodore Géricault, then only thirty-two, exclaimed, "If I had painted only five pictures!" And yet his production in the twelve brief years between 1811 and 1823 had been intense and prolific. More than three hundred canvases, drawings, and lithographs were brought together for his centennial exhibition in 1924. Nevertheless only the immense canvas of the *Raft of the Medusa* (1819)—measuring about 16 by 23 feet—and his *Epsom Derby* (1821) can be considered finished canvases, the rest nothing more than sketches. Many of these, however, can be described less as rough studies for a composition—such as the drawings showing Fualdès dragged by his murderers—than as components intended for incorporation into

Overleaf: Géricault's Raft of the Medusa is at once great art and brilliant reportage of the fate of an unseaworthy, ill-fitted, overloaded ship sent by the authorities to take colonists to Africa.

an aggregate. We shall never know for what "Fall of Napoleon" those battle scenes, those wounded cavalrymen, those mounted trumpeters were intended or what frightful scene of asylum would have united those faces of insanity. And yet this lifework barely begun is among the greatest of its time—it creates a bridge from David (whom Géricault admired and visited in exile in Brussels) to Delacroix, by whom he was admired, but not without a touch of jealousy.

Like David, following the example of ancient bas-reliefs, Géricault sometimes composed his paintings and sketches by dividing them into parallel vertical sections; he modeled form with light and shade, and he revered the nude. The murderers of Fualdès are naked, and although the crowd in the version of his Race of the Barberi Horses (1817) in Baltimore is shown in contemporary dress, the horsebreakers of the version on display in Rouen (dating from the same year) have the majestic nudity of the ancients. He drew like a sculptor, in clear, deliberate outlines. None of his subjects, however, are ancient themes; they are all events of the day-the Napoleonic epic, the brutal murder of a provincial magistrate named Fualdès, and new faces in the street-and they include a notable series of lithographs done in England on subjects covering journeymen, the poverty-stricken, blacks, the insane, and even the hanged. He took the contemporary epic as a subject for painting and as a vehicle for social criticism-his lithographs are unquestionably a form of social indictment, although it is doubtful whether the Raft of the Medusa, a shipwreck that appears to have been the result of negligence, contains any political grievance. He himself denounced both the liberals who referred to the painting as from a "patriotic brush," a "national touch," and the extremists who saw in it a seditious act.

Géricault introduced elements that were fully exploited only after Romanticism; his work gained recognition especially after 1848.

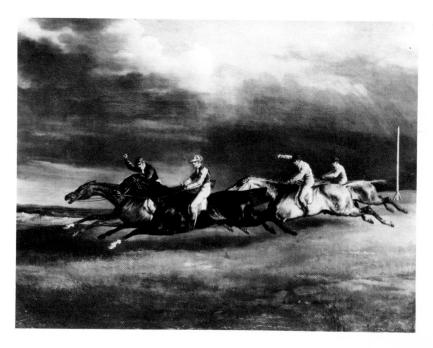

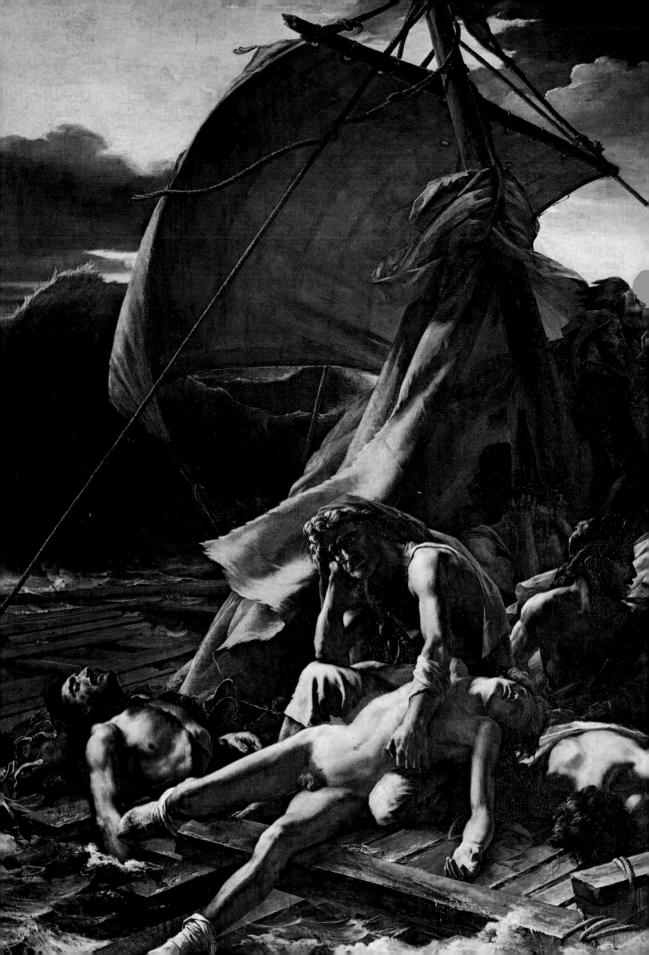

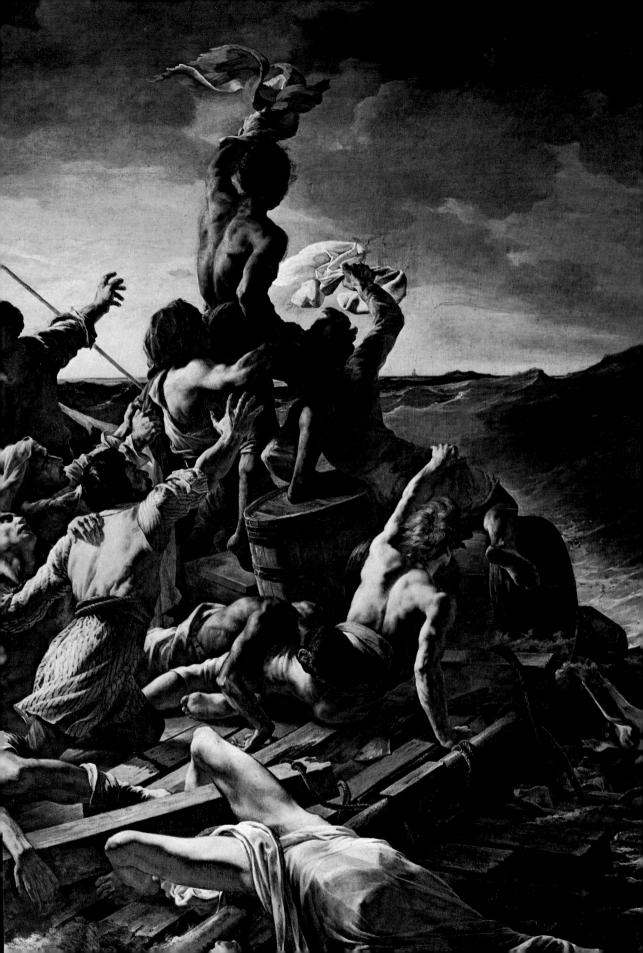

Although his earliest works extend the tradition of chiaroscuro, with his dramatic penumbras (aggravated by the bitumen he used in underpainting), paintings like his Epsom Derby, the Horse Market, and the Lime Kiln (c. 1822, viewed on the spot following the example of the English watercolorists) have broken color and expressive brushstrokes closer to Jean François Millet and Gustave Courbet than to Delacroix, the Epsom Derby even anticipating Degas's instantaneous vision and Impressionism. What he does share with Delacroix and with his time is a sense of passionate expression, showing as much power in the embrace of a couple (1815), the bronze Satyr and Nymph, or a unique landscape of trees twisted by the wind as in the onslaught of wild horses, in battle scenes, and in boxing matches. It is energy expended in flight rather than conquest, to escape this life menaced on all sides not only by death but also by torture, madness, and the agonizing aftermaths of heroic action. But Géricault seeks neither to turn aside from this anguish nor to look at it with the detachment of Delacroix's Sardanapalus. The anguish is totally his, more than his time's.

Even though Eugène Delacroix paid his due to David, it was he who effected the total break with antiquity-not so much in subject matter (having included in his repertory The Justice of Trajan and the unfinished Orpheus and Eurydice, 1862) as in a system of forms. In his great compositions and in the inspired frescoes of Saint-Sulpice, one looks in vain for the controlling lines, the axes, and the schematic arrangement underlying classic composition. What strikes the eye are masses in movement, a drift of colored clouds, a passage of contorted arabesques that are projections of human life, the fire of passion from edge to edge of the canvas, an upheaval of forces culminating in the crest of a wave no less than in the mane of a lion, and a deep and restless space. Delacroix was a supremely intelligent and cultivated spirit, entirely linked to the past even though he never went to Italy. He sought to perpetuate a great tradition of which antiquity was, to his eyes, only a variant seen through Rubens, Titian, and Veronese; he rediscovered the spontaneity and power of the masters by tackling great subjects.

Delacroix left only a few portraits and practically no landscapes or still lifes. The plain in the Massacre at Chios, the distant view of the city and sea in the Entry of the Crusaders into Constantinople, the stormy sea in Christ on Lake Gennesaret, all wonderful settings, are integrated into their respective themes; and the well-known Still Life with Lobsters of 1827 is a still life incorporated into a landscape depicting a stag hunt. And yet Baudelaire remarked that a canvas by Delacroix affects us from a distance solely by its color before we even know the subject; he declared that "Delacroix's color has its own thoughts." Even more than the drawing, which makes the forms readable and identifies the subject, it is color and colors in the aggregate, in the total space, that characterize a painting by Delacroix. It is hardly necessary to dwell on the contrast between the color and the drawing-his drawing is admirable, consisting of a kind of splatter of spots and scrawls, trails of hatching rather than of meticulous delineation. But it is chiefly color that interested him and on which he dwelled in his Journal, contrasting the mixed and leaden tones of the David school to the "bold

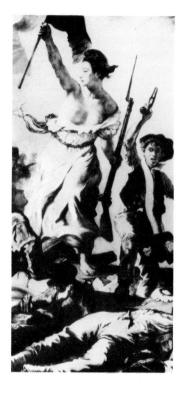

Delacroix's Liberty Leading the People (detail above) commemorates the 1830 uprising that toppled Charles X's reactionary regime and is one of the paintings that won for Delacroix the coveted title of History Painter. His Death of Sardanapalus (detail at right) is based on Lord Byron's tragedy of an Assyrian tyrant who had himself and his court immolated as his capital was overrun by conquering Medes.

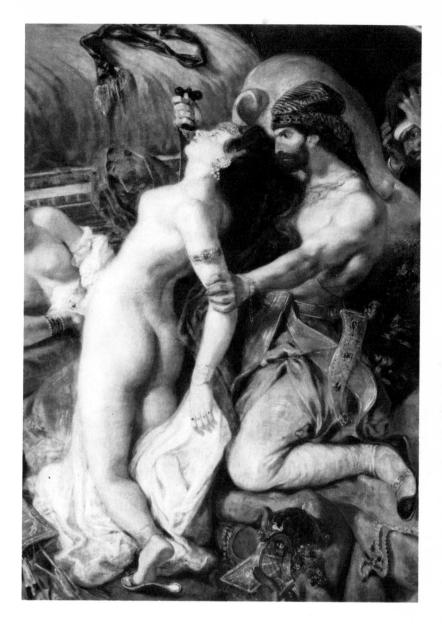

and pure" colors found in Rubens and Titian. Almost always within his canvases there is a dominant tone—carmine in *The Justice of Trajan*, light blue in the *Battle of Taillebourg*, sea-green in *Chios*, dark blue in the *Crusaders*. These overtones of color applied in small nervous strokes give a vibration to the canvas. It is no longer just local tone placed on the object but a relating of the object to a space full of reflections and interactions. Delacroix makes object and subject disappear in a blaze of color. From him Baudelaire learned that nature is a kind of dictionary providing not phrases to copy but words that the imagination, "queen of the faculties," is free to associate.

Yet with these words, the painter creates new phrases that express his response to life—perhaps an abstraction of a few moments of sensuality as in the marvelous *Women of Algiers* (1834). Almost always he is inspired by the dramatic revelation of an instant: the crowning moment of a continuing episode when the tiger is about to rend his

prey or the hunter to kill the lion or the arms in battle about to break or a look of detachment on the face of a dying person, an expression more of despondency than serenity. Both of these extremes are confronted in the *Sardanapalus* (1827), where a stabbed woman is still crying out—there is still a spark of life—while the tyrant looks on as if

the deed had already been consummated.

Only when related to the sublime do such tragic moments excite Delacroix's imagination, and such examples rarely occur in real, contemporary life. Instead, he drew his sources from the past, from legend, from exoticism. In Morocco he loved the hunt and strife of wild animals, subjects more apt than Parisian life to captivate the painter of the crusaders and the struggle of Jacob with the angel. This painter of heroic action was certainly a far cry from the art that was to come. And yet the Neo-Impressionist Paul Signac saw in him the beginning of

Impressionism.

Jean Dominique Auguste Ingres was born in 1780, before Géricault; he died in 1867, after Delacroix. He seems close to David, whose pupil he was. An important part of his work, from Oedipus and the Sphinx (1808) and Jupiter and Thetis (1811) to The Apotheosis of Homer (1827), is inspired by the Classical past, although more by Greece than by Rome. In Florence and in Rome, he discovered Masaccio. ("How they misled me!" he exclaimed.) He had no interest in the statuesque effects of antiquity but instead sought perfection of draftsmanship; he painted flat, and his first canvases were criticized as being "Chinese." Then, closer in this regard to Delacroix than to David and Géricault, he avoided contemporary history as subject matter (with the exception of Napoleon). In keeping with his time, he shared only the dreams, the escapism: in history, The Vow of Louis XIII, Joan of Arc; in Christian legend, The Martyrdom of St. Symphorian; in Orientalism, the odalisques, The Turkish Bath; in dreams, the Dream of Ossian, which is the essence of Romantic painting. Where he stands in contrast to Delacroix is less as a draftsman (even though drawing was essential to him) than as a colorist. His color is bright, with the vividness of a medieval illumination, as if reflected in a mirror; it fills form without gradation or halftones; it does not radiate but sparkles-somewhat similar to Sienese painting. Ingres condemns the conspicuous brushstroke resorted to by Delacroix; instead he seeks to give a perfect illusion of an object, as if untouched by the hand of the artist. Form must be made manifest without any evidence of the role of the painter. Reflections and the surroundings are of little importance; what really counts is fullness and beauty of form. Whereas Delacroix tends to diverge from a given center, to lose himself in the whole, Ingres relates everything to the center of the painting.

Is Ingres then a realist? The large number of portraits he painted, their meticulous precision, the quasi-trompe l'oeil of his art would seem to indicate this. But it is a realism made up of exclusions. Ingres rejected Géricault and the modern taste for ugliness and scenes of suffering. Art must commemorate only the triumphs of nature, only what is worthy of being immortalized. In painting the portrait of a contemporary, he excluded expression, passing moods, or psychological fac-

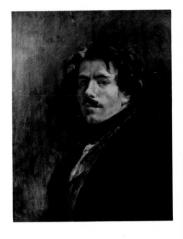

The rivalry between Delacroix (whose self-portrait is shown above) and Ingres was so bitter that Ingres once threw open the windows of a room in the Louvre after Delacroix left, to rid it of "the smell of sulphur." Among the early works of Ingres is his portrait of Madame Rivière (below). The artist is better known, however, for such works as The Turkish Bath (right), embodying what he once referred to as "chaste" sensuality.

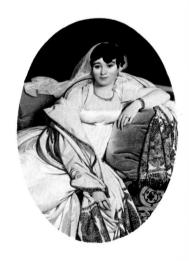

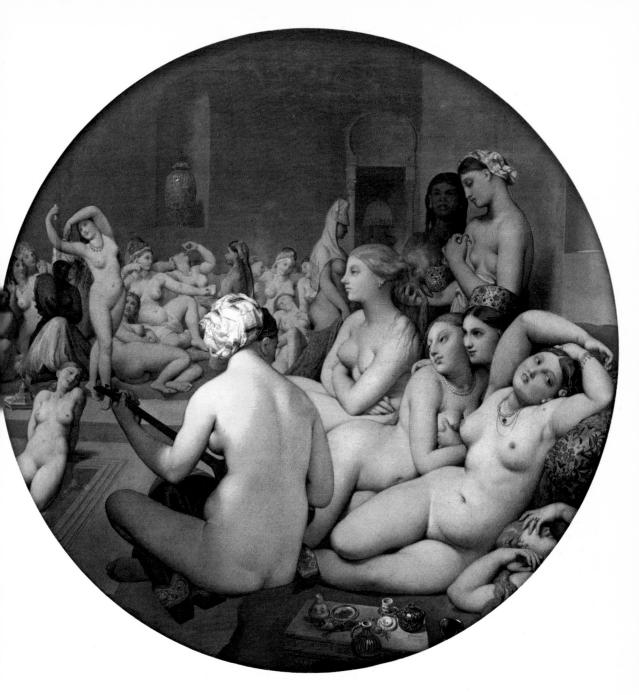

tors: immutability and perfection can be reached only by physical structure. More than by man, who is always defined by his activities or his profession, Ingres was inspired by woman, by female beauty of face and body. Ingres's nudes are among the most beautiful of painting. Yet they have often been criticized for their falsity. Baudelaire spoke of his "preconceived" style and denounced his too evenly tapered fingers—indeed three vertebrae too many have been counted on the back of the 1814 Odalisque. Ingres himself is said to have remarked that it is as impossible to conceive beauty excelling nature as to imagine a sixth sense. But he also said, "When it comes to truth, I am prepared to go a little beyond it, whatever the risk." Actually he stylized, he pushed truth of

line to hyperbole, and he resorted to manneristic elongation, which is not an affectation but the irresistible urge of instinct. This conflict with truth, which rendered his task more difficult, almost impossible, often confronted him: "To draw the head of a woman is impossible . . . I no longer know how to draw!" Contrary to the romantic concept of inspiration, which gives painting the immediacy of life, Ingres—so gifted that one of his earliest portraits, *Madame Rivière* (1805), is one of his most beautiful—was master of a difficult art; building slowly, stone by stone, he produced works of rare distinction in which nothing was left to chance. *The Turkish Bath* dragged on for years; he never completed *The Golden Age*; he made numerous variants of some of his paintings.

Ingres has been accused of formalism. A contemporary critic quite rightly asserted that as opposed to David and Delacroix, who placed form at the service of idea, Ingres only believed in perfection of form; he was exclusively interested in straight and curved lines. This explains why, after having suffered a certain eclipse, he was to be rediscovered by the Cubists and the purists, those who seek to construct independently of meaning. But there is meaning in that form, which can be found in the noble nudes of *The Turkish Bath* and *The Golden Age*—sensuality, without question, but "chaste" sensuality, as he himself termed it, musical and contemplative, with the discretion born of wonder after overcoming desire.

Romanticism in France was not limited to these great names. There were the painters of history, of medievalism, of the troubadour style. Some depicted the Napoleonic legend; others explored the light and exoticism of North Africa, which had just been opened by the French

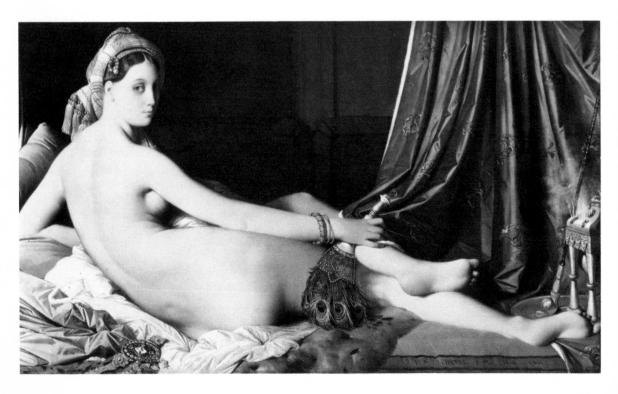

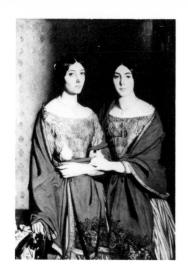

One of the few artists of his time to integrate Ingres's sense of line -as embodied in his Odalisque (left)-with Delacroix's feeling for color was Théodore Chassériau. Although he died at thirtyseven, he left several masterpieces, including The Two Sisters (above). Among the German Romantics the finest was Caspar David Friedrich, whose desolate landscapes, like The Wreck of the Hope (right), project melancholy overtones of the transience of human life against nature's permanence.

conquest of Algeria. But the only great artist of this group is Théodore Chassériau. Born in Santo Domingo, he was marked with a grace, a certain Creole ease combined with nostalgia for a native paradise. The charm of his art appears chiefly in his nudes, including some classical nudes (*Venus Anadyomene*, 1839) and biblical figures (*Esther Preparing to Meet Ahaseurus*). He is stimultaneously the incisive portraitist of *The Two Sisters* (1843) and the muralist who between 1844 and 1848 executed vast compositions for the Cour des Comptes in Paris, which were transferred to the Louvre. They are on the abstract themes of *Peace*, *Silence*, and *Meditation*. Animated by the grace and Prud'honian

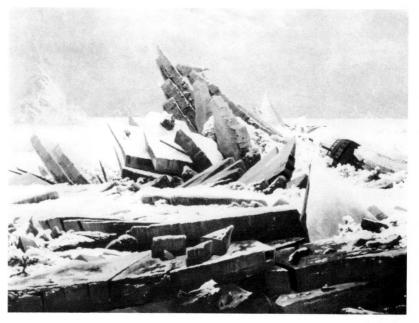

sensuality of feminine faces, these paintings are among the last to revive the tradition of great classic compositions, but they do so with a sort of morbid mellowness that seems to foreshadow the artist's early death.

Elsewhere, Romanticism was a convention that fostered numerous works but none of really great creative importance. In Germany, where a mass of artists, or rather draftsmen such as Peter von Cornelius and Alfred Rethel, devoted themselves to illustrating the Bible, national legend, the spirit of Dürer, or Goethe's Faust, there was one impressive singular oeuvre, that of Caspar David Friedrich. Unlike any other painting, his work conveys what German poetry and music had just been expressing: the poignancy of solitude, the ecstasy of communion with nature, perhaps with God. He also painted vast landscapes, which seem to belong to an age before the advent of humankind, as in Mountains in Silesia (1820), or which survived after human life as exemplified by an extraordinary glacial chaos in The Wreck of the Hope (1821). If people are present, only their shadows are visible, in silhouette before a landscape that escapes the ridiculous only because we feel a mysterious communion binding the two presences together.

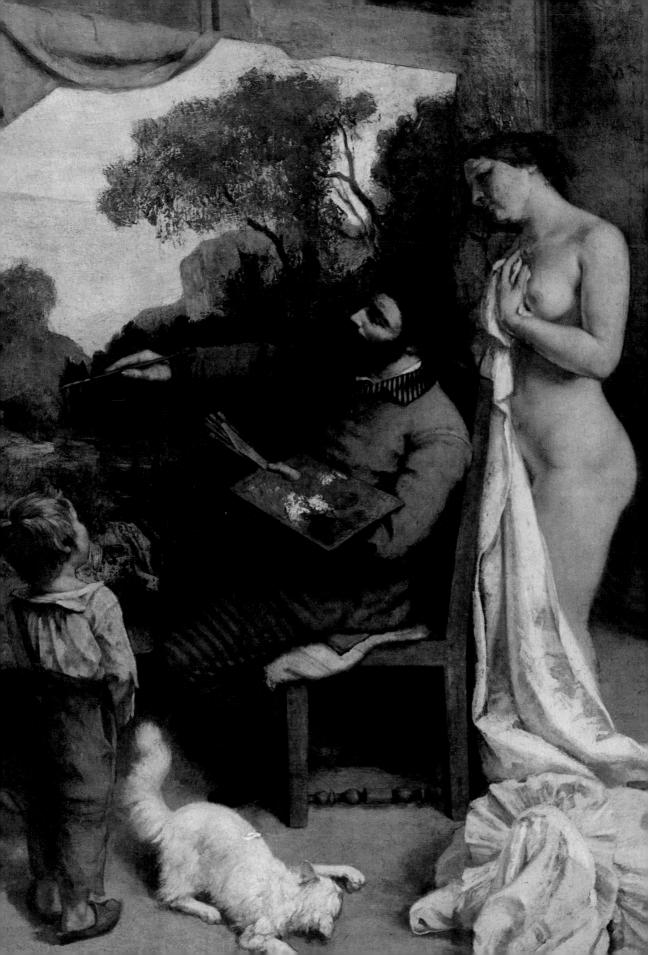

The Realist Moment

Realism was not the only kind of painting practiced between 1840 and 1860—there was also an "official" art that was vapidly eclectic, there were the trailings of Romanticism, and there was more than one current of idealism. But Realism defines the era and expresses it by its innovation. It has been claimed that the era was characterized by indifference to subject, making subject simply a pretext for painting. In fact, it was not indifference; what had appeared was an entirely new type of subject matter. Courbet, Millet, Daumier all have, without question, a subject to which they cling with all their strength. They all have something they want to say, a message they want to deliver; but their subject, quite simply, is no longer connected either with the past or with the imagination.

To this new school, only that which exists counts and what exists is not only a face or a tree but the whole of society in its time. In addition to portraiture and landscape, the great Realist painters were to sign their names, as did the old masters, to vast meaning-filled compositions in which modern man in his milieu and his problems are represented. "Real allegory" was the phrase Courbet used to describe his great canvas *The Artist's Studio*; he was saying that reality is interpreted and evoked in its deepest signficance by artists through their own emotions and their own faith. The official critics were wrong in reproaching the Realists for having a taste for ugliness (Millet, for example, for having wanted to paint a "cretin" in *The Man with the Hoe*). But Baudelaire was equally wrong in attributing to them a simply photographic reality.

There is a relationship between this style of painting and life shaped by the inception of industrial civilization, the transformation of cities, and the power of a bourgeoisie delivered from its complexes, daring finally to see itself face to face. There is also a sort of contemporary optimism in the painting, in violent contrast to the pessimism of Romanticism. Optimists or not, all these painters were more or less in sympathy with the revolutionary events of 1848 in Europe, the first general uprising of workers. They depict the misery of the people with brotherly sympathy and support the social and socialistic issues; but none of them turned their backs either on industrial civilization or on the bourgeois faith in work as the foundation of property. They simply wanted to help a class alienated from the benefits of bourgeois society, which they intended less to destroy than to improve. It is incorrect to see this

In such works as The Artist's Studio (detail at left) Gustave Courbet attempted to break away from the fusty academicism of the past and create what he referred to as "real allegory." The full painting includes figures from his youth at Ornans as well as Parisian friends and critics, including the poet Baudelaire, deeply immersed in a book.

painting as revolutionary. If it is hostile to the vices and absurdities of the bourgeoisie as a governing class, it is in accord with bourgeois ideology, which denies exalted values (religious, martial, and ideal), believes only in what it sees and touches, and seeks to transform the world by work. In other respects, the revolt is intermittent and less social than psychological. Daumier does not denounce any precise and reformable inequity so much as injustice in general, the everlasting human selfishness; Millet contends that although humankind is overwhelmed by toil, man also perceives "the infinite splendors that surround him." Furthermore, it is the peasant, the craftsman, the individual tradesman who is evoked, rather than the factory worker. Courbet, the most socially committed of all, paid for his involvement with exile in Switzerland where he died. His connection with the Paris Commune uprising of 1871 had brought vicious official harassment and forced him to flee France. Still, his reply to the anarchist Pierre Joseph Proudhon, who saw in The Stone Breakers (1849) the first socialist canvas, was that he never gave any thought to that but simply painted what he saw.

By far the most representative of the Realist tendency—for it is less than a movement—is Gustave Courbet. He had the power of the masters and the strength—in both the mental and the physical sense—to tackle the most enormous compositions; he possessed ambition, seriousness, and gravity of thought along with facility and brilliance—gifts that made him an incomparable painter of detail, triumphing in a piece

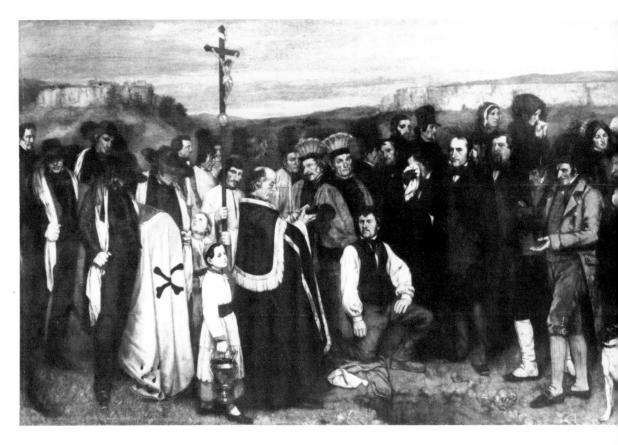

Because the French bourgeoisie of the time expected funerals to be conducted with all the dignity and ceremony that the family could afford, Courbet's Burial at Ornans (below) came as a shock. The suggestion that some of the burial party could be indifferent, even callous, as they were depicted, was considered not truth but unspeakable vulgarity.

Overleaf: In Young Women on the Banks of the Seine, Courbet showed himself capable of portraying a rich sensuality in addition to the "vulgarity" of which he was accused.

of cloth, a head of blond hair, the radiance of flesh, the fur of an animal, or a clump of trees in a rock. Born in the village of Ornans, near the French-Swiss border, son of a prosperous farmer, he communicated the weight and timelessness of the earth in remarkable landscapes. As a portrait painter—and self-portraitist not unaware of his own good looks—he conveyed the spirit behind the face, in such portraits as those of Baudelaire and Proudhon, with as much skill as he did the dignity of a workman or the self-satisfied stupidity in the sotted features of the beadles in *The Burial at Ornans* (1850). Violent, coarse, tearing away all the masks of convention, to the horror of the bourgeoisie, he was also a painter of sensuality—enamored of the female figure caught at rest, in sleep, and in self-indulgent moments, as expressed in *The Hammock* (1844), *The Bather Asleep* (1845), and *Young Women on the Banks of the Seine* (1857).

The Burial at Ornans, a scene of everyday life containing ordinary and even ludicrous details, attains a striking majesty in the frontal movement unfolded by the frieze of figures massed under the line of a cliff rising to the sky and the beauty of a somber tone broken by whites and reds. But the most impressive and representative elements of Courbet's art are manifested in *The Artist's Studio* (1855), a huge canvas measuring 113/4 feet by 19 feet and comprising thirty life-size figures. The studio brings together the whole texture of the artist's life: the easel, with a landscape he shows himself painting; the nude woman, who is not a model but the muse of truth; his friends; admirers of his art; and a couple of lovers. Everything that Courbet painted shows the hand of a master. Fundamentally, he was a master in the traditional sense, linked to the past by the aspiration to convey a message, by breadth of style, and by a chiaroscuro similar to Caravaggio's. Yet a canvas like The Trellis (1863), among others, certainly anticipates the plein-air painting of Impressionism. Delacroix said that the landscape on the easel in *The Artist's Studio* gives "the effect of a real sky in the middle of the canvas."

Another representative of French Realism, Jean François Millet, was of peasant stock (from the Cotentin in Normandy) and was to pass almost his whole life in the village of Barbizon, south of Paris, where he could have been solely a landscapist like the others of the school that arose there. But although he did paint some straight landscapes, including Spring with a notable rainbow, he did not like to separate people from nature. The bulk of his work depicts the tender and solemn chant of rural labor. Against the peaceful, far-reaching horizon the human gesture is his theme; the gesture is not caught haphazardly, in the chance of the moment, but in its most telling light. Millet waits for the moment that discloses the essential, that which is worth recording for eternity-he seeks the archetype. "I aim to avoid having things appear to have come together by mere chance but rather to give them an essential, inevitable interrelation. I want the people I represent to appear dedicated to their situation, and that it be impossible to imagine their having the idea of being anything else." His aim was, in other words, a classic aim, and there is in Millet an admiration for Poussin, with dominant yellow-blue tonalities in the manner of the seventeenth

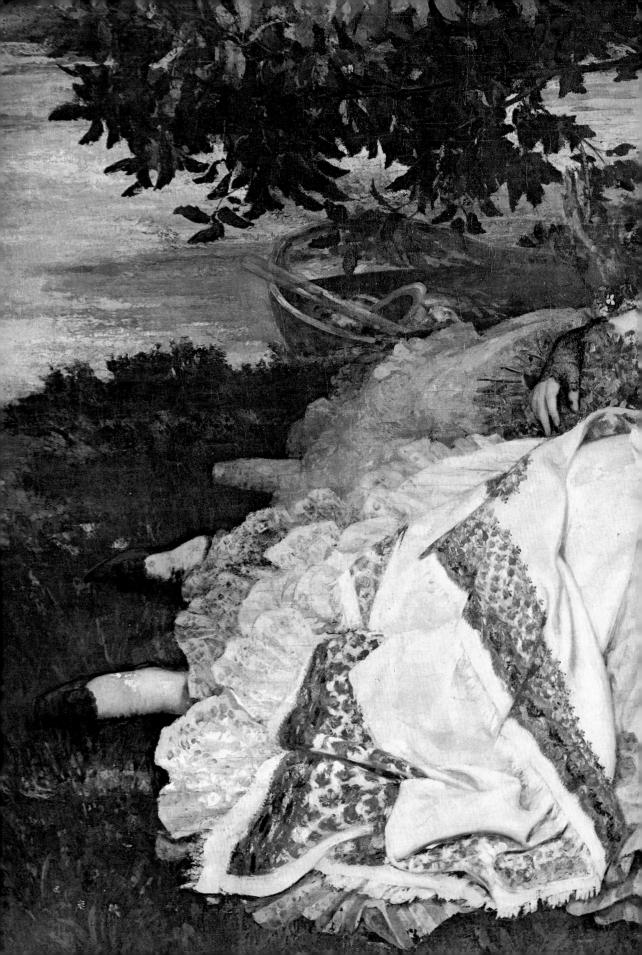

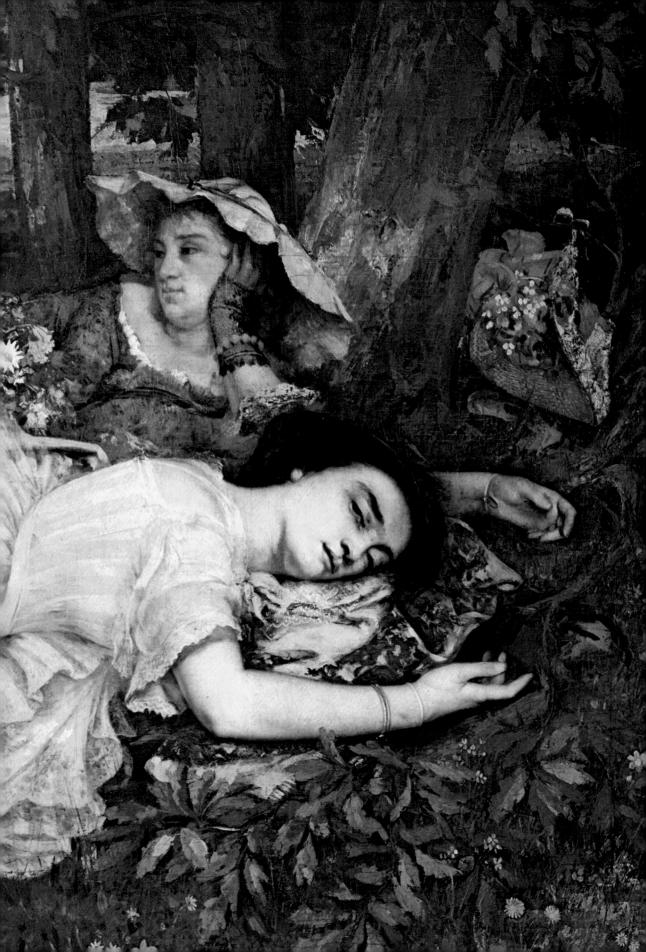

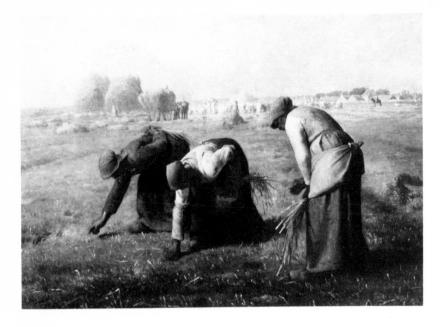

century, for example, in his celebrated *Gleaners* (1857). And yet even in the most pronounced realism (as in the astonishingly superreal *Death* of a Pig, 1870), he succeeds in preserving a latent, gentle poetry. Van

Gogh was to love his humanity.

Honoré Daumier, on the other hand, was a man of the city-he was born in Marseilles and lived in Paris. He was at first only a caricaturist but gradually started painting; most of his canvases date from between 1860 and 1863, after the journal Le Charivari, in which his lithographs appeared, suspended publication. All his paintings have a definite subject: occasionally religious, The Penitent Magdalene, Christ with his Disciples; literary, Don Quixote and Sancho Panza; political, The Fugitives-men, women, children, and cattle fleeing before the wind of disaster, a painting inspired by the repressions after 1848; and especially social satire of contemporary society, a game of vengeful retribution. But to say that horror and wrath make of all these figures just so many masks looming up from a nightmare is not enough. For of all the Realists of his time, Daumier came the closest to extracting power plastically. Far from standing out against the illusionistic space of perspective, all the typical personages he painted-judges, lawyers, clowns, checker players, third-class railroad passengers, workmen, street singers-are caught in the texture, the impasto of such palpable painting that we see nothing else but that. Painting fills the canvas from edge to edge, animated throughout by oblique strokes like slanting rain and swirls resembling commas-it devours form, leaving nothing but a diagram, a flexible skeleton like an X-ray film. The caricaturist, who must execute his work swiftly, was undoubtedly the preparation for the painter, in an art whose final result counts less than the gesture and its trace: Daumier was the most modern of the Realists.

In 1869, Courbet made a triumphal journey to Munich, where he was to have great influence on German painting, notably on Wilhelm Leibl. But the best German artist in the Realist mode, Adolph von Menzel, is closer to Daumier. Theater scenes (*Recollection of the Gymnase*, 1856), strollers along the Tiergarten and Unter den Linden, por-

Like Courbet, Jean François Millet was received with scorn. In paintings like The Gleaners (above, left) he tried to raise the realistic depiction of rural labor to a level traditionally reserved for more idealized figure studies. Honoré Daumier devoted most of his energies to political cartoons in a desperate attempt to acquire the time and money to spend on his paintings, which include Don Quixote Attacking the Windmills (above) and Advice to a Young Artist (left).

traits—including portraits of the workers of the growing industrial might of the country—all are recorded in hatching, with quivering forms, as if illuminated by the flickering light-and-shade of lamplight. In Russia, on the other hand, Realism—both mystical and revolutionary—denounced French Realism as a form of art for art's sake; art must serve the people, proclaimed Nikolai Chernyshevski in 1865. Realism there was not preoccupied with perfecting or changing painting but with denouncing misery, often giving to the poor the face of Christ. In this spirit, in 1863, the young artists broke away from the national Academy of Arts and founded a group known as the Wanderers, which tried to bring art to the people.

While Realism dominated and scandalized, a less turbulent kind of painting was being born as an independent category and breaking soil for what was to come. To the Barbizon School, which took its name from a village near the Forest of Fontainebleau, must be given credit for a new approach to landscape painting, notably in the work of Théodore Rousseau. Rousseau lends majesty to his treatment of nature and often retains a classic feeling for composition and tonality. Nature is for him-as for the Romanticists-a living refuge, even perhaps a compensation for the political deceptions of 1848. At the least it is a means of communion; "I hear the voice of the trees," he once said. Rousseau brought to his canvases a new attention to detail and exactitude; brushstrokes establish-as he wrote-"the nerve center" of the painting. He also brought breadth and the will to seize as a whole everything that is a whole: the underlying structure of earth expressed through thick, closely knit strokes, the aerial drawing of the branches, the breathing of the leaves, the fiery reflections of a pond, the shadows of a storm, the sheen of surfaces, and the depth of space.

The true precursor of Impressionism, who owes little to the Barbizon School, was Johan Barthold Jongkind, a Dutch painter who established himself in Paris and exhibited there in 1848. At Honfleur, where he met Eugène Boudin and Monet, he produced numerous watercolors depicting seascapes, jetties, and clouds. The watercolors were executed on the spot in astonishingly abbreviated, elliptic strokes and with a wonderful play of white spaces that create a hitherto unknown feeling of aerial motion.

The greatest landscape artist of the period was, however, Jean Baptiste Camille Corot, whose long life (1796–1875) enabled him to bridge the Neoclassical and Romantic traditions as well as the Realist trends and nascent Impressionism. He is the most personal, the freest of the Realist painters, a master of landscape and an admirable painter of portraits. But although these were the two great kinds of Realist (and bourgeois) art for him, he did not let Realism stand in the way of an elusive poetry and beauty: through the truth, he still pursued something intangible. Before dying he confessed: "It seems to me that I never learned how to paint sky. What is there before me is much more beautiful, much deeper, much more transparent."

Because he thought successful painting should achieve a certain charm, a mellowness, an elusive reverie in light and form, surface and depth beyond the merely visible, the difficulties of painting seemed great to Corot. The museums were of little help for the task: although he spent several years in Italy, it was not the great masters that In Russia, Realism became the domain of the "Wanderers," one of the most renowned of whom was Ilya Repin. His Procession (above) is a conscientious work but of lesser stature than some of his portraits. At the same time in France, landscape painting was evolving; the style was embraced by the Realists but snubbed by the Romanticists, even though landscape conveys just those qualities of reverie implicit in Romanticism. Among the greatest landscapists of the time was Camille Corot, whose Collecting at Mortefontaine (right) had strong appeal for the bourgeoisie of the Second Empire.

attracted him but the countryside, and especially the marriage of architecture and landscape. He painted a few relatively academic landscapes (Hagar in the Wilderness, 1835, and The Flight into Egypt, 1840, which recall Poussin), but his early landscapes, from his first stay in Italy, were perfectly free, without figures, conceived exclusively with plastic problems. The study for the Bridge of Narni (1826), for example, upsets classical perspective and inverts distance by the use of intense color; the blue of the river in the shade of trees seems nearer than the muddy yellow, which is in the immediate foreground. Thus he is already close to Cézanne in attempting to give the feeling of spatial depth by relating everything to the plane of the canvas and giving light a role in volumetric structure. Corot resorted to this miracle to create landscapes like those of Claude Lorrain, but he failed to follow his genius. For a long time (like Constable) he abstained from exhibiting his sketches, which, freed from the fiery juices of Romanticism, sparkle with his clear palette of plein air and sun and his gamut of silvery grays, somewhere between ivory and mauve.

Corot's need for lyricism, along with the clarity and rigor of the visible, also led him to diffidence, experiments, and wavering. After 1850 he produced his numerous softly blurred landscapes, in which nymphs are shown dancing among the glades of the Forest of Fontaine-

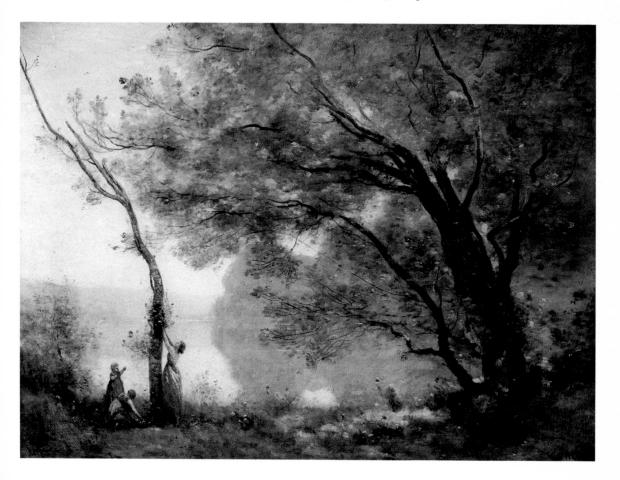

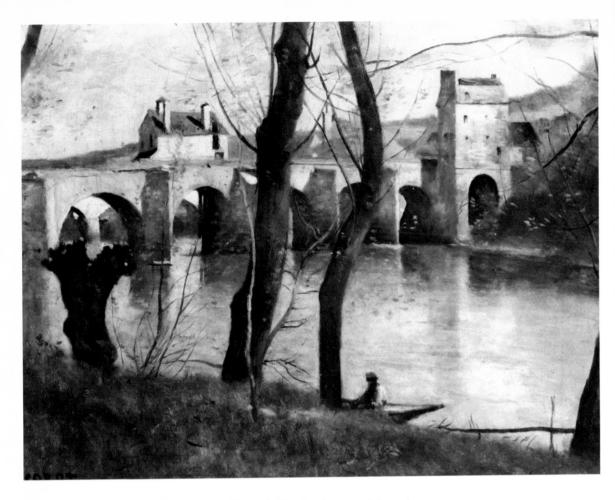

bleau. Such canvases delighted the Second Empire bourgeoisie, who had often been shocked by Courbet's audacities. Often engaging, as in Collecting at Mortefontaine (1864), and illuminated, according to Corot, "by the sun of the soul," they were sometimes quite facile but were inferior to a number of his earlier canvases. His last paintings, however, fully demonstrate his genius: in The Bridge of Mantes (c. 1868), a mass of arches and trees scans gray space in which a single red point sparkles, and in The Belfry of Douai (1871), yellowed stucco walls are punctuated with golden and vermilion accents.

Finally, Corot also had a genius for portraits, which were not so much images of readily identifiable sitters as anonymous figures of reverie and feminine grace—The Interrupted Reading (1865), The Young Woman Dressing (1865), The Atelier (1868). The palette is on a higher key than the landscapes, with more intense reds, blues, and yellows. The figures are placid but monumental, even though the canvas is small, as is often true of the landscapes. Social indictment is entirely absent from Corot's work; he is indifferent to those problems. His peasant girl is never the victim of humiliation but the essence of youthfulness and often a nymph.

Despite the dominating presence of Realism, there were many concurrent trends—among them a strain of Romanticism in France—but one of the main reactions to Realism, in painting as in literature, was a symbolic idealism that was first represented by Gustave Moreau.

Corot's full genius flowered in such works as The Bridge at Mantes (above, left). But Corot was not merely a gifted landscape artist. He was also an accomplished painter of portraits, many of which, including the Lady with a Pearl (above), immortalize anonymous models.

Moreau's treatment of myth and legend, as in *Theseus* (1855), *Jason and Medea* (1865), and *Orpheus* (1866), is the expression of the soul, of depth psychology. It is an art of antiquarian detail (a profusion of curios, jewels, enamels, and ivories with the glitter of porphyry) exhuming languishing, disquieting, and potentially cruel female apparitions. There is something disturbing, a feeling of magic that seems almost demonic in Moreau's vision, particularly when compared to Pre-Raphaelitism, with which it is related.

The greatest reaction to Realism was, in fact, English Pre-Raphaelitism. In 1847, during a discussion in Sir John Everett Millais's studio, William Holman Hunt and Dante Gabriel Rossetti, then students at the Royal Academy, decided that there was something artificial about Raphael's *Transfiguration*, due to its virtuosity and general feeling, and that it marked the beginning of decadence in art. In the following year they founded the Pre-Raphaelite Brotherhood and began signing their canvases with the initials P.R.B., exhibiting as a group in 1848 and 1850. The movement was short-lived as a community—Millais broke away quite quickly—and the critics reacted violently. Dickens, referring to Millais's *Christ in the House of His Parents*, likened it to a tramp entering a hovel. Ruskin defended them, however, in his *Modern Painters*, and their own review, *The Germ*, started in 1850, set forth their ideas.

As a communal movement—an anomaly in English painting, which is made up mostly of individual temperaments rather than schools—Pre-Raphaelitism sought a return to ancient sources, at least to the quattrocento and to the Middle Ages. ("The general feeling of the Renaissance schools," wrote Ruskin, "is one of laziness, infidelity, sensuality, and frivolous pride.") This kind of reproval was a romantic rupture, a denial of contemporary reality in the name of sincerity, ingenuousness, and depth of feeling. But such anachronism, which opposed a distant to a nearer past, was a means of regaining contact with a lost reality.

Like the Realists, the Pre-Raphaelites painted from nature but with an unequaled attention to detail-Ford Madox Brown spent the years 1851 to 1859 painting blade by blade and flower by flower the meadow of his Pretty Lambs and square by square the uneven relief of the woolly cloth the shepherdess is wearing. But nature, for the Pre-Raphaelites, was not that of the Realists, it was neither the everyday proclaimed the equal of the beautiful and the sublime, nor was it a depiction of misery, the responsibility for which must be laid to society. Reality, for them, was beauty-the beauty of nature and of humankind -and the task of restoring it with consummate meticulousness was an act of offering to it a sort of prayer. Pre-Raphaelitism was, thus, a kind of religious movement, a reformation. There are, of course, many homely anecdotes included in these pleasant landscapes (in The Pretty Lambs and The Hireling Shepherd, for example), but the integration of sacred history with landscape was the supreme aim: "Far from being exhausted, historical painting and religious painting have hardly begun," Ruskin said; "Moses has never been depicted." Painting must say something and say something sublime; it must elevate the soul.

Undoubtedly this message also denounced a society trapped in hard

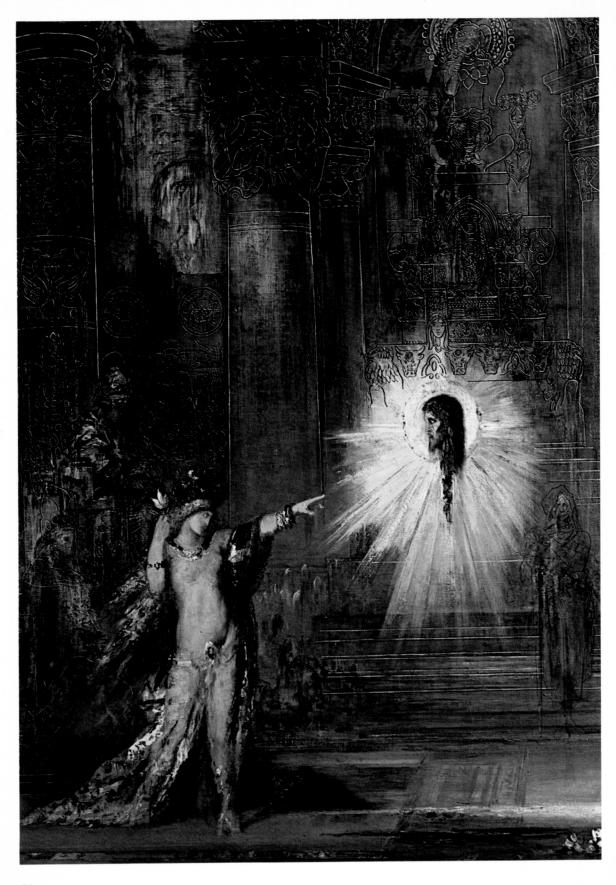

Gustave Moreau was not a member of the Pre-Raphaelite Brotherhood, but in paintings like his Apparition (left), he showed himself to be spiritually akin to them. Among Pre-Raphaelite canvases are Rossetti's Beata Beatrix (above, right) and Sir John Everett Millais's portrait of the sympathetic critic John Ruskin (above).

times brought about by industrial progress and the exploitation of misery. But there was no political intent in setting the England of steel and coal against a dream of childlike colors, of Christianity, occasional paganism, and a chivalry of stained glass. Pre-Raphaelitism has been described as an esoteric, aristocratic movement. And yet it contained a social sense, although its aim was simply to create a community of craftsmen similar to those in the Middle Ages; in 1861 its members founded a collective studio of artist-craftsmen. Its new gospel was in no way directed against the economic structure of society.

Millais, the most gifted and the most painterly of the community, willingly sacrificed message to execution, to the painting itself, for example, in the web of water flowers in which *Ophelia* (1852) is floating. After Madox Brown, the precursor, the most representative of the movement were Holman Hunt and especially Rossetti, who was of Italian origin and a poet as much as a painter. In structures with right angles (which are not classic in design but a sign of uprightness of

heart), he evokes feminine and sometimes angelic figures, occasionally disquieting, at any rate obsessional, as in his *Beata Beatrix* (1863). Sir Edward Coley Burne-Jones, whose celebrated *Mirror of Venus* reflects his reverence for Botticelli, was only later linked with the movement, and he represents a less well-defined, more symbolistic stage in the development of Pre-Raphaelitism, which he was to summarize as follows: "My concept of painting is a beautiful dream of something which never happened and never will happen, in a more beautiful light than ever shone, in a country that cannot be visited, only desired."

Against the stream of an irresistible current, since it narrates and details, gives meaning and reaches conclusions, Pre-Raphaelitism nevertheless inaugurated a kind of plein-air painting, freed it from the classic penumbra, and painted violet skies and garish greens in the light of the sun. If Impressionism repudiated it, it was because the excess of precision in the representation of reality produced a kind of dreamlike disorientation. Not until the advent of Surrealism and contemporary Hyper-realism has it been possible to reevaluate Pre-Raphaelitism, which, all things considered, must be given credit for an important chapter in the history of ideas. The brief movement also produced some beautiful, highly unusual paintings.

Toward midcentury, American painting also identified itself with the Realist trend while offering truly indigenous characteristics. William Sidney Mount and George Caleb Bingham depicted scenes of rural life, combining figures and landscape. George Inness and Ralph Albert Blakelock were offshoots of the Hudson River School, which was modi-

In midcentury America, Realism was to take its own form, from the sensitivity of George Inness's Two Sisters (above, left) to the naturalism of Audubon's timeless studies of the continent's birdlife (left). Anecdotal Realism was perpetuated in paintings such as William Sidney Mount's Bargaining for a Horse (above).

fied by others, especially Fitz Hugh Lane and John Frederick Kensett who used a brighter palette. Frederick Remington distinguished himself as the painter of the Far West. But most explicit is the naturalism of John James Audubon in his extraordinary record in watercolor of the birds and animals of North America. Martin Johnson Heade associated botanical and zoological subjects with landscape backgrounds. In the same spirit of dispassionate observation, George Catlin depicted Indian tribes in their native life and customs. Another characteristic aspect of American painting is the *trompe-l'oeil* tradition, notably represented by William M. Harnett in still lifes such as the one of a gun hanging on a door, *The Faithful Colt* (1890).

In an entirely unforeseen way, the only movement that anticipates French Impressionism—or more properly *tachisme*—occurred in Italy, after a period of the lethargy that often accompanies political turmoil. Suddenly and only for a few years—between 1855 and 1860—in Florence, a provincial setting deprived of any international exhibitions, loomed the astonishing Macchiaioli School. Their art, according to the theoretician of the group, consisted of recording "impressions directly received by means of spots of color, bright spots and dark spots, for example a single spot for the face, another for the hair. . . ." The work of Giovanni Fattori, the outstanding painter of the group, affects us in a direct, unique way, in such paintings as his *Women on the Beach* (1866) or *The Ruins of Mantua* (1855).

4

Impressionism

Although modern painting had its origins in the years surrounding the French Revolution, its moment of full emergence occurred in Paris in 1863. It emerged from the Salon des Refusés and the offense taken at Manet's *Déjeuner sur l'Herbe* followed by outrage at his *Olympia* when it was exhibited in 1865.

At that time Parisian art galleries rarely held exhibitions, and the official Salon provided the main opportunity for artists to show their works. The selection committee was composed of members of the Académie des Beaux Arts, who were mainly academic painters and professors and administrators with equally conformist points of view. In 1863, from three thousand artists submitting five thousand works, only two thousand were accepted. Confronted with the protest of those excluded, Napoleon III settled the question by decreeing a Salon des Refusés to be held alongside the official Salon.

It cannot be said that the painters in one hall were all bad and those in the other all good. In the Salon there were admirable works by Corot, Courbet, and Millet; and although the Salon des Refusés included Manet's Déjeuner sur l'Herbe, James McNeill Whistler's The White Girl, and two distinguished paintings by Johan Barthold Jongkind, there were also any number of mediocre works. But the Salon des Refusés was exemplified by Manet while the official Salon was typified mostly by mythological and historical works that are now simply regarded as banal.

It is difficult today to understand the outrage evoked by the Déjeuner and Olympia, especially since they have been assimilated into tradition and forged their own links with the history of art. Indeed, the Déjeuner is a transposition of Giorgione's Country Concert, and the influence of Velázquez in some of Manet's other paintings is marked. But nonetheless, between the new painting—so brilliantly represented by Manet—and traditional painting, there was an incontrovertible break. Works of mythology and history, corresponding to the great tradition of the past, had cast their last flares with Ingres and Delacroix. They were replaced by the painting of everyday life, of the here and now. Émile Zola described the new approach as "a window open on nature," and Stéphane Mallarmé spoke of "the instant freshness of encounter." Painters henceforth became concerned with seeing and no longer with knowing, because of the realization that what we know fal-

The face of Manet's Olympia looks out with a brazen stare, much as the painting itself thrust its challenge at the Parisian art world of the 1860s. To a society accustomed to admiring paintings grounded safely in the past or seen through a romantic vision, Manet brought a note of contemporary reality that totally outraged his critics.

sifies what we see. What was needed, according to Ruskin, was to regain an "innocence of eye."

Since the Renaissance, representation had followed the lines of receding perspective. The new painting substituted for depth a flat surface, where everything has the same intensity and in which objects are spaced and diminish in size according to distance. The background is not inanimate and the impression of space remains, but instead of being a distance that draws the viewer into the painting, it becomes something moving toward us. Furthermore, the object that gives the painting its subject and title had habitually been centered. In the new painting the frame might cut through the middle of a face or the principal figure might be found near the edge of the canvas, with empty space in the center. Finally the new painting took advantage of the viewer's attitude toward a canvas: accustomed to seeing what we know must be there, we think we see what is not really there, such as details that are not visible to our angle of vision or a uniform color in an object we know is usually red or blue. The new painting arrested vision before the structure and definition of the object was realized; it caught the object not in its totality but in one of its profiles, according to a truncated perspective and the main lines of a simplified shock of sensations. It recorded not one color but juxtapositions of many tones and entanglements of different colors.

With the dazzling plane of the canvas lacking both the illusion of

The breadth of Manet's great talent enabled him to paint different subjects with equal skill and feeling. In The Races at Longchamp (above) he preserves the climactic moment of a race as viewers crowd the rail and the horses drive toward the finish. In The Fifer (left) he concentrates on a single figure—a young soldier in the Garde Impérial, who is almost silhouetted against a flat background.

Overleaf: The provocative mixture of reality and fantasy in Manet's Déjeuner sur l' Herbe had a startling impact on the spectators when it was shown at the Salon des Refusés in 1863. perspective and the traditional balance and finish, and with the juxtaposed strokes left to the viewer for optical mixture (instead of colors mixed on the palette), the new painting was so baffling that Zola advised: "If you want to reconstruct reality, you must move back a few steps. Then a strange thing happens. Each object falls into place, the head of Olympia stands out against the background in startling relief. . . ." But why this new distance from the canvas? What use is circumvention if we simply rediscover what can be found at the normal distance in the traditional canvas? Does the optical fusion of juxtaposed colors give the canvas greater vividness? Do the accented, abbreviated strokes, contrasting with parts barely indicated, or even omitted, give great energy to the form? The answer is that everything that demands our active participation in order to be perceived introduces actuality—life—to the picture. The canvas is no longer an image but a field of action in which the image becomes reconstituted.

The great event of this revolutionary new painting was an exhibition in 1874 that was comprised of three Cézanne canvases, ten by Edgar Degas, others by Camille Pissarro and Alfred Sisley, and Claude Monet's famous *Impression: Sunrise*, which gave the movement its name. Succeeding exhibitions in 1876 and 1877, which included works by Gauguin and Auguste Renoir, further established Impressionism in the public mind, although the prevailing opinion was echoed by a critic who said: "They take canvases, paints and brushes, splash on a few colors haphazardly and sign their name to the whole." By the fourth exhibition in 1879, Monet and Renoir were also exhibiting in the official Salon. By 1880 there were signs of a breakup; Monet had an independent exhibition and began theorizing about a movement that had hitherto been essentially spontaneous. The last group exhibition was in 1886, quite naturally coinciding with the end of public resistance to it.

The first master of the new painting, although he never exhibited with the Impressionists, was Edouard Manet. A fastidious and socially conservative Parisian bourgeois, Manet systematically painted what he saw, not what he knew. In The Balcony, for example, a woman's face is realized with nothing more than the line of its contour and light in a virtually empty oval (with eyes but no nose); in The Races at Longchamp, not one of the horses has four legs. Manet was above all else a painter of modern life, of masculine and feminine elegance, and of crowds on vacation, in paintings ranging from Music in the Tuileries (1862) to Bar at the Folies Bergère (1882). His real subject is the human figure, whether in groups (Luncheon in the Studio, 1868) or portraits (of Zola and Mallarmé). But in certain still lifes, such as the Asparagus, he proved that painting need not have a subject. Under the influence of Monet, in his so-called Argenteuil period, which resulted in Boating, Monet Painting in His Studio Boat, and a little later, Rue Mosnier Decked with Flags (1878), he expresses light and the outdoors in strokes of sparkling color. Yet even in this Impressionist period he retained somber and contrasting values, such as the black of Spanish painting that Degas admiringly referred to as "prune juice." Unlike the true Impressionists, he painted less in the open plein air than in the studio or the interior plein air of the greenhouse or winter garden,

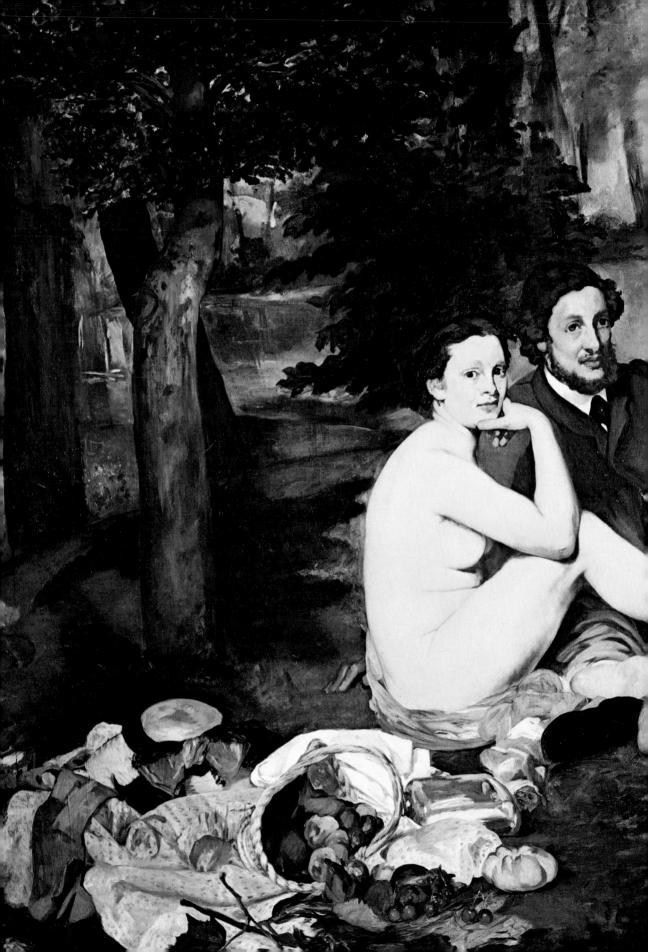

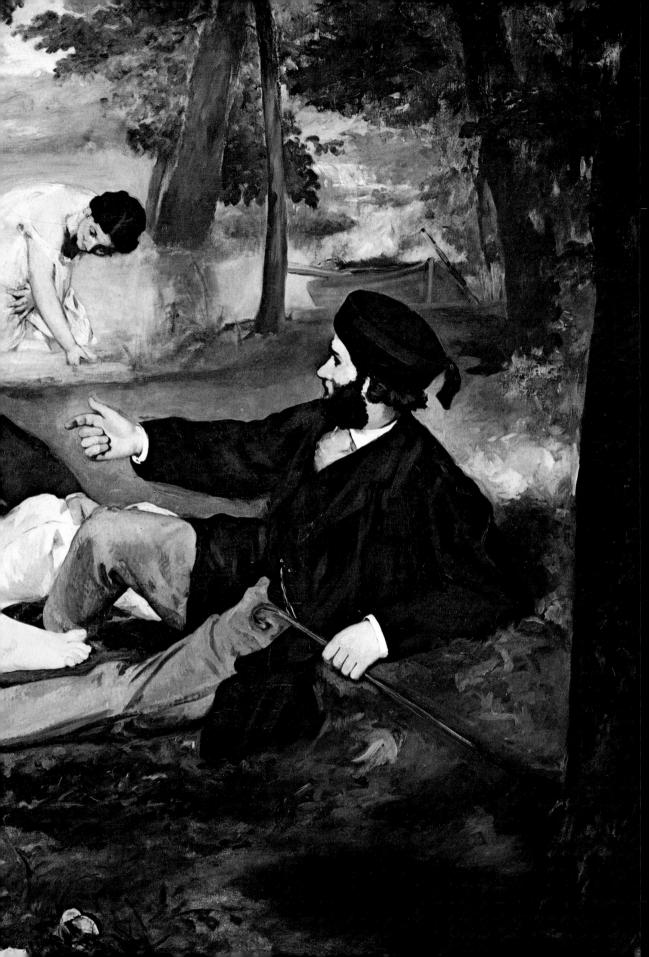

Contrary to the broken color of Impressionism, he also painted decoratively. The large flat surfaces of violent color in The Fifer reflect the influence of Japanese prints. His work is extremely complex and cannot be reduced to a system. Not exclusively a painting of immediate sensation, it retains reminiscences of the museum.

There is a relationship to Manet in the works of Théodore Fantin-Latour, a sensitive painter of still lifes, mostly flowers, as well as portraits, whose A Corner of the Table (which depicts the poets Verlaine and Rimbaud), Homage to Delacroix, and Atelier at Batignolles (an homage to Manet) have documentary as well as pictorial value. Also within Manet's orbit was Berthe Morisot, chiefly a portraitist, who persuaded him to experiment with the Impressionist "rainbow palette." Jongkind and Eugène Boudin both had settled at Honfleur; they lured Manet there and had a certain initial influence on him. Also closely related were landscapists including Alfred Sisley, a painter of unobtrusive, subtle, variegated views of the Seine and the Ile de France (Snow at Louveciennes, 1878), and Camille Pissarro, primarily a painter of the soil, an architect of form, and an analyst of light. Pissarro, a technician, systematically decomposed tones and laid onto the canvas a system of streaks like a grid. This was to influence Cézanne, by whom he was in turn influenced. Pissarro is an important link between Monet and Cézanne.

Claude Monet was the very incarnation of Impressionism. "Nothing but an eye, but what an eye!" was said of him. He was the first to make a clean sweep of the past, which he considered an obstacle to vision. Even as a student he was reproached by his professor for painting what he saw rather than developing his own style. In his earliest canvases he still emphasized drawing-there are outlines and contrasts of tone and form -but little by little everything became dissolved in a dazzle of light

and clouds of color.

Monet is the great magician of color. His preferred subject is nature rather than the human figure: landscapes in sunlight and snow, reflec-

Two of the most sensitive landscape painters among the Impressionists were Camille Pissarro and Claude Monet. Pissarro's Boulevard des Italiens (left) is characteristic of a series of canvases in which the artist captured in fine detail the atmosphere of late nineteenth-century Paris. Monet painted his Women in the Garden (right) in the garden of a rented villa. In order to reach the upper sections of the nearly ninefoot-high canvas, he dug a trench and devised an elaborate series of ropes and pulleys to raise and lower the painting.

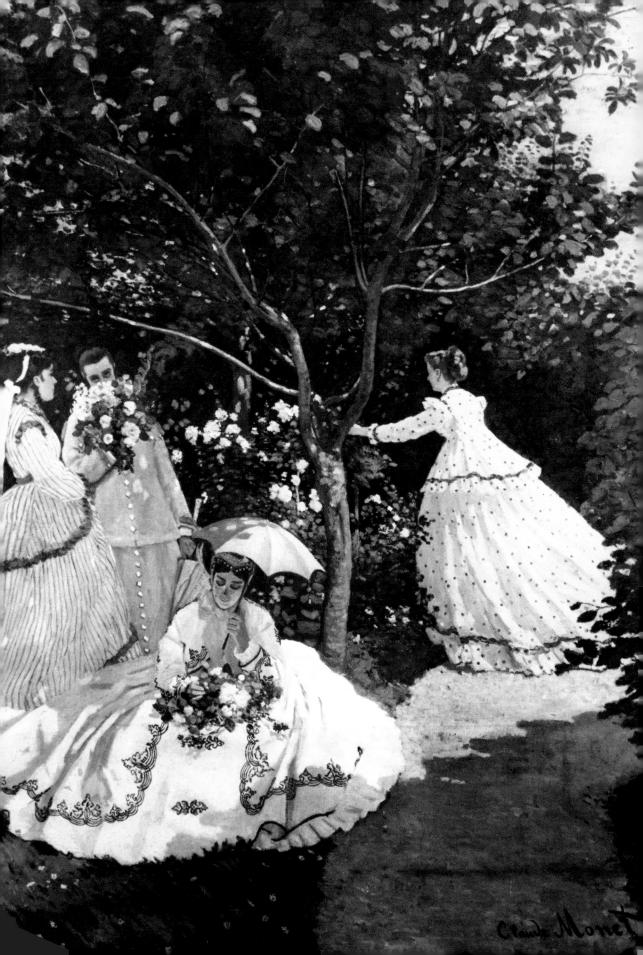

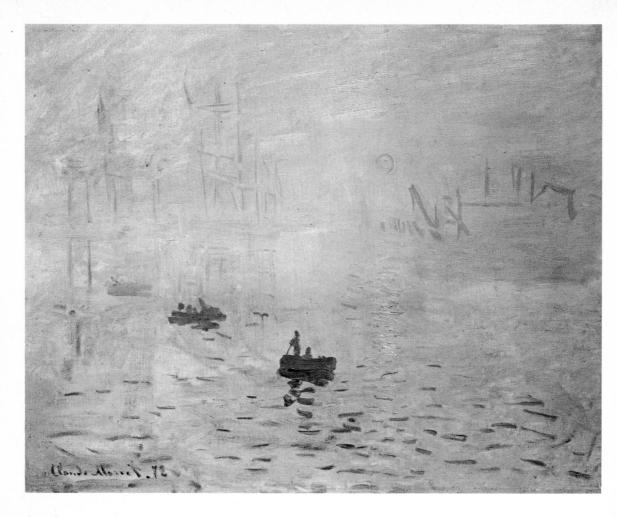

tions in water of the regattas at Argenteuil, fields of poppies. Even the gray and violet smoke of Saint-Lazare Station (1877) becomes a kind of landscape. His style actually consists of the ultimate expression of a realism of sensation, due to his exceptionally sensitive perception of color. But this sensation was finally self-defeating. In order to catch nature undisturbed, Monet arranged it, submitted it to artificial conditions: he created a water garden to be painted from his studio boat. Then, late in his career, in his series of Cathedrals, Haystacks, and Water Lilies, he submitted the same subject to different viewpoints, each corresponding to a particular moment and each defined by a dominant color. The canvas can no longer be titled Rouen Cathedral in Full Sunlight but a harmony in blue, mauve, rose, and green.

Monet's work symbolizes the decline of the role of the museum, and as that role declined, Japanese prints began exerting an important influence on artists and collectors. In the mid-nineteenth century Japan opened commercial relations with Europe and America, and inexpensive color woodblock prints often served as wrapping paper. Manet and his friends were among the first to admire them. Depicting scenes of daily life or of a fleeting incident, the prints were captivating because of their off-center, paradoxical compositions, breaking the laws of classical European perspective, even more than their flat colors. Such art was to have many adherents, among them Edgar Degas.

Few painters delighted in the application and manipulation of pure color as much as Claude Monet. In the painting that gave Impressionism its name, Impression: Sunrise (above), Monet's delicate touch conveys the eerie stillness of Le Havre harbor at dawn as the sun begins to burn off the nighttime mist. Later works, such as Rouen Cathedral in Full Sunlight (right), reveal an even stronger preoccupation with light and hue, leaving the painting's subject obscured by the technique used to render it.

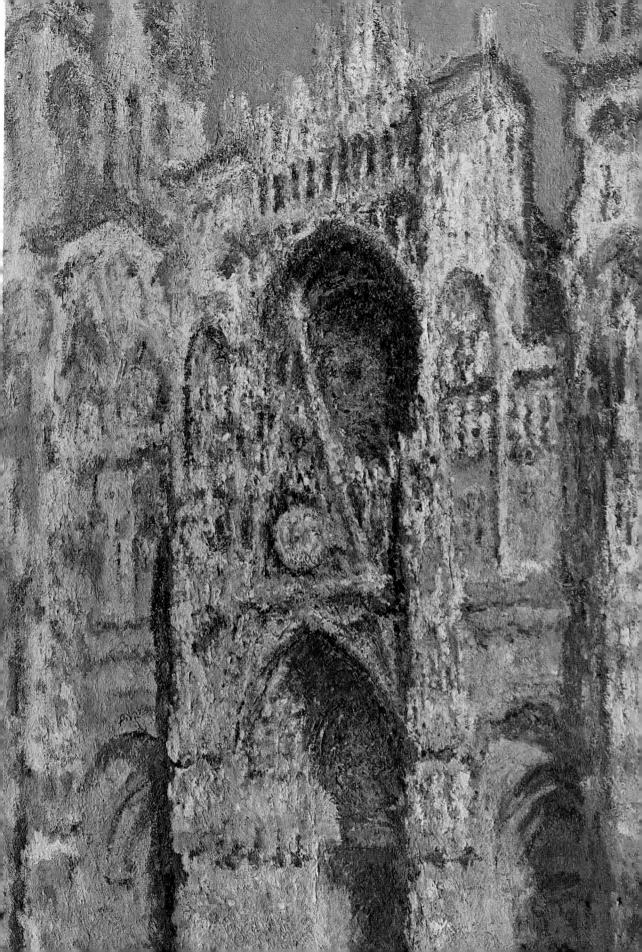

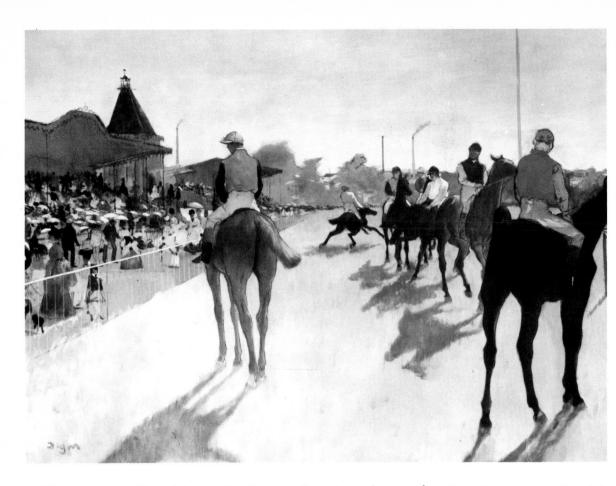

Degas was a cultivated bourgeois of means for whom the art of museums meant a great deal. He traveled in Italy, was an assiduous visitor to the Louvre, and admired Ingres. His first canvases (1860-65) are large historical compositions that place him closer to Puvis de Chavannes than to Manet. But his discovery of Japanese prints was technically decisive. He came to realize that his subject was modern life. His work has very little of the open air and few landscapes; it consists mostly of people-dancers rehearing in green rooms, musicians in an orchestra pit, ironers at work, milliners in their shops, acrobats at the theater or circus. If the scene is laid outside, as in Race Horses at Longchamp, the focus is less on light than on the movement of the horses and jockeys; in his innumerable paintings of women bathing, he concentrates less on flesh than on posture. Degas excels in seizing the precarious equilibrium of a body at the instant when it passes from one position to another. The position of the body is acrobatic, the figures often appear against the light with the principal figure near the edge of the canvas. One has the feeling of a panel gliding before the eye rather than of a fixed image centered in space. An oblique sometimes cuts across the canvas, or the floor on which the dancers are performing seems to be rotating. All this contains an astonishing alliance of dignity and instantaneousness, of unavoidable necessity and the unforeseen.

Toward 1890 his palette became brighter; from this period date astonishing landscapes in monotypes which contain no identifiable forms, only clouds of color. But whether painting, drawing, charcoal,

Edgar Degas devoted his artistic life to the study of ordinary people working, relaxing, or doing daily chores. Jockeys Before the Grandstand (above) is an early example of a series executed after visits to the racetrack at Longchamp with Manet. More characteristic of Degas's work are interior scenes such as Absinthe (above, right). In later years, as his eyesight began to fail, Degas worked more frequently in pastel rather than oil. The Tub (right), completed in 1886, is one of his most sensitive figure studies in any medium.

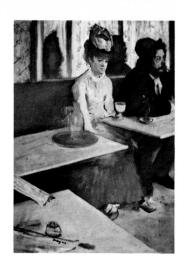

pastel, or even sculpture, and whatever the period, Degas's art is both original and masterful. His connection with Impressionism consists less of his style than of his contempt for academic painting, to which his caustic mind directed many biting witticisms.

Auguste Renoir, who took part in all the exhibitions of the group, represents better than any other the essential character of Impressionism-harmony with the visible world and joy in life. Many of his landscapes painted in the open at Argenteuil or Châtou, his rivers in sunlight, bourgeois amusements or popular diversions evoked in The Loge (1874) or the Moulin de la Galette (1876) are among the most significant of the spirit and technique of Impressionism. Notable is the Moulin, which treats the numerous faces like so many spots of light piercing through the crowd. Having first been a porcelain painter, then a decorator of fans, Renoir was initially a craftsman. He liked to think of himself as linked to tradition, to the eighteenth century, Rubens, and Venice. The black and the pink in The Loge are reminiscent of Velázquez and Goya, whereas the Moulin recalls Rubens. "I have been really myself only when I was able to disentangle myself from Impressionism and return to the teachings of the museums," he once said. Yet Renoir pursued Impressionism to its ultimate conclusion, and he certainly never proposed a return to traditional styles. He did give a definite

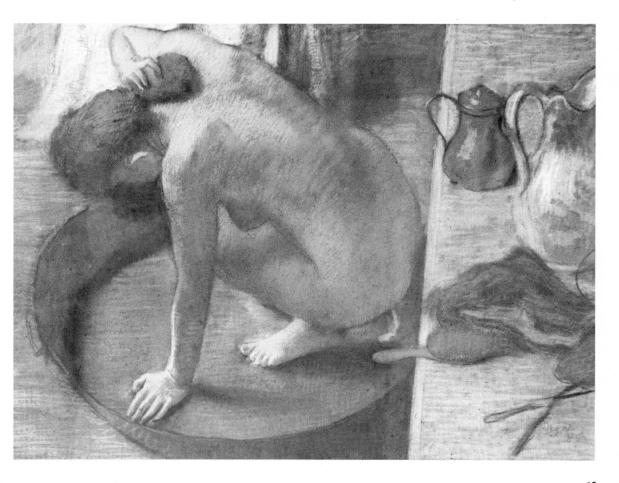

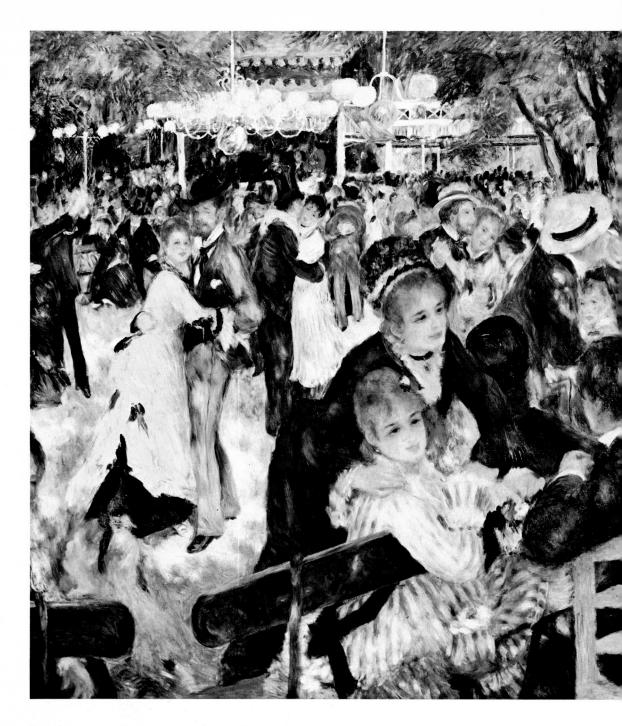

importance to drawing and form. For a time he resorted to dull colors and outlined, built-up forms: *Umbrellas* (c. 1884) is a highly structured canvas. Then returning to color, in the wonderful pearly canvases of his final period, with flushed rosy-red nudes, he continued to play with volume, to swell the powerful bodies of his bathers, and to organize them in palpable rhythms. Renoir painted the paradise he loved to live in; his painting opens up a dream of happiness.

Henri de Toulouse-Lautrec, who belonged to a later generation, joined the Impressionist movement at a very early age. He started with

In one of his best-known canvases, Moulin de la Galette (above), Pierre Auguste Renoir captured the cheerful ambiance that made the dance hall a favorite haunt for Parisians of all classes. Two years earlier, in 1874, Renoir painted a memorable study of mature beauty. The Loge (right). open-air scenes (landscapes and horse races), but then, like Degas, he turned to interiors in which the human figure assumes exclusive importance. More than the café, the circus, or the music hall, his chosen locus is the brothel, in which, deformed by falls during his youth, he liked to take refuge. He painted the prostitute with both cruelty and tenderness. Beyond that, his posters for the Moulin Rouge, with its stars of the day—Jane Avril, La Goulue and her partner, Valentin le Désossé—constitute an incomparable documentation of the period. Technically he painted in clear colors, with hatched and juxtaposed strokes, without using impastoes.

With the predominance of Impressionism, Paris became the center of living painting for the whole Western world. Toulouse-Lautrec came from the provinces, Jongkind was attracted there from Holland, and James McNeill Whistler came from America. A nomad, Whistler also went to Italy and to London where he exhibited in 1877 and was

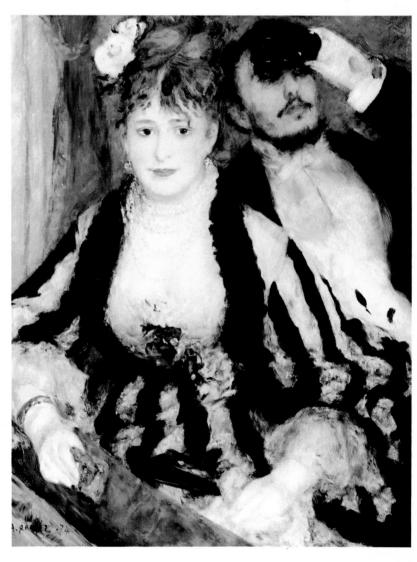

to confront Ruskin, Burne-Jones, and the Pre-Raphaelites with the achievements of Manet. But it was in Paris at the Salon des Refusés that he exhibited *The White Girl*. He is not really an Impressionist, his quest being not light or the outdoors but a new concept of composition. His famous *The Artist's Mother* (1871) shows the sitter in profile, set toward the right, with two-thirds of the canvas given over to bare walls. The painting was first exhibited under the title *Arrangement in Black and Gray*. Likewise, his portrait of Sir Henry Irving was titled *Arrangement in Black*, No. 3, of Thomas Carlyle *Arrangement in Black and Gray*, No. 2, and a series of *Nocturnes: Blue and Silver*, *Blue and Gold*, and *Black and Gold*. The element that interested this portraitist and landscapist was not the subject but its treatment—line and color.

Like Whistler, John Singer Sargent lived in Europe, in Italy and Paris, but his work was independent of Impressionism. Although he was open to the Japanese influence and incorporated a compositional daring close to Manet and Degas, he was faithful to accuracy of depiction and to a classic, Spanish chiaroscuro in which violent reds and whites stand out. Outside of European currents, there is great boldness and inventiveness among a few of the painters who lived almost entirely in America. Starting with drawings for periodicals and initially inspired by Civil War subjects, Winslow Homer painted landscapes,

Dissatisfied with his first version of the painting, Henri de Toulouse-Lautrec added strips of canvas to the bottom and right side of At the Moulin Rouge (below, left) enabling him to deepen the picture's perspective as well as add the striking woman at right. By these adjustments he transformed a realistic scene into a macabre apparition. Toulouse-Lautrec also made innumerable sketches of the performers at the Moulin Rouge, and among his favorite subjects was Jane Avril (seen above, left, in a poster for the Jardin de Paris). Although James Whistler counted many of the Impressionists among his friends, he remained aloof from identification with them or indeed from any artistic movement; instead he experimented with color and composition along his own paths. Whistler is best known for his famous The Artist's Mother (above, right).

notably watercolors in which the influence of Japanese prints is evident. His scenes of hunting and fishing constitute an imposing epic of man against the elements as in The Gulf Stream (1899); the painting Right and Left, of two ducks shot in flight, is striking both in its inventiveness and unique viewpoint. Thomas Eakins is a classic realist whose somber palette evinces Spanish influence; his multifigured The Gross Clinic (1875) depicts a lesson in anatomy recalling Rembrandt on the same subject. On the other hand, Albert Pinkham Ryder is a visionary influenced by Poe's poems: Death on a Pale Horse evokes German Romanticism and Symbolism.

In contrast, Impressionism is clearly the source of the work of William Merritt Chase, Childe Hassam, and particularly Mary Cassatt, who, although having studied first in Philadelphia, spent the major part of her life abroad. She moved on from the Spanish masters to be influenced chiefly by Degas, whose friend she was. The theme of mother and child was the inspiration for her series of color lithographs in which the

Japanese influence reappears.

Photography presented painters of the last half of the century with a major aesthetic problem. At first there was a feeling of rivalry-"Painting is dead!" was the immediate cry-and, in self-defense, painters in 1862 issued a manifesto that proclaimed "Photography is not an art," to which Ingres added his signature. Photography is also cited as having induced abstract painting, on the belief that it had assumed the role of all possible realistic representation. But the problem is more complex. In the beginning photography stimulated painting in the direction of realism. The snapshot and the portable camera, appearing simultaneously with Impressionism, shared with it unexpected angles of

vision and anomalous compositional arrangements. Photography and the new vision in painting both date from the moment when perception became sharpened and extended. Beyond that there was to be a certain sharing of functions-photography was to exempt painting from being an art of highly finished representation and confirm it in the direction,

for the time being, of color.

Following the uproar of the Salon des Refusés and the Impressionist exhibitions, art and the public branched off in two separate directions. After 1863 there were to be on the one hand an inventive, experimental art and on the other, a conventional academic art. This dichotomy was a phenomenon without precedent in art history. Until then every period had known but one style, within which there might be differences of quality (or kind) but not a radical divergence in orientation. After 1863 these two contradictory arts were to advance separately.

In France, the art running parallel to creative art was the art of the Académie, which enjoyed the backing of the state and the general public and retained traditional technique: primacy of draftsmanship, somber palette, modeling, finickiness, and a style of classical beauty in mythological compositions; but it also dealt with historical subjects and contemporary anecdotes and customs. France was also the seat and focus of experimental art, and, accordingly, the opposition there was the most vociferous. Elsewhere, talent, ignoring the bifurcation in France, preserved a certain strength. Germany maintained the tradition of somber painting, looking for depth both of meaning-psychological expression-and of third-dimensional effect. It remained hostile to superficial painting, which-according to Spengler-can be conceived In 1909, while recuperating from the affects of a stroke that contributed to his death a year later, Winslow Homer painted the powerful close-up view of two goldeneye ducks, Right and Left (below). The American artist Mary Cassatt completed many studies based upon her favorite theme, the emotional and physical relationship between mother and child. Whether in oil or pastel, all of Cassatt's work reflects the fine sense of form and color seen right, in a canvas entitled Mother and Child. In the midst of the Impressionists and their disciples, some artists continued to work in the classical tradition. Chief among them was Puvis de Chavannes whose painting Girls on the Seashore is seen below, at right.

only in "the debilitating, decadent atmosphere of the cosmopolitan capital, Paris."

But in France one painter—Pierre Puvis de Chavannes—at least was able to rediscover the classic tradition without falling into academic insipidity, as in fact is indicated by the hostility shown him by his contemporary academicians. Like Ingres, he undertook vast allegorical compositions in which the nobility of the human body is placed in the setting of majestic trees: The Sacred Grove, Winter. Although Puvis's frescoes for the Sorbonne are of a tedious grayish Pre-Raphaelitism, his Marseilles and Gateway to the Orient are painted in modern, fresh color. The canvas of The Poor Fisherman, far from any conventional grandeur, is moving in its ingenuousness and poetic simplicity. Puvis was a solitary figure, but his work was a prelude to Symbolist painting, a movement that was soon to react against the painting of purely visual perception that had been asserting itself with such brilliance.

The Logic of Color

THE NEO-IMPRESSIONIST PERIOD, dominated by Cézanne, Seurat, Van Gogh, and Gauguin, is both a prolongation of Impressionism and a decisive break with it. The work of Cézanne especially, but also of Van Gogh and Gauguin, blazed new trails for painting. But Cézanne did not just break with Impressionism, he also reacted against it. Thus everything that happened between 1886, the year of the Impressionists' last exhibition as a group, and 1906, the death of Cézanne, is intelligible only in terms of that movement.

In 1839 Paul Cézanne was born in Aix-en-Provence to which he soon returned after spending a few desultory years in Paris, thereby losing touch with the Impressionist painters—Monet, Degas, Renoir, and Manet—who had momentarily been his friends. He also broke completely with Émile Zola, a companion of his school days, who so completely misunderstood Cézanne's genius that he cast him as the model for a failed painter in his novel L'Oeuvre. But Cézanne, quiet conformist, provincial bourgeois though he was, was also one of the greatest

revolutionaries of painting.

Cézanne was wealthy enough to devote all his life to art without having to worry about selling his pictures or having them accepted by any particular group. No artist has lived so alone and yet so freely faceto-face with his art, but the confrontation was strained and difficult. In contrast to the Impressionists, who were immediately brilliant in spite of the novelty of their aims, Cézanne seems maladroit at first sight. He was probably the first unskilled great painter, unable to profit by ability—whether measured by the accuracy with which a subject is depicted or by his ease in accommodating to a particular style of representation. Cézanne was probably the first to confront the bare canvas not knowing exactly what he wanted, or wanting so many things, so contradictory and dimly defined, that initially he was uninspired.

Cézanne was not an intellectual; he mistrusted theories and literary men and lived apart from the effervescent Paris where writers and critics laid down the laws. "Outside of tonal contrasts and their relationships . . . everything else is . . . but poetry," he was to say. In other words, painting should be discussed in terms of technique or not talked about at all, for it develops in its own way. Nevertheless, in order to reply to his eventual admirers, Cézanne endeavored to define his aim, and he defined it with extraordinary depth and precision. "I have

Among his many accolades, Paul Cézanne justly earned recognition as the master of still-life painting in the nineteenth century. In his hands, as the detail at left from Cézanne's Still Life with Peppermint Bottle amply demonstrates, the simple arrangement of inanimate objects on a table becomes a lesson in the dynamics of structure.

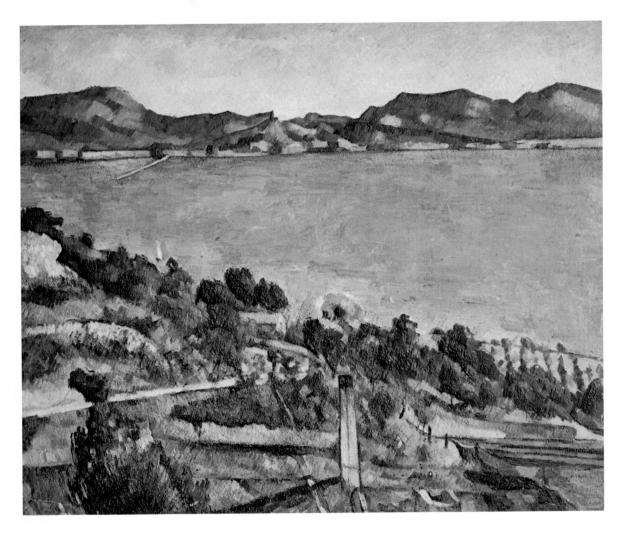

endeavoured to make of Impressionism something solid and enduring, like the art of museums," he said, and also "to do over Poussin entirely from nature." But this extension of Impressionism was much more radical than he implied. He did not simply add volume and structure to colors that were tending more and more toward the dissolution of form; nor was he simply supplementing the untamed eye of a Monet with the example of the masters. Actually, Cézanne challenged the traditional relationship of painting to nature. The Impressionists had turned their backs on all precedents in art in order to be more faithful to nature, to retain a more truthful response to their senses, an attitude that completed the long conquest of visual reality undertaken since the Renaissance. Cézanne said that nature is the only master and he went further into nature than his predecessors. For the first time since the Renaissance an artist was truly convinced that nature is not what it appears to be, that it is "more in depth than on the surface." Cézanne painted by direct observation and preferred subjects that didn't move -apples, Mont Sainte-Victoire, the Château Noir-because, he thought, it is impossible to see things right away.

What was new in Cézanne was the intuition that it is possible to reach the inner reality beyond visual reality by keeping close watch on

Although the narrow-mindedness he found among the inhabitants of Aix-en-Provence deepened Cézanne's sense of isolation, the physical setting of the area proved to be an overflowing source of artistic stimulation. Time and again he returned to paint Mont Sainte-Victoire until, in the years just prior to his death in 1906, Cézanne could declare that he had become one with his picture. Mont Sainte-Victoire and the Château Noir (opposite) illustrates the lyricism of this artist's mature handling of one of his favorite subjects. Cézanne also spent considerable time living in the village of Estaque in southern France. The Bay of Marseilles Seen from L'Estaque (above) is one of several views of the gulf that he executed from a spot in the surrounding hills.

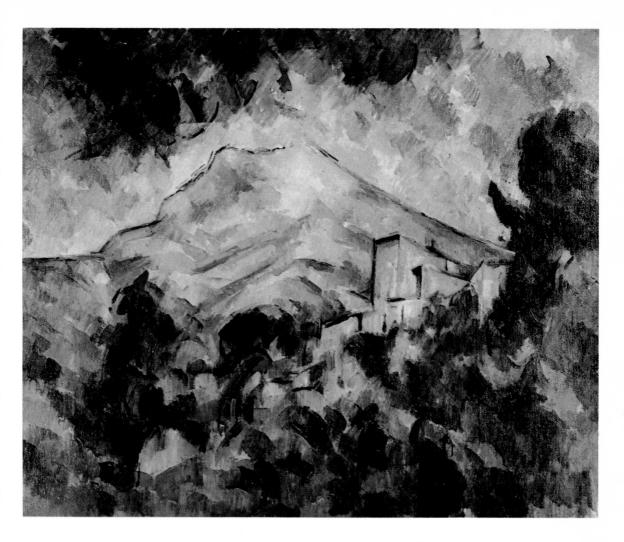

appearances to see what they reveal. Equally new was his conviction that the ability to seize the structure of reality at the level of appearances is inseparable from developing the technical possibilities of painting. What comprises nature in depth will be precisely revealed by the very structures, harmonies of line, and color relationships that define painting itself.

Just as nature in Poussin must be sifted from appearances, Cézanne's painting styles must be sifted from his overall work. There is something of El Greco in his earliest canvases, as, for example, in Sorrow (or The Magdalen) and the Christ in Limbo; the blacks of Spanish painting are present in his early still lifes, even as late as The Black Clock (c. 1869); and there is also an early admiration for Delacroix and a respect for Manet. But before long Cézanne no longer resembled anyone, because no one ever extricated, as he did, that "logic of color" that is, mysteriously, homogeneous to the integral nature of things. Mont Sainte-Victoire as a theme in his paintings is not the composition it would have been for Poussin, the sensation it would have been for the Impressionists, nor the object it would have been for the Realists, but Cézanne's rendition of it remains, inescapably, still a "mountain painting."

Cézanne succeeded in uniting seemingly incompatible elements. His

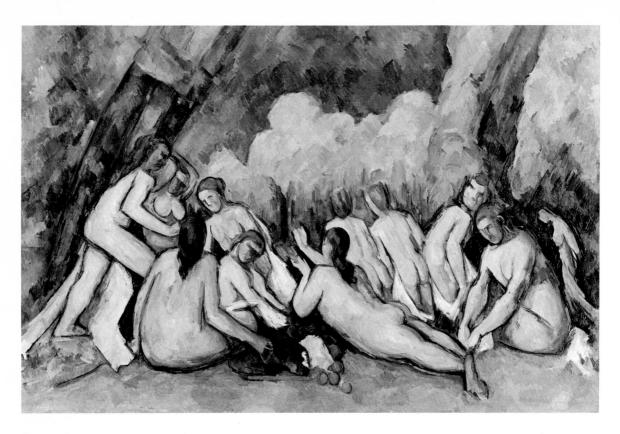

intensity of color renders fullness of form and depth of space without resorting to perspectival illusion (his blue makes you feel the air); light, the mobility of leaves and water, and the transience of reflections are represented not with the lightly sketched, diluted, scumbled touches of Impressionism but with thick, heavily applied strokes. The intangible or the unstable is anchored in structure. "Nature is always the same, but what we see is always changing," Cézanne said. "Art must convey the pulse of duration by means of constantly changing elements and appearances." The definition of planes, the rhythm of solids and voids, the direction of the brushstrokes-whether slanting or concentric-are signs akin to writing as well as revelations of the object. Each stroke contributes to the general effect but at the same time must be seen for itself, remaining the key to a potential vision. Because he was striving to bring together so many incompatible elements, Cézanne often felt driven to despair-"I never seem able to reach my goal," he said; he was misunderstood for a long time and sometimes seemed satisfied with very little. "I am not displeased with the shirt-front," he remarked of his renowned portrait of the art dealer Ambroise Vollard. The miracle of his work is that after the initial, groping, heavily impastoed black period, followed by his lighter period under the influence of Pissarro and Impressionism-as in The House of the Hanged Man (1873)-he eventually reached a peculiar combination of sensitive and cerebral grandeur. This is evident in the various views of L'Estaque, beginning in 1876, Mont Sainte-Victoire, the Château Noir (1885-87), and finally the great series of *Bathers*, from 1892 to 1905.

Cézanne's influence on later artists was decisive. First Cubism was to put his own program into practice: "to treat nature by the cylinder,

Diversity of styles and techniques became a hallmark of Neo-Impressionist painting. In Les Grandes Baigneuses (opposite), one of the last large canvases he completed, Cézanne achieved extraordinary fluidity of brushstroke and design. By contrast, Georges Seurat's careful analysis of color and light led him to develop the tightly controlled style known as pointillism. Just one month before his death in 1891, Seurat exhibited his unfinished work, The Circus (below, left). For Vincent van Gogh the decision to move from Paris to the southern French village of Arles unleashed the great talent at his command. During the fifteen months he spent in Arles, Van Gogh completed nearly two hundred paintings, including Bedroom at Arles (below).

the cone and the sphere...." And all modern art was to learn from him that it is necessary to sacrifice—in Matisse's words—exactitude to truth. A still life, or a painting like Cézanne's *The Cardplayers* (1890-92) sacrifices correct draftsmanship and the natural balance of forms to their function in the composition. Some artists were to learn from him this freedom in dealing with visual reality, the development of a specific logic; others, a deeper scrutiny of appearances in order to pierce through to inner reality. But none was to realize as he did that pictorialization of nature of which he was the initiator.

Georges Seurat's short life—from 1859 to 1891—did not permit him to reach the full measure of his potential, but he later became known as the founder of Neo-Impressionism. In the group's 1886 exhibition, he entered A Sunday Afternoon on the Island of La Grande Jatte, which contrasted sharply with the Impressionist movement in its architectonic organization, its stability, its nobility of form, and its touches of juxtaposed primary colors. When Seurat said that "painting is the art of digging into a surface," he was echoing Cézanne. He too aspired to re-create the grandeur of the past, but the tall, vertical silhouettes of Sideshow and The Circus give less the feeling of depth than of a shadow play, of cutouts against a screen. He also sought to develop

structure by much simpler and more systematic ways than Cézanne, employing contrasts of tone (black and white in charcoal drawings to render shadow and light), contrasts of hue (complementary colors), and contrasts of line (static, as in *Sideshow* and dynamic, as in *The Can-Can* and *The Circus*). Where Cézanne followed intuition, Seurat insisted on theory as his guide in the actual execution.

Seurat's spontaneous sense of grandeur prevented his cerebral approach from resulting in a purely mechanical application. It was a danger that Paul Signac was not always able to avoid. But the latter's theoretic writings are important: in his book-length essay entitled From Eugène Delacroix to Neo-Impressionism, he describes his aim "to seek the power and harmony of color by using colored light with its pure elements, relying on the optical mixture of these elements, keeping them separate and proportioning them according to essential laws of contrast and gradation." Seurat and Signac systematized what Impressionism had utilized intuitively, the separation of spots of pure color that then mix optically from a distance.

By contrast, Van Gogh and Gauguin drew their sources of inspiration directly from native instinct. Both also had roots in Impressionism, but they did not attempt to make a system of it or to organize it or give it formal structure. They focused on another weakness of the movement, its lack of feeling and lack of an expression of the anguish or exaltation of being in the world. The two artists do share with Cézanne his departures from a literal representation of nature, but for them painting was only a means of rendering to the whole of a person's being the sustenance it needs. In the intensity of a yellow or in the flaming forms of a cypress, in the images of the Tahitian paradise, both sought something beyond purely visual satisfaction, something that would have left nothing more for the soul to desire.

Van Gogh's life is one of the most dramatic chapters in the history of painting; but it was from the difficulties of life that he suffered, not from the difficulties of painting. Born in Holland in 1853, the son of a pastor and possessor of a profoundly religious disposition, he sought a religious vocation and was assigned by the consistory of evangelical missions to the Belgian mining district of Borinage. But he was soon dismissed for an excess of zeal, and he retired to a life of misery. In a spirit of charity and revolt he started to draw and paint realistic subjects with a somber and impastoed technique; utilizing ochers and other earth colors, he produced tragic scenes, evocations of peasants' and workers' suffering as in The Potato Eaters and The Weaver, of his own suffering, and of his solitude, in The Shoes. While he lived in Paris, between 1886 and 1888, his palette brightened considerably and his characteristic comma-shaped stroke appeared; the influence of Japanese prints is evident, along with that of the Impressionists, in such subjects as The Bridge at Asnières, The Moulin de la Galette, and The Restaurant de la Sirène.

Attracted by an easier life (his brother Theo was supporting him and this obligation tormented him) and driven by instability, while searching for an intensity of light that was not merely a retinal pleasure for him but spiritual ecstasy, Van Gogh moved to southern France and

In his many self-portraits Van Gogh chronicled both his developing technique and color sense as well as his deteriorating emotional balance. Only a few weeks after his mental breakdown on Christmas Eve, 1888, Van Gogh completed Self-Portrait with Bandaged Ear (above), which portrays with astonishing honesty his empty eyes and frightened visage. Following twelve months of treatment in an asylum, Van Gogh went to live in Auvers with the physician and amateur painter Paul-Ferdinand Gachet. In what proved to be the last few quiet moments in his life, Van Gogh completed several masterful paintings including Church at Auvers, (opposite) a work distinguished by its softly expressive brushstrokes and striking colors.

settled in Arles. And if his anguish seemed to be extinguished in the brilliant yellow of his Sunflowers ("How stunning is yellow!" he exclaimed), it reappears in the nocturnal depth of Starry Night, and even in the Bedroom at Arles, in which he had thought he was depicting his own repose. In October, 1888, Gauguin came to stay with him and they aspired to work together, but they were both fundamentally given to solitude. In the course of a quarrel, Van Gogh cut off his ear (recorded in the famous Self-Portrait with Bandaged Ear) and was committed first to the asylum at Arles, then at Saint-Rémy. From the period of these confinements come his most intense canvases, cypresses and olive trees twisting like flames, roads like flows of lava, lurid skies -and an obsessive Prisoners at Exercise in which a closed circle of captivity expresses his own delirium. His portraits, with their asymmetry of contour, their fixed stares, their yellow or orange pupils, and their green hair, are hallucinating icons. At Auvers-sur-Oise, where he lived under the affectionate supervision of Dr. Paul Gachet and where he was to take his own life in July, 1890, he signed two canvases that clearly convey the feeling of a toppling world and warn that death is at hand: The Church at Auvers and the Wheat Field with Crows.

"I have sought with red and green to express the frightful passions of man," Van Gogh said. As a doctor studies the drawings of the insane ("It is a sick person who painted them," Van Gogh said of his own

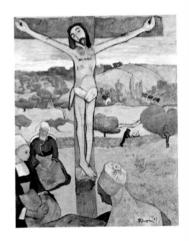

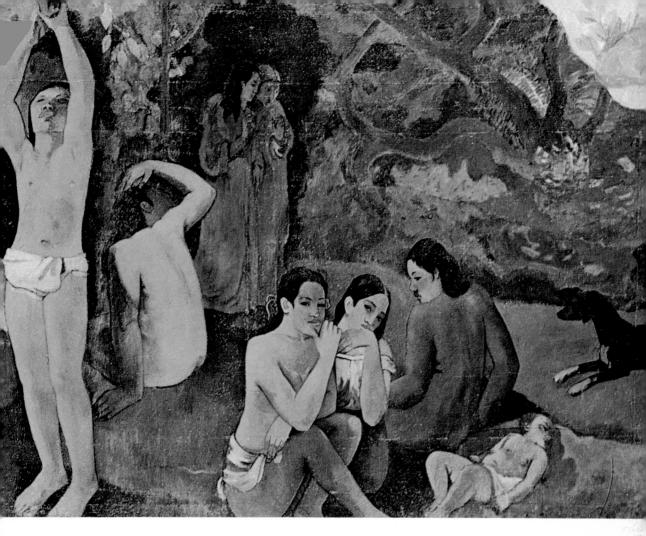

By artistic standards Paul Gauguin's flight to Tahiti succeeded in untapping a new sense of form and color that was probably unattainable for him in Europe. On a personal level, however, Gauguin failed to find satisfactory answers to the fundamental questions so brilliantly presented in his monumental canvas Where Do We Come From? What Are We? Where Are We Going? (above). Earlier in his career, Gauguin settled briefly in Brittany, where he worked with the young artist Emile Bernard and produced a number of unusual paintings, chief among them The Yellow Christ (left).

canvases, "and I assure you I do not do it on purpose"), the viewer can read in his work the anguish that gripped him. But he also said that "life returns a little only when I stand before the canvas." His canvases rarely express joy, yet he succeeded in keeping his demons at bay—he succeeded in being a great painter and feeling that perhaps he was one. His art also contains an important element that is entirely independent of the turmoil it conveys. Painting in small dots juxtaposed directly on the canvas without being mixed on the palette, and also resorting to large flat colors, he is the link between Neo-Impressionism and Fauvism. The deformations, the curvatures, and the asymmetries are a kind of language, as are those increasingly distinct and serried strokes which he himself compared so pertinently to words that follow each other in a sentence, communicating with each other.

Paul Gauguin—who clearly had an influence on Van Gogh, as can be seen in *Gauguin's Armchair* (1888)—likewise led a restless life, as if seeking something other than painting, an unattainable serenity. In Paris, under the influence of Pissarro, he risked becoming an Impressionist like the others. But in Brittany, at Pont-Aven between 1886 and 1890, he discovered a group of painters, among them Emile Bernard, with whom he elaborated the new practice and doctrine of cloisonnism, which consists of surrounding pure flat colors with a dark outline, recalling the leading of stained glass. He also called this synthetism—

simplifying forms and colors to heighten the visual impact, thus implying a will for symbolic significance. After the disastrous experience of communal life with Van Gogh, Gauguin departed for Tahiti in

1891; he went again in 1895 and in 1903 died in the Marquesas.

Gauguin was the first deserter from Europe, the first to look elsewhere and as far away as possible for the innocence he dreamed of and needed in order to create. Brittany was already—as opposed to Paris—a primordial source, closer to the primitive: Gauguin's paintings of that period, *The Yellow Christ* of 1889 for example, tend away from the Western tradition of objectivity and toward Japanese prints, Chinese enamels, medieval glass, and—quite simply—folk imagery. But Tahiti was to give him what Brittany was only able to suggest. "Savagery rejuvenates me," he said. "I have moved back very far, farther than from the horses of the Parthenon, all the way back to the stammerings

of my childhood, the good old wooden hobby-horse."

This outlook helps to explain the eccentricity of his art, an art that deviates both from Impressionism and from Cézannian structure—"a decorator, not a painter" was Cézanne's judgment of Gauguin. Although his art is, like Van Gogh's, a manifestation of pure feeling, it does not express emotional violence by distortion of form but universal meanings in harmony of composition, as in the 1897 Where Do We Come From? What Are We? Where Are We Going? By covering large surfaces with a single, unmodulated color and by heightening the color as much as possible—"How do you see that tree? Green? Then put green, the most beautiful you can find on your palette"—he sought to produce a unified effect, as plain and striking as possible. In the process, he evolved a very personal scale of color-orange, blue, yellow, violet: "mat, muted, powerful tones" he called them-and never hesitated to substitute one color for another. The pink of the beach in Riders on the Beach (1902) had unprecedented audacity. Complementing the freedom of color was a hitherto unequaled freedom of outline, a transforming of the lines of nature into heavy, strongly accented outlines and arabesques. Thus, with the intent of conveying a thought, Gauguin eliminated analytical detail and the representation of spatial depth, laying his obtrusive, simplified forms on flat backgrounds.

In the solitude of exile, Gauguin had created an historic and definitive work. The desire to say something that could be said in some medium other than painting (he could also express himself in writing) distinguished him from his predecessors. But the greatness of his work can be evoked only in terms of painting. In his flat surfaces of color he immediately heralds Fauvism; in his denial of any suggestion of spatial depth, he clears the way for abstract art. Finally, his accentuated forms were seemingly intended to be seen from a great distance, those freely curving lines often tending toward the arabesque partake of the turn-of-the-century mannerism called *Jugendstil* or art nouveau or the Modern Style, according to the country in which it appeared. Painting falls in with this style whenever it tends toward the poster. Especially notable during Gauguin's time was the relation that existed between an art aiming to strike the spectator immediately, almost physically, like the poster, and a more recondite art aimed at anyone capable

The German-born painter Hans von Marées died in almost complete obscurity in Rome in 1887. However, the classical sensibility be possessed, as seen in The Hesperides (detail above), significantly influenced German art in the beginning of the twentieth century. Another painter whose artistic legacy far outstripped his public acclaim is Odilon Redon. For more than half of his career Redon worked exclusively as an engraver and lithographer, producing nearly two hundred works. Many were inspired by literary themes, such as the lithograph Redon produced in 1874 for the first edition of Gustave Flaubert's The Temptation of St. Anthony (top).

of delving into the significance of symbols. With his genius Gauguin dominated the whole symbolic reaction against Impressionism, opposing depth of concept to superficiality of eye: Where Do We Come From? What Are We? Where Are We Going? is metaphysical painting rounding out the complete cycle of human life.

In France, Symbolist painting of poetic and fantastic inspiration found a master in Odilon Redon. In addition to being a painter (the least of whose nosegays indicate his exquisite gift of color), he was an engraver, a charcoal draftsman, a master of black and white, and a writer, having left a fine diary, A Soi-même. His first album of lithographs was titled Dans le Rêve (In the Dream): in effect, the submission of form to an idea becomes for him a submission to dreams. A precursor of Surrealism, Redon once wrote that "everything can be done by docile submission to the advent of the unconscious."

German painting at the turn of the century was also of symbolic inspiration, but it does not have the same technical qualities. Arnold Böcklin, a German Swiss who lived almost all his life in Italy, expresses in somewhat sad colors his philosophy of existence: *Vita Somnium Breve* corresponds to Puvis de Chavannes's and Gauguin's allegories. But his obsession with death (a skull appears behind his self-portrait) and his eroticism (as in *Play of the Waves*) are more important than his ideas. The German Hans von Marées, who also lived mostly in Italy, produced equally philosophic painting with pleasing ellipses in "modernistic" curves, especially in *The Hesperides*.

A leader of Neo-Impressionism in America was William Glackens, who was initially influenced by Renoir; another of the same school was Maurice Prendergast, whose canvases present a kind of marquetry, a mosaic of vibrant, sparkling spots of color: balloons, flags, and umbrellas punctuate a feast of color. A more indigenous trend toward a kind of modern realism is seen in the work of a group that includes Robert Henri, George Luks, John Sloan, and George Bellows, along with Glackens. Keeping within a muted range of colors, they painted miners, boxers, ferryboats moving through murky waters, and generally speaking the abject, squalid reality of urban life. From this they earned the name of the Ashcan School, which exhibited as a group in 1908 in New York. The group was largely responsible for organizing the huge Armory Show in 1913 in which, besides their own works, the latest French paintings were presented for the first time in America.

In Russia, the only important artist of the turn of the century was Mikhail Vrubel. He remained unappreciated in his lifetime, died blind and insane, and is still today a truly "outcast" painter. In the toils of a hallucinating imagination (*The Demon*, 1902, is typical), he painted with a richness recalling the splendor of Byzantine decoration, using a technique with plaques of color that is astonishingly modern in feeling.

Painters at the beginning of the twentieth century tended to break up into various groups, each in search of a unity of principles but also seeking to become established, to find a base that could serve to disseminate their ideas, often proclaiming these ideas in periodicals and in prints and lithographs. But there was also another great change, a shift to two great geographical focuses of concentration. Paris remained the

more important, where the triumph of Impressionism attracted not only provincials but also foreigners. The other center was Munich, where the essays of a young art historian, Wilhelm Worringer, were being published. Paul Klee, Wassily Kandinsky, and Alexis von Jawlensky came and mingled with German Expressionists such as Ernst Ludwig Kirchner who were aware of what was going on in Paris but were nevertheless looking for something different.

One of the groups that arose in France, less as a reaction than as an extension of Impressionism, was the Nabis-the name comes from the Hebrew word for prophet or visionary, which, however, was hardly applicable in this instance. They were the painters Maurice Denis assembled in his Homage to Cézanne canvas of 1900, including Pierre Bonnard, Edouard Vuillard, Redon, Albert Roussel, and Félix Vallotton. Some of them were certainly open to the aims of Symbolist painting, but they wanted to express themselves only in plastic terms, as proclaimed in Denis's famous definition: "Remember that a painting, before being a cavalry horse, a nude woman, or some anecdote, is essentially a flat surface covered with colors in a certain order," a definition that legitimatizes abstraction. The best painters of the Nabis had no need of great subjects: a street scene, a lighted interior, the radiance of a woman's skin or of fruit sufficed for Vuillard and Bonnard. Vuillard's most beautiful canvases, in a relatively subdued range of browns and maroons, date from the late 1890s. Pierre Bonnard pursued the magic of color throughout his life. His last canvases, the Still Life of 1947 and the unfinished Almond Tree in Bloom, are among his most beautiful. Like Renoir, he was a painter of happiness, of the golden age, and of harmony between painting and natural sensation; he perpetuated a style close to Impressionism.

The school of painting called Fauvism, on the other hand, tended toward Expressionism. The first exhibition of the Fauvist group took place in Paris at the Salon d'Automne in the fall of 1905. The word fauves (wild animals) was used by an antagonistic critic to designate a savage element that was manifest in the art of the young painters. A violence of color, heavy outlines, deformation of line, a certain decorative mannerism, all at the service of spontaneous vision, all in the search for direct, uninhibited expression brought the Fauves close to Gauguin and Van Gogh in their opposition to Impressionist decomposition. Their primary aim was a cohesive image, a shock image. But they rejected philosophic pretension and took Impressionist subjects as their own (landscapes, beaches, trees, the quays of the Seine, the cliffs of Normandy), and their vision proclaimed the joys of seeing. These are violent joys, life-giving elation-no longer simply retinal refinementwhich they expressed in coarsely outlined forms, flat areas of contrasting tones, and daringly transposed colors including red trees and green hair. They can be traced directly from Gauguin and Van Gogh.

Albert Marquet, Raoul Dufy, Émile Othon Friesz, Maurice de Vlaminck, André Derain, Georges Rouault, and Georges Braque all practiced Fauvism, and even Picasso came close to it in his *Self-Portrait* of 1906 and in two nudes of the same year. Some of the painters, however, were to move far away from it. Braque turned to Cubism; Marquet

French painting at the end of the nineteenth century was dominated by two groups of artists fascinated by the expressive use of color: the Nabis and the Fauves, Bound by an appreciation for the aesthetic outlook of Gauguin, the Nabis worked within the simple, flat color patterns he had employed. View of Cagnes (above) by the Swiss artist Félix Vallotton is typical of this approach. Led by one of the masters of modern painting, Henri Matisse, the Fauves were bolder than the Nabis in their use of pure color for its emotional and decorative effects. Two fine works produced by this school are Raoul Dufy's Posters at Trouville (opposite, above) and Maurice Vlaminck's The Seine River at Nanterres (opposite, below).

used tender blue monochromes in painting the quays of the Seine and then returned to a blot technique in the beautiful *Easel* of 1942; Dufy invented a stenographic style consisting of delicate scattered strokes to express movement, distinctive images that no longer had anything to do with Fauvism. He was fundamentally an experimenter, as indicated by his astonishing *Violin* of 1948 with harmonies of red around a white triangle. But Vlaminck, Derain, and Friesz perhaps never expressed themselves better than in the context of the characteristic violence of the movement. Derain, with pronounced Cézannian influence, later integrated figure with structure, as in *The Two Sisters*. Vlaminck ultimately developed a coarse realism.

Henri Matisse was not only the most gifted artist among the Fauvists but also the spokesman of a movement that, for a while, was so closely knit that almost everything any of the group painted seemed to

Brücke, an association founded by a group of young German painters in Dresden in 1905, became the fountainhead of the German Expressionist School. One of the group's charter members, Ernst Ludwig Kirchner, memorialized himself and his fellow pioneers in Painters of Die Brücke (left), which shows (from left to right) Otto Müller, Kirchner, Erich Heckel, and Karl Schmidt-Rottluff. A principal influence on the group was the work of Norwegian-born painter Edvard Munch, whose early work, The Dance of Life (opposite) clearly illustrates the sharp, linear style he employed to depict the misery he saw in so much of human existence. The painter Henri Rousseau possessed a far sunnier nature, as can be seen in the fanciful Portrait of Pierre Loti (above).

have come from the same hand. The canvases that Derain and Matisse brought back from their joint summer sojourn in the village of Collioure in 1905 are difficult to tell apart—Matisse painting Derain (1906) is in the same style as Derain painting Matisse (1905) and Vlaminck painting Derain (1905). Matisse's Woman with a Hat of 1905 and the Gypsy Woman of 1906 have all the characteristics of an art that he, in his Male Nude of 1898, was the first to introduce.

In an entirely independent category was Henri Rousseau, known as the Douanier because he worked as a customs (douane) official. He was the first self-taught painter, the first naïf to enter the history of painting, the first to take a place in it without having been preoccupied with the problems confronting all painters. Whether his painting depicts a dream or an imaginary scene, like The Snake Charmer (1907) or a real spectacle, The Sleigh, he conveys the same feeling of poetic invention: his meticulous depiction makes dream familiar and reality weird. Without leaving the streets of Paris, Rosseau depicted the same primordial innocence that Gauguin went all the way to Tahiti to find.

German Expressionism, which centered in Munich, was not, like French Fauvism, a momentary phenomenon but a durable one, for its violence corresponded to the national temperament. It did not need, as in France, to be constantly inhibited by that requirement of grace, measure, and taste that is so evident in the work of Matisse. Moreover, this violence was not, as among the Fauves, a simple game with color basically at odds with the subject. Through color and line what is represented, even relived, is the anguish of a relationship with the world that of its own nature calls forth this violence, this outcry.

This agitation reflects, if not a strictly German temperament, at least

a Nordic one, as stressed in Wilhelm Worringer's Formproblem der Gothik (Gothic Problems of Form), which appeared in Munich in 1912. The Nordic man, who is by tradition unaware of the immediate satisfactions of lucid representation of form in the world, flees from his anxiety into a world of his own creation, fantastic or imaginary: this is "Gothic transcendentalism." But even more than the fantastic, anguish is transcendentalism's common denominator. Ecstasy of color alone speaks unmistakably in Jawlensky's Woman with Flowers (1909) or Kirchner's The Artist and His Model; Kandinsky's and Piet Mondrian's early landscapes, along with those of August Macke, Franz Marc, and Constant Permeke bear witness to the pure joy of looking and breathing. Moreover the arabesques of the Austrian Gustav Klimt reflect a decorative fantasy inspired by the splendor of Byzantine mosaics. But the major theme of these artists is the human figure, with Edvard Munch's famous canvas The Cry (1893) typifying the symbolic expression of the movement.

A poignant feeling of solitude, the impossibility of communicating, and the anguish of life inspired Munch throughout his work, whether through the strollers in *Evening on the Karl Johans Gate* (1892), the dancers in *The Dance of Life* (1899), the dream visions of such woodcuts as *Women on the Shore* and *Rendez-vous with the Universe* with their arabesques approaching those of the tragic *Jealousy* (1890), or man's last hour unforgettably evoked in a canvas of 1892, *The Death Chamber*. Born in Oslo in 1863, Munch died in 1944 after an unhappy and painful life. His work—one of the most powerful of the century

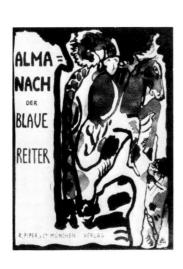

German expressionist painting was distinguished by the profound social and political ferment it exposed. The Tragedy of Man (opposite, above) is one of a series of powerful social statements that Oskar Kokoschka produced for the avant-garde periodical Der Sturm, which was published in Berlin. A group of revolutionary artists rallied around the Russian-born painter Wassily Kandinsky to form an association called Der Blaue Reiter. Kandinsky executed the woodcut shown above to illustrate the group's first almanac. The work of Belgian artist James Ensor reflected a bizarre imagination and strong social conscience. The horrified expressions on both the masks and human faces in his painting The Entry of Christ into Brussels (opposite), make this work, which was completed in 1888, seem contemporary.

—is the reflection of his suffering, marked by the loss of his mother when he was a child, by unhappy love affairs, and by illness. But Kirchner's street scenes, Karl Schmidt-Rottluff's women, and the gaudy facial masks that make up James Ensor's street throngs in such paintings as *The Entry of Christ into Brussels* (1888), express the same tragic vision with analogous stressing of forms and chromatic violence. The anguish expressed is the anguish of the world but also of a moment in history. The Austrian Oskar Kokoschka painted such portentous images—including his *Tragedy of Man* (1908) and particularly *The Tempest* (1914) of a pair of lovers being swept along by an irresistible force—that it is difficult not to read into them a premonition of the impending war.

There was also a link between Expressionism and the work of Chaim Soutine. But his early dark palette, at first in harmony with his anxieties in such paintings as *Still Life with Herrings* (1916), changed after his discovery of southern France. Then his canvases explode with vibrant color together with touches and distortions of form reminiscent of Van Gogh. Most of his works, however, which include flayed animals, bleeding flesh, and faces marked with interior emptiness, are a projec-

tion of anguish subject both to fervor and to a kind of hope.

Beyond that, the history of Nordic Expressionism passed through various groups and localities. *Die Brücke* (The Bridge) was formed in Dresden in 1905 by Kirchner, Max Pechstein, Schmidt-Rottluff, and Emil Nolde and dissolved in 1913; it was characterized by an aggressive realism, ultimately evolving into controversy and socialism. After World War I, the movement became the November Group, which aimed at an art for the people and included Otto Dix and George Grosz and featured ferocious caricatures of traffickers, profiteers, and Berlin dives frequented by capitalists with cigars.

Another group had been formed in Munich as early as 1909 around its spokesman Kandinsky. The artists of Neue Künstlervereinigung (the New Artists Federation) included Jawlensky, Alfred Kubin, and Karl Hofer. They had little in common except the desire to create a new art, and Rouault, Picasso, and Braque exhibited with them in 1910. But a dissident group that called itself Der Blaue Reiter (The Blue Rider), after a 1901 canvas by Kandinsky, soon broke away; it included Kandinsky, Marc, and Macke and was soon joined by Paul Klee. Generally romantic in spirit, peculiarly attentive to the specific lyricism of color, Der Blaue Reiter was opposed to the realism of Die Brücke. It is therefore not surprising that it evolved both toward abstraction (already in evidence in a canvas like Forms in Combat by Franz Marc) and toward Klee's subjectivity. In 1912, Der Blaue Reiter organized a widely representative exhibition that included not only their own works but artists of Die Brücke, French Cubists, and Russian Suprematists, and a Swiss group, Der Moderne Bund. The Blaue Reiter Almanach of that year contained reproductions of folk, medieval, and primitive art. Thus, in addition to the many decisive inventions already witnessed in the first decade of the century, a complete repertory of styles came into view, opening up the Western tradition to all that had hitherto been overlooked.

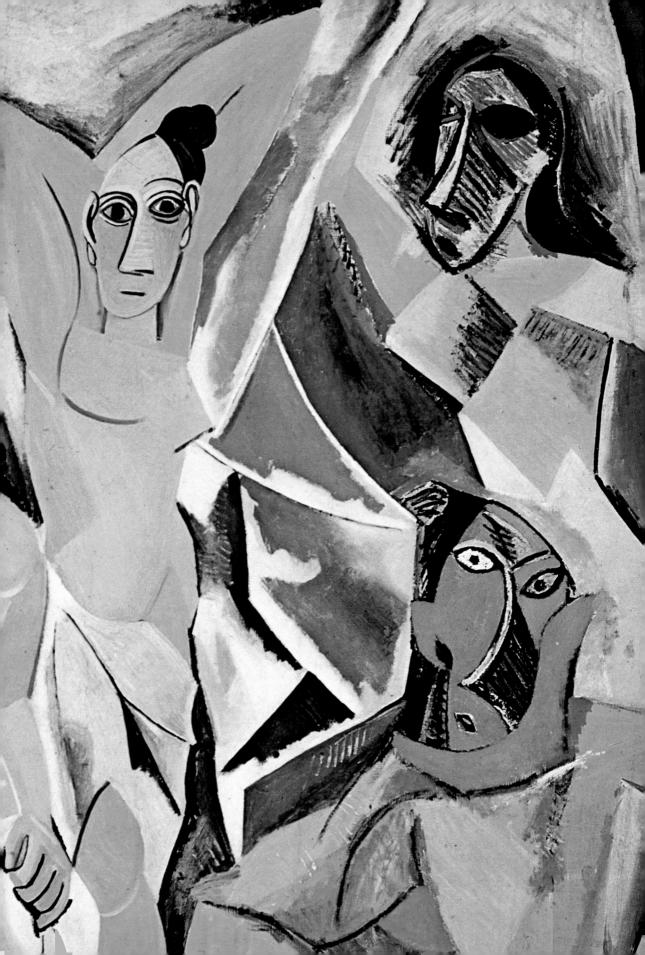

New Directions: From Cubism to Surrealism

In 1906, when a Cezanne retrospective was having a profound effect on the art world, a twenty-five-year-old Catalan painter named Pablo Picasso painted a picture that resembled nothing anyone had ever seen. It marked a decisive break with everything that had gone before. The pretext of the painting, Les Demoiselles d'Avignon, was anecdotal. In the initial sketch the inclusion of two men in clothes in the presence of five nude women made it clear that it was a brothel scene. But in the final work only the women appear, and their anonymous, sexless bodies topped by faces resembling African masks produced such a peculiar impression that even Picasso's best friends were shocked.

Never had art been so deliberately divorced from beauty. Or rather, never before had it been demonstrated that beauty of rhythm could exist entirely apart from natural beauty. Picasso had distorted the female face and figure—ever a symbol of beauty in art—into patently ugly forms. Whether or not this particular canvas was influenced by African art—Picasso claimed that he had not yet seen African masks—such art, with its dependence on rhythm and symmetry rather than on imitation of nature, was to have an influence on the ultimate course of European art. Furthermore, the geometric treatment of the figures in Les Demoiselles announced Cubism.

Cubism developed about 1908 in the Bateau-Lavoir group (named after the house in Montmartre where Picasso had been living since 1904). The group included writers—Max Jacob, Guillaume Apollinaire, Gertrude Stein-as well as painters-Marie Laurencin, Juan Gris, Georges Braque, Picasso, and later, Fernand Léger, Robert Delaunay, Albert Gleizes, Jean Metzinger, August Herbin, and Francis Picabia. The word Cubism was first used by a critic to find fault with a style of painting that used small cubes. Actually, the cubic effect is present only when volume is clearly suggested; more often a Cubist canvas expresses the feeling of spatial depth without resorting to perspective: it makes no distinction between the content and the contained, the space and the forms themselves. The figures in Les Demoiselles are not really Cubist -they are simply flat forms standing out against a background. At least as often as one finds cubes in Cubism, there are structures of triangles resembling randomly juxtaposed facets of broken glass, or an effect like a window pane in which broken planes, flat surfaces, angles, a series of doors, windows, and façades are reflected and jumbled together. The

Even Picasso's friends were taken aback when he unveiled Les Demoiselles d'Avignon (detail at left) in Paris in 1907. Its deliberate distortions and rejection of traditional perspective were so radical that the painter was even encourged to destroy the picture. It has since been recognized as one of the major paintings of the modern era.

common denominator is therefore not the cube but merely a suggestion of volume. Even when the feeling of a third dimension is lacking, all the elements to reconstruct it are present. It is as if volume had been fragmented and reassembled on a flat surface by a pictorialization that offers simultaneously a view of all that is normally seen in successive views: the front as well as the side and back of the object.

Cubism is therefore the depiction of a decomposed object, one broken down into its components and thus not immediately recognizable. Its usual appearance is lost in a reconstituted, prismatic layout resembling a shimmering, kaleidoscopic image. When all the components are dispersed to the four corners of the canvas, or rearranged so

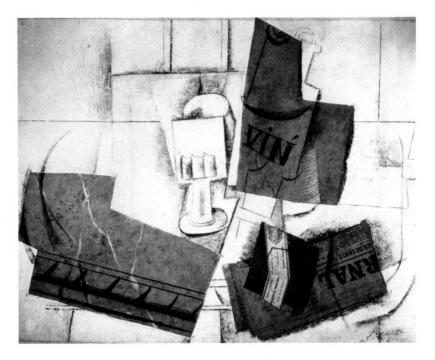

Cubism, which received its name from a hostile critic, developed along lines suggested by Pablo Picasso's Les Demoiselles d'Avignon, although that painting was not itself Cubist. The directions the school took include the collage, as seen in Picasso's Glass, Wine Bottle, and Newspaper on Table (left), and a decomposition of form, as seen in the same artist's portrait of the art dealer Ambroise Vollard (right).

that elements ordinarily far apart are piled one on top of the other, the picture becomes increasingly difficult to decipher. This is particularly marked in Picasso's *A Woman with Guitar* (1911), *Man with Pipe* (1910), and his portrait of Vollard.

The Cubist movement went through two phases, respectively called Analytic Cubism, as described above, and Synthetic Cubism, which followed. In the latter phase, the object is reduced to its most essential features and placed against an empty ground, which makes it easier to read. The introduction of papier collé (pasted paper) also modified the initial concept of Cubism. An example of this is Picasso's Still Life with Chair Caning (1912) in which a piece of embossed paper—giving both the visual and tactile feeling of actual caning—is introduced in a painting of various objects. This kind of experiment, according to the poet and critic Louis Aragon, is a way of "challenging painting" and short-cutting the difficulties and slow pace of the painting process. But the chief aim of this imposition of raw material onto a canvas was to iden-

tify the object unequivocally and to widen the normal range of sensation beyond the merely visual to include the tactile as well.

The papier collé therefore appears as a manifestation of realism. Paradoxically, however, Cubism constituted a fundamental break with realism and the definitive abandonment of Impressionist illusionism. In depicting an object not as seen by the eye but as it exists in the mind, the Cubists strayed from visual reality toward conceptual reality. Braque himself declared that "the senses distort, while the mind creates." And Gris described his approach as follows: "I attempt to put the abstract into concrete form. I start with the abstract to arrive at factual reality." Yet the papier collé gives but limited expression to the

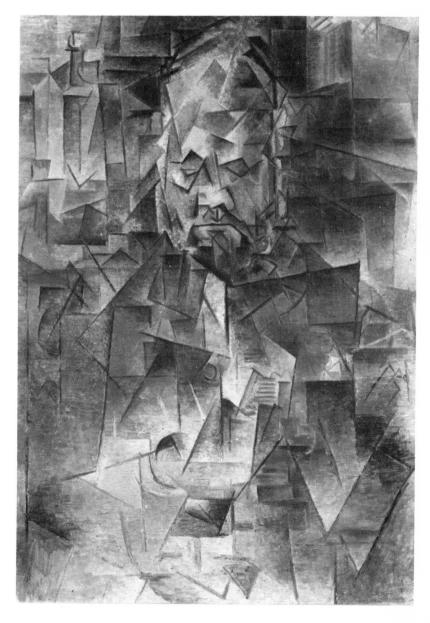

Cubist tendency, for it deals only with everyday objects—paraphernalia of the studio such as pipes and packages of tobacco, newspaper clippings, bottles and glasses, and musical instruments. Moreover, the Cubists endeavored less to seize the conceptual structure of objects at hand than simply to paint them the way they wanted them to look—perhaps not more real but more satisfying, more perfect, more delectable than nature. And in making of an object what they wanted, these painters opened the way to abstraction. In contrast to abstract art, however, Cubism is essentially a transcription of the object, recorded in such novel terms that it is necessary to learn to read them; but the meaning is always the object.

This transcription accentuates the stability and distinctness of the object, retrieved from the accidents of movement and light. Form, and not color, is what arrests the attention; only an austere range of colors—earths and sands and gray monochromes—is used. The colors are

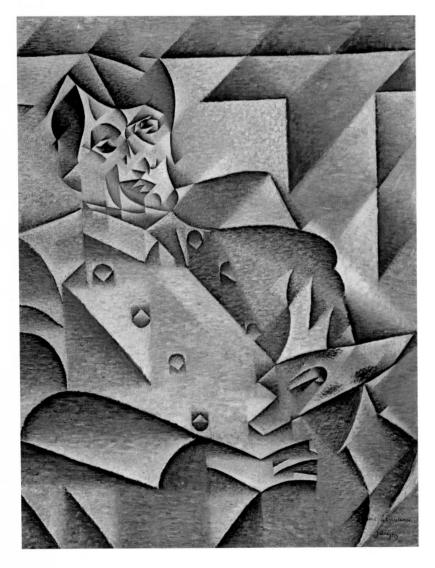

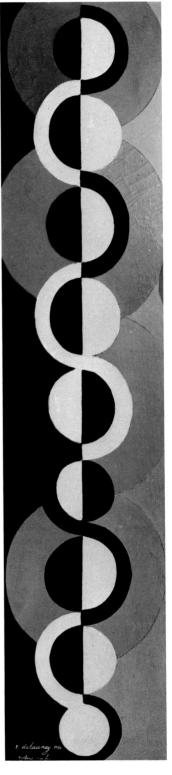

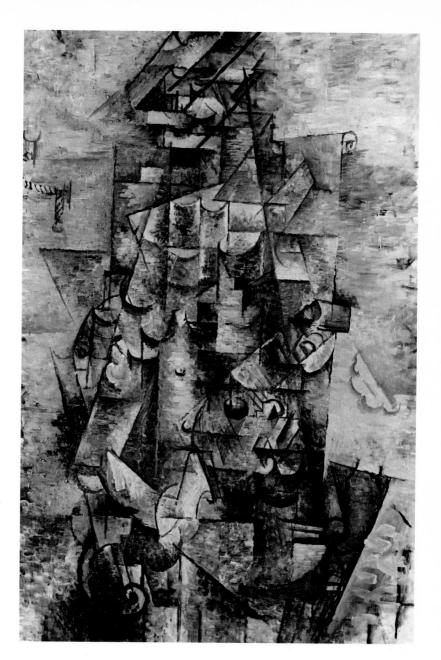

Among the enthusiastic early adherents of Cubism were Juan Gris and Georges Braques. Gris's Portrait of Pablo Picasso (far left) is an almost mathematical entanglement of planes, angles, cylinders, and cubes, whereas Braques's Man with a Guitar (right) seems a more advanced geometric dissection of the subject. Subsequently, others attempted to do for color what the Cubists did for form. A leading Futurist spokesman for this tendency was Robert Delauney, whose masterful Rhythm without End is at left.

often so neutral and the planes so clearly indicated that the forms would only have to be cut out to be converted to sculpture. In painting the object the way he wanted it to look, the Cubist painter also brought art closer to objects already made, the products of industry. The scattered elements of the canvas evoke the parts of a machine. Thus, it is also possible to see in Cubism the first painting of the industrial age. Although descending directly from Cézanne, it was a long way from an art modeled on nature. To paint the world the way humankind has made it but with a capacity to charm never possessed by industrial products was Cubism's aim and accomplishment.

Juan Gris was the only Cubist to remain faithful to the spirit and letter of the movement and yet toward the end of his brief life (he died at forty), the suggestion of volume in his paintings diminishes; his

Pierrot of 1919 anticipates Matisse's paper cutouts. In Grapes (1921), he used dislocated, divided forms that anticipate Braque's works, whereas the nuances of green, brown, and maroon are somewhat reminiscent of the monkish gamut of his own early work. Gris maintained and systematized the Cubist ethos as a transcription of reality in accordance with exclusively plastic laws, eliminating all emotional reaction, all expression. Out of a desperate existence wasted away by drink came,

nonetheless, a serene and pure body of work. Georges Braque, in contrast, showed a progressive evolution. His Musician and Still Life on Pedestal Table, compositions of 1917-18, relate to Cubism in the way the planes are structured and in the way he has disposed such elements as the figure's eye and hand, a bowl, and a bunch of grapes on the canvas. But a plaster sculpture, Nude (1920), shows that he soon felt the need to reintegrate the figure; his palettewhich never abandoned fundamentally wood and earth tones-became enlivened with pinks, lilacs, lemons, and sky-blues, and his draftsmanship opened out to undulating outlines as in his Still Life (1929). Like Picasso he passed through a Neoclassic period inspired by Greek vases, resulting in Heracles (1931) and The Canéphore (1926), a monumental study of a nude with a basket of fruit. But the following years are marked chiefly by divided forms. In his Woman with a Mandolin (1937) he silhouetted the form of a woman so that it appears to be but half of itself, and in The Painter and His Model (1937), the model is bisected by a sunbeam. Although Braque's treatment changed, his subject matter tended to remain essentially that of Cubism-the closed world of the studio with it familiar objects and its models. But he did turn to nature: Boats under the Cliffs (1938) and his last canvases, many of which depict plows and harvests, bring a return of earth

After 1910, Roger de la Fresnaye, Louis Marcoussis, and the three Duchamp brothers—Jacques Villon (born Gaston Duchamp), the sculptor Raymond Duchamp-Villon, and Marcel Duchamp—were to widen the Cubist movement. But there were splits. In 1912, Gleizes and Metzinger published *Du Cubisme*. By then at a far remove from the sensibility of Braque and Picasso, they attempted to formulate the principles of Cubism into an ideal of mathematical proportion called the Section d'Or. But the relationship with the object depicted was thereby lost. Moving in the same direction of nonobjectivity, but with superior power, Robert Delaunay turned to something the poet Apollinaire was to call Orphism. Delaunay concentrated on color but color associated with form in a series of discs or rainbows, in which the prismatic decomposition of color follows curves instead of taking place within the spatial cube.

colors along with blue on brown backgrounds.

The tendency toward abstraction evident in Delaunay is even more pronounced in the work of Fernand Léger, who was much more closely identified with the Cubist movement. He stressed the relation with the machine and finally—in his *Contrasting Forms* (1914)—excluded all objective references. But he subsequently abandoned both Cubism and abstraction when he discovered the humanity of man during the war. He described his reaction, which many were to

Although his output was small, Marcel Duchamp was one of the most startling innovators among modern artists. His Nude Descending a Staircase (right) is considered a culmination of Futurism-even though it was completed before the Futurists' first exhibition in February, 1912, and even though Duchamp himself considered it an "organization of kinetic elements" rather than a painting. When it was displayed at the 1913 Armory Show in New York it caused a sensation. Equally sensational were Duchamp's Dadaist "readymades," manufactured objects that he selected and exhibiteda urinal, a bottle rack, a combin an effort, he later wrote, "to discourage aesthetics" but which were later to recur in an aesthetic context in the work of Pop artists and the Neo-Dadaists.

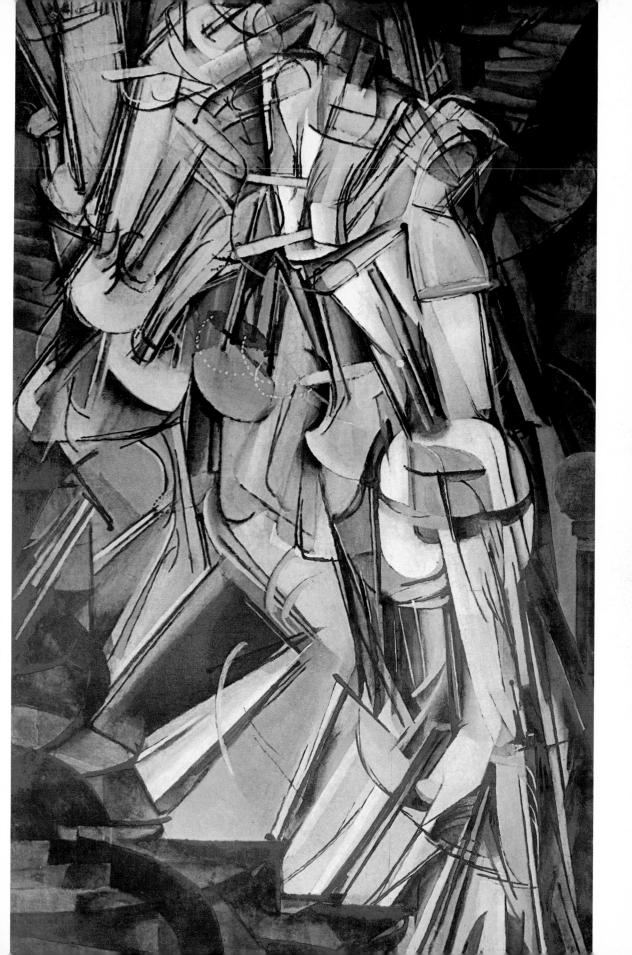

follow, as "return to the object." Into compositions of cylinders, connecting rods, turbines, and the like, he introduced human figures, as in his series of Animated Landscapes, including Man with a Dog (1915). Throughout his work the sense of architectonic planes, which create spatial depth without perspective, is striking, as is his use of color, which is distributed on the canvas according to the requirements of the composition and not as it relates to the object. In Léger's work the color floats like a banner attached to the object to which it belongs or divides in two like a current (rather than a line). Struck by the Sistine Chapel and the mosaics at Ravenna, then by American architecture, Léger also became a mural decorator. The power of the machine is symbolized in his murals for the Palais de la Découverte in Paris, on the theme of Transfer of Energy. But paradoxically it was in easel painting that he attained the monumentality of wall painting, whether in the well-known Composition with Three Figures (1932) or in somewhat less successful compositions such as Leisure Times, or The Constructors, subjects dealing with ordinary life. In any case, throughout his later work is an association with the human figure, as solid as a cathedral statue and with botanical elements treated as if they were products of industry, such as cactus leaves resembling sheets of metal.

Abstract art had not yet arrived, but its possibility was contained in the realization that the essentially Cubist balance between the object

One of the masters of Cubism was Fernand Léger, who abandoned the abstraction of his youth after rubbing shoulders with his fellowmen, "the inventors of everyday poetic images," in the trenches during World War I. Fascinated by the dynamism of machines, he also widened his work to include people, as in his Composition with Three Figures (above). Giacomo Balla, like other Futurists, was involved in the depiction of motion, as in his jaunty Dog on a Leash (right).

and its symbolic image could be destroyed. Only Picasso, Braque, and Gris preserved that balance and only for a short time—the outbreak of World War I brought an end to an experiment that was really a collective style. In August, 1914, Picasso accompanied Braque to the station platform, seeing him off to war. The joint enterprise was never revived.

The depiction of movement, of no interest to Cubists, was a major preoccupation of the Futurists, who treated movement in much the same way that the Cubists treated stability. As with Cubism, the starting point of Futurism is the decomposition of the object, but the emphasis is on successive instants of a moving object and not on simultaneous aspects of a stable point of reference. Moreover, very often several objects are involved. In many ways Futurism seems like a romantic expansion of elements already present in Cubism: it rejects the cultural heritage, the value placed in things of the past, and it extols the machine in a much more vehement way. To express "the whirl of modern life, a life of steel, excitement, pride and speed" is the language of the manifesto of 1910, one of the numerous texts of a movement that, in contrast to the reticence of the Cubists, was very vocal; for the first time, meetings and demonstrations were used for propaganda in addition to exhibitions.

In 1909 the Italian poet F. T. Marinetti gathered around him a group of painters and writers from Turin and Milan: Umberto Boccioni, Carlo Carrà, Luigi Russolo, Giacomo Balla, and Gino Severini. Movement, whether mechanical, human, or cosmic, was the chosen subject in canvases with such titles as *Automobile and Noise* (Balla, 1912); *What the Trolley Car Told Me* (Carrà, c. 1911); *Lines of Force of Lightning* (Russolo, c. 1911); and *Dynamic Hieroglyphic of the Tabarin Ball*

(Severini, 1912). Not far removed from Futurism is the English movement called Vorticism (a name suggested by Ezra Pound to designate the vortex, the point of maximum energy), developed by the painter and writer Wyndham Lewis. Like Cubism, the Futurist movement was brought to an end by the war in 1914, and no great painter did complete justice to its potentialities. Most of its aspirations are found elsewhere, and ultimately it wound up in Dada.

Marcel Duchamp's *Nude Descending a Staircase* (1912), which astonished and scandalized the American public at the Armory Show of 1913 in New York, can be considered the major expression of Futurism in that it depicts movement by means of a prismatic dislocation and upheaval of form. Duchamp went much further, however, with a color scale almost completely limited to woodlike tones (whereas Severini's colors are dazzling). "This canvas is not intended to be a painting but an organization of kinetic elements," he said. "If I want to depict an airplane taking off, I try to show what is happening. I don't paint a still life." But how it is possible to show, on a flat surface, what the airplane does and not what it is, is a question Duchamp does not attempt to answer. His large composition *The Bride Stripped Bare by Her Bachelors, Even*, measuring almost ten feet high, on which he worked from 1915 to 1923, was to be his farewell to painting. While devoting himself to a desacralization of painting (he added a mustache and beard to a copy

In their early efforts, Abstractionist pioneers Kandinsky (whose Improvisation 9 is at left) and Mondrian reflected recognizable structures, only to become, in their different ways, more geometrical as they progressed. The change in Mondrian's work can be seen graphically by comparing the early, identifiable Tree (above, right) with the later and much more austere Composition 1921 (right).

of the *Mona Lisa* in 1919), he exhibited constructions of glass, metal, wood, and even, as works of art, manufactured objects—"ready-mades"—which he simply lifted from their everyday context: a bottle rack, a urinal, a comb, a bottle of perfume. In so doing he dismissed both artistic creation that has nothing better to do than repeat everyday items and all of manufacturing and consuming society. Duchamp is the precursor of all modern attacks on art that simulates nature and on a society and humanism that take objectivity as a function of art.

About 1915, a group of artists took refuge from the war in Zurich, in neutral country. It included the Rumanian Tristan Tzara and the Germans Jean Arp and Hugo Ball. Looking for a name for "manifestations" they were organizing in 1916 (including Russian music, Negro music, poetry readings, and art exhibitions), they picked out *dada* (a French babytalk word) and appropriated it, proclaiming that it meant nothing. Their main interest was not in wanting to say something but in proclaiming that there is nothing more to say, that everything should be destroyed, rejected. It was a multifaceted movement, which extended to literature and music and became international after the war: Tristan Tzara went to Paris in 1920 and organized a Dada Festival; in Berlin, a Dada exhibition was shut down by the police; and groups sprang up in Cologne (including Max Ernst), Hanover (with Kurt Schwitters), Basel, and Barcelona. Dada was the first expression of

the profound crisis uncovered by the war, the first outburst of radical subversion. Whereas painting had previously been more or less indifferent to current events, Dadaists reacted to catastrophe and accused bourgeois society of having brought war to its own doors. But they found it difficult to dwell on something about which there is nothing more to say. The alternative was to find a compromise: Kurt Schwitters made compositions with rubbish (the *Merz* series) and Picabia imagined crazy machines that were obviously useless. Another alternative is to rebuild after having destroyed, and that was what the Surrealists were to do.

Meanwhile, in Munich in 1908, a Russian artist, Wassily Kandinsky, who had played a prominent role in figurative expressionism, made a discovery that he related in these words:

I opened the door of my studio and found myself suddenly confronted by a painting of indescribable and incandescent beauty. Astounded I stopped on the spot, fascinated by the work. The painting had no subject, it represented no identifiable object, it was exclusively composed of luminous spots of color. Finally I came closer, and it was only then that I saw that it was one of my own canvases, laid sideways on the easel. . . . One thing then became absolutely clear, the description of objects had no place in my canvases, they were actually detrimental.

The art misleadingly called abstract, which should more appropriately be called nonobjective, was born. The first work to be inspired by this discovery was a watercolor by Kandinsky in 1910. Certainly the drift toward abstraction had existed previously (from Monet's *Water Lilies* to Cubism), and it was in the air elsewhere at the same time; but no one before Kandinsky had gone ahead and based art entirely on the disappearance of the object. His first abstract works were titled *Impressions* and *Improvisations* and suggest a sort of lyrical explosion and effervescence. Soon, however, his canvases were even more simply called *Compositions*.

The disappearance of the object did not mean the disappearance of reality for Kandinsky, whose painting was still nourished by forms and sensations that came from the visible world. Important as his initial discovery was, it was not Kandinsky who became the master of that severe discipline that can be called structural abstraction but Mondrian. Born in Holland, Piet Mondrian began painting realistic canvases, figures, and landscapes. But his puritan upbringing, with its denial of everything sensual, emotional, and personal, made him dream of an art free from anything disturbing, with nothing to recall the vicissitudes of lifesomething approaching a Bach fugue. For him, abstraction was not to be a sudden discovery but the reward of deliberate purification. The evolution of his art can be followed by comparing the different versions in the Trees series (between 1908 and 1912) and The Sea (between 1914 and 1918). The Tree, at first represented by a tangle of bare branches divided into two stems inscribing a semicircle, becomes, through increasing simplification, a play of simple curves and ovals. The Sea, which began as a schematic representation, becomes a flat circle filled with plus and minus signs, as symbols of ebb and flow, recalling the regularity of waves. An object is reduced to a sign by a

In his later and totally abstract works, such as Victory Boogie-Woogie (above, left), Piet Mondrian was able to renounce the objective world with his dynamic yet simplistic use of color. The Russian painter and theoretician Kazimir Malevich went through a Cubist and a Futurist stage before establishing Suprematism around 1915. In such canvases as Eight Red Rectangles (right), he sought an extreme form of "pure painting" that, like the work of Mondrian, would liberate art from the objective world.

vertical or horizontal stroke, and these signs together create a symmetry or an asymmetry. With nothing but these elements, with the simplest forms, Mondrian was to build up a work that, in discreet variations, repeats the same theme.

After banishing all suggestion of living form (the curve and the diagonal), Mondrian utilized only vertical and horizontal lines intersecting at right angles and rectangles containing only one flat color, in search of a kind of minimal statement rather than richness. Blue, yellow, and red fill unequal rectangles, and black serves to separate the planes with bands of uneven widths, with white acting as counterpoise. In his final canvases, however, such as New York City and Broadway Boogie-Woogie, the mosaic of small squares of alternating colors gives an effect of multiplicity that creates, if not a restless feeling, at least a flickering dazzle.

Shortly after Kandinsky had discovered abstraction at Munich, Kazimir Malevich founded Suprematism in Moscow, a movement that immediately carried the ideas of the abstractionists to the absolute limit of possibilities. In 1913, Malevich exhibited Black Square on a White Ground and in 1918, White Square on White Ground, in which the laid-on square is distinguished from the ground only by a slight change of direction in the brushstrokes. There are no longer even any signs in

The liberation of the imagination from the arbitrary confines set upon it by reason and society were the goals of the Surrealists. In the paintings of some of its adherents, such as Giorgio di Chirico, whose Disquieting Muses is at left, a curious, static world is depicted, populated with people and objects that have no relation or connection to one another, and illuminated with eerie lighting. Salvador Dali, who was evicted from the group by its leader, André Breton, painted-with the sureness of touch that marks the master hand-such hallucinations as the limp watches in his Persistence of Memory (right).

this art. His 1916 manifesto shows abstraction to be the logical outcome of Cubism and Futurism, to which he had at first dedicated his efforts. A second text, published on the occasion of a visit to Germany, defined this new art as "the non-existent revealed." And yet the nothingness expressed by the white placed on white, which Malevich thought was the end of painting, is not like the desperate mockery of Dada but rather an absolute, mystical ecstasy—the region where, in Malevich's words, "high, low, here, there, are things that no longer exist."

Malevich exerted a deep influence both on the painters of the Section d'Or and on the Russian painters Vladimir Tatlin and Alexander Rodchenko and the sculptors Antoine Pevsner and Naum Gabo. In architecture and sculpture, as in painting, the desire to construct essentially coherent forms was given the name Constructivism. But there was an irreconcilable conflict between the nihilistic (and metaphysical) purism of Malevich, the ultimate politicization of art by Tatlin (who saw meaning only in constructing useful objects), and Constructivism properly speaking, which aimed at the creation of forms that are both rational and beautiful. But the end of freedom in art in the U.S.S.R. put an end to fertile controversies. The only artists who stayed in their native land were Tatlin (who became an industrial draughtsman) and Malevich, who died in 1935.

The last great invention of the first quarter of the century, Surrealism, followed on the heels of Dada. Tzara participated with André Breton and Philippe Soupault in the review titled ironically *Littérature*, founded in 1919. But there was a split, and Breton carried away with him all who were dissatisfied with the rowdy nihilism of Dada. Surrealism appropriated the revolt of Dada but sought something beyond it, about which it could become excited. The movement was chiefly literary, but it swept along with it a number of painters. The first major Surrealist, Giorgio de Chirico, founded with Carrà what he called the Metaphysical school of painting at Ferrara. Between 1911 and 1917, his

canvases (including *The Enigma of the Hour* and *The Disquieting Muses*) project architectural settings, empty squares, and deserted street arcades running off into the distance, in which decapitated statues, helmeted or masked faces, and martial insects appear. They depict dreams in which unreal elements coexist with real ones according to the theory of dreams newly enunciated by Freud, whose doctrine served as a revelation to the Surrealists. The painter, now liberated from external themes, is submitted, as Breton described it, to an "interior theme," painting his mind instead of his visual perception. In Surrealism there is a surrender to automatism, to all that looms up from the depths of the unconscious or from the accidents of gesture. Everything that is given to the painter without having been sought is accepted unequivocally as celestial manna.

Around the years of the first Surrealist manifesto, published in 1924, Max Ernst, Jean Arp, Yves Tanguy, Joan Miró, later Salvador Dali, André Masson, and still later René Magritte and Paul Delvaux joined the movement. But they are all quite different from one another and represent Surrealism unevenly. The work of Yves Tanguy demonstrates genuine Surrealism. No one-even in the quasi-monotony of his workhas succeeded so well in creating a realm of ambiguous forms, from pebbles standing on end to protozoa coming out of the sand, casting their shadows on endless beaches. Max Ernst gave the movement its first plastic illustrations in The Revolution by Night and The Virgin Mary Spanking the Christ Child. He also used techniques such as collage and frottage (using rubbings of the wood graining of floor boards) that enabled him to achieve unexpected, haphazard effects. But his work was finally to evolve in a highly personal direction. In America, where he took refuge from 1940 to 1949, he became especially entranced with the wild vegetation and the grandeur of the Arizona desert.

Salvador Dali, who came to Surrealism in 1929, contributed in The Persistence of Memory (1933) one of its most characteristic images and also contributed an important invention-the "paranoiac-critical activity," an induced disorientation that both permits the artist to draw at will upon delirious images and associations and persuades the viewer of the reality of the artist's irrational vision. This so radically widened the scope of the passive automatism, or self-induced hallucinations, of other Surrealists that Dali and his invention were quickly rejected by André Breton and his friends. Moreover, whereas all the other Surrealists were revolutionaries, Dali chose to be reactionary-his Premonition of Civil War (1936) is a thoroughly Surrealist painting but its author takes the side of Franco. His genius for publicity, his technical virtuosity, his religious sentimentality, particularly as displayed in The Last Supper (1942), makes for an increasingly academic art. It is easy to understand why Dali was repudiated by his friends but remains the best-known exponent of Surrealism to the general public.

By introducing automatic drawing and the practice of sprinkling sand on his canvases, André Masson provided the movement with some decisive tools, although they proved less useful to Surrealism than to Action Painting. Automatic response rapidly became for him the act of

Surrealism developed in several directions, including the eerie atmospheres of Yves Tanguy's Palace of the Windowed Rocks (above), the bizarre combinations of René Magritte, whose False Mirror is below, and the weird imaginings of Max Ernst. Ernst's Two Children Are Threatened by a Nightingale (right), depicting the prostrate form of a child, and another child with a knife chasing a bird. is an illogical setting intended to evoke all the irrational terrors associated with childhood.

a master technician grasping the world in order to record its violence, its drama, and its eroticism. Masson is a painter of hypnotic trance, of horror, bacchanals, and massacres.

The major exponent of Surrealism, whose style suggests photographs of strange dreams realized in realistic perspectives and color, is René Magritte. From *The Lost Jockey* and *The Birth of the Idol* (both 1926) to *The Domain of Arnheim* (1962)—in which a mountain becomes an eagle sitting on its nest—and *Le Dernier Cri* (*The Latest Fashion*, 1967)—in which a tree stands up within its leaf—his is always the same world. Its elements, meticulously depicted, are always recognizable but we lose our bearings in it. Breasts are placed in eye sockets, a shoe ends in toes, and even if an object is not transformed it gives the feeling, in its space and milieu, of being something else. *This Is Not a Pipe* announces the title of a famous canvas. In spite of resorting to a technique repudiated by many Surrealists, Magritte's painting—with his pastel pinks and blues—is the work of a very subtle painter.

Masters of the New Techniques

Many of the major artists of the period between the two world wars had been active before 1914, and some, especially Picasso, continued to work well after 1945. Rather than discussing the theories that controlled their work, it is more important to consider what distinguished each one, for, generally speaking, their individualities are so great that to associate them with any group, although a convenience of classifica-

tion, serves no real purpose.

Henri Matisse, without doubt the greatest painter to have come out of Fauvism, is the only major contemporary painter to owe nothing to the spectacular inventions that marked his century. He soon went beyond the impastoed palette and sparkling staccato strokes of his Fauve period. But even then, as he searched for his own style, his violent tones, his delicate outlines, and his emphasis on grace rather than violence distinguished him from most of the Fauves, as did various structures inspired by Cubism. His paintings show large areas of flat color, pure, simplified, shadowless lines, and forms reduced to essentials. A face, for example, may be simply an empty oval with no indication of nose or eyes, like a mirror reflecting light. This style is in keeping with an exalted vision of the world and life, of a pure, harmonious, and noble nature. Matisse's development can be seen by examining three portraits. His 1905 portrait of a woman, which might be by Jawlensky, and his Madame Matisse of the same year, whose face is divided by a green band as in a polychrome Cubist canvas, can be contrasted with the admirable 1913 Madame Matisse. In that portrait the natural play of verticals and perfect oval of the face reveal what belongs to Matisse and Matisse alone: his integration of style with life. He proclaimed a "soothing" art, as restful "as a good armchair," and said that "composition is the art of ordaining the different elements of a subject in a decorative manner in order to express feeling." But the interlacing and arabesques of such spacious and complex compositions as Dance (1909-10) and Music (1910) and of his Luxe, Calme et Volupté (1904-5) prove that the words "soothing" and "decorative" are exceptionally charged.

In his early period Matisse was trying to find out whether he could maintain grandeur of style by reducing his scale and retain an impression of space even while filling it up. Successive canvases such as the *Pink Nude* (1935) and the *Rococo Armchair* (1946) indicate that he was able to accomplish this with maximum effect and minimum means.

Cubist influence is notable in Matisse's 1905 portrait of Madame Matisse (detail at left). In the ensuing years, however, Matisse was to develop his own individual style and outlook until at last there is no school or tendency that can claim him as an adherent.

Although both are modest in scale, they appear monumental through elongation of figure or use of arabesques. Toward the end of a long, untroubled life Matisse executed the paper cutouts that are among the most astonishing and modern aspects of his work. By imperceptibly displacing two bands of color in *Zulma* (1950), a gouache cutout, he created an effect of optical illusion (although everything is on a single plane, the lower band seems to recede in space), and the use of blue or red forms on white ground in the shape of dancers and acanthus leaves produces an extraordinary effect of space and light with the most elementary means.

Less marked was the stylistic development of contemporary Expressionist painters, who conveyed mood through deformation and accentuation. For Georges Rouault, tormented forms expressed conviction. A fervent Catholic, he was trained in the technique of stained glass and the contours in his paintings resemble the leads of windows, just as his faith evoked dreams of a medieval world of charity and unity. His favorite subjects at first were the forsaken and stigmatized victims of the modern world: prostitutes and clowns come to life in a few violent

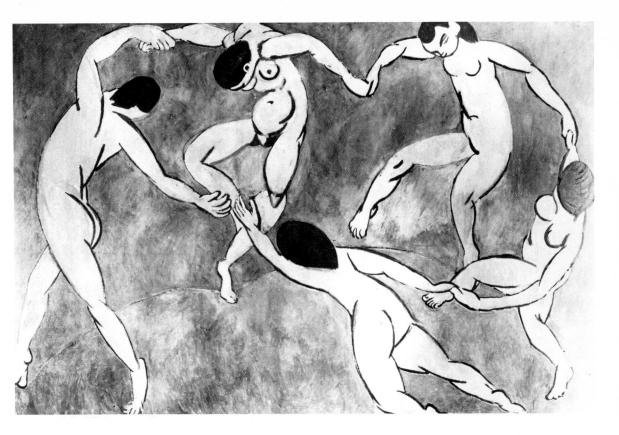

The curves and elongation of line in Modigliani's Portrait of Jeanne Hebuterne (above, left) convey a melancholia completely at variance with Matisse's joyful Dance (above). Echoes of Impressionism and of pointilliste spotting of color inform Matisse's Luxe, Calme et Volupté (left), an early painting that had a pronounced effect on the emerging Fauvists.

Overleaf: Matisse's ability to express monumentality in a small space is shown by his Pink Nude, which appears to need a wall at least to do it justice. The painting itself is but three feet long.

and rapid strokes, in dramatic light and shade, along with executioners and judges. But about 1928, Rouault began working more deliberately, transforming his vision from a cry to carefully articulated speech. At the same time his still heavily impastoed palette became rainbow-hued, with moiré effects that resemble oil on water. Religious paintings such as the face of Christ and landscapes of the Holy Land replace the faces of a godless world.

Maurice Utrillo falls somewhere between Expressionism and factual representation. He never tired of painting Montmartre, either from life or from picture postcards, with a precision recalling Rousseau's ingenuousness but with a subtle and varied technique; some of his canvases are flecked and impastoed, some very colorful, some white on white. But his deserted streets and silent façades always give an impression of anguish and solitude.

Amedeo Modigliani tends toward a mixture of Expressionism and stylization. He created a style of female figures with elongated necks and oval faces of extreme grace, but (in contrast to Matisse) this stylization suggests not joy or harmony but morbid melancholy.

But of all twentieth-century painters, the greatest is Pablo Picasso. His gift was immediacy; his spontaneous perfection of drawing in particular is incomparable. And yet the same man who could draw like Raphael destroyed traditional beauty, opened the door to primitive art, and went through so many metamorphoses that he is impossible to define. His composition *Three Musicians* (1921), resembling a glittering and joyous theater decoration, put an end to the chromatic reserve and intimacy of Cubism. In 1917, separated from his friends by World War I, Picasso went to Rome and executed for Serge Diaghilev the

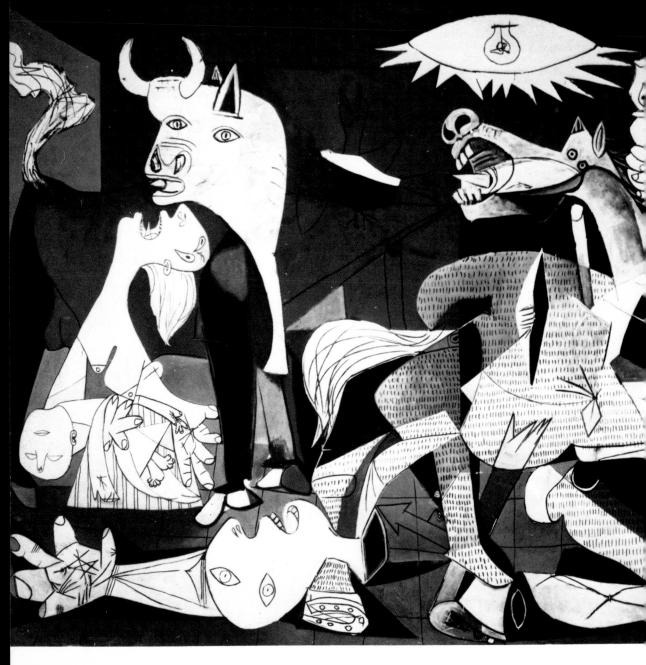

stage sets for *Parade*. But while devoting himself to the theater and dance, he simultaneously discovered the antique. From this developed his "Ingres period," in which he drew stylized figures of classic perfection, still lifes that mingle Cubist-derived elements such as guitars and fruit stands with anomalous Roman busts, and majestic nudes in some of his *Bathers*. But in such canvases as *The Three Dancers* (1925) and *Seated Woman* (1927) a savage wind blows once more: the female figure is again subjected to cruel distortions. A few years later, under happier personal influences, a quiet lull intervened and in *The Dream* (1932) Picasso seemed to be trying to compete with Matisse's evocations of sensual joy.

Around 1937 anguish at the events of history became, for the first time, a source of inspiration to Picasso. Although indifferent to the war of 1914, he did not remain indifferent to the civil war in Spain. His Guernica (above) was created as a protest against the bombing of a Basque village by German planes supporting Franco's insurgent forces in 1937. It remains the most eloquent antiwar statement ever painted. With relatively few elements-a horse and a bull, women weeping, a dead child, a dead soldier-all expressed in Cubist terms, Picasso has conveyed terror and rage together with a haunting sense of compassion. The painting retains its power even if the horrors of modern war have all but eclipsed its pretext.

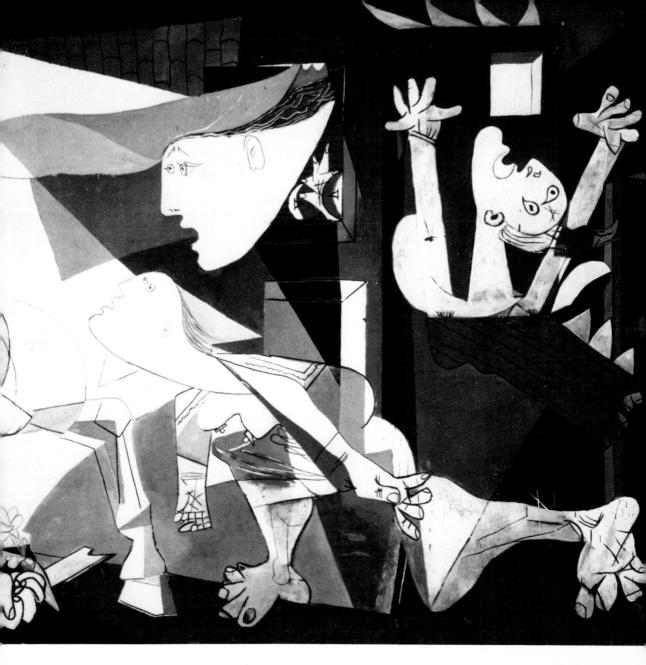

bitter opposition to the Nationalist cause inspired the series of prints *The Dream and Lie of Franco*, and his famous *Guernica*. The latter was executed in 1937 for the Universal Exposition in Paris and commemorates the bombardment of the quiet Basque village of Guernica by German planes employed by the Nationalists. The huge canvas, in the colors of night (blacks, whites, and flecked grays), brings together several of his previous themes, including the Minotaur, bullfights, and a broken statue. The disfigured women express horror and pity. *Guernica* is the only twentieth-century masterpiece generated by a historical event and it is looked upon by many as the last masterpiece of traditional art conveying a legible message and organized with contrasting, balanced, and recurring forms.

Picasso's succeeding canvases are somber and dramatic and influenced by events of his personal life. After 1944 and the end of World

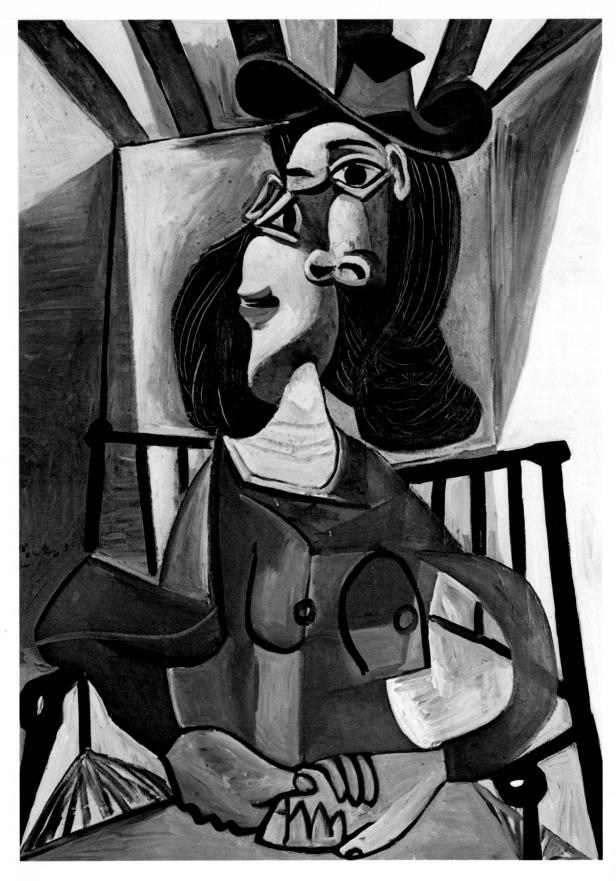

Picasso's Woman Seated in an Armchair (left) amply illustrates the painter's dictum "I paint what I think, not what I see." In Les Demoiselles des bords de la Seine (below) he demonstrates his ability to take the work of another and redo it as his own, in this case using as his model Courbet's picture on the same theme that appears on pages 42-43.

War II, he joined the Communist party while also engaging in an increasingly active and glorious life at La Californie, his home in the south of France. These are the sources of a somewhat disconcerting dichotomy between politically oriented canvases such as Massacre in Korea, Charnel House, and his panels Peace and War and the more abundant canvases that express so magnificently the joys of life. Woman in Her Prime, glorifying women, and Woman with Orange, glorifying maternity, are set in a Mediterranean paradise with fauns and satyrs dancing and shepherds playing flutes. This dichotomy might be considered unified by the frequently depicted dove of peace, serving as a link between revolutionary themes and the themes of happiness, but there was even more to his work. He was also doing linoleum cuts, innumerable erotic drawings that belie his age, and canvases that depict the painter in his studio or transpose well-known masterpieces, such as Velázquez's Las Meninas, Delacroix's Women of Algiers, and Courbet's Les Demoiselles de la Seine. Whatever Picasso was dealing with, whether nature or the work of another artist, he made it clear that he would do with it as he wished. In applying the same freedom that he practiced in dealing with nature to interpreting the work of other artists, he had no intention-like Duchamp-of mocking or-like Ernst or Dali-of bringing together incongruous ideas. He simply wanted to assert that there was no limit to his ability to transform anything he desired.

For Picasso there was no such thing as abstract art, but for those who first practiced it, abstraction seemed like a definitive law. For Mondrian, abstraction opened a whole new territory to explore, a project he quickly realized in total unity. For Kandinsky, on the other hand, the gradual evolution of his ideas is important. The discovery of abstraction meant that "Everything is permissible!", that there were no limits to the possibilities offered. "A circle in painting can have greater

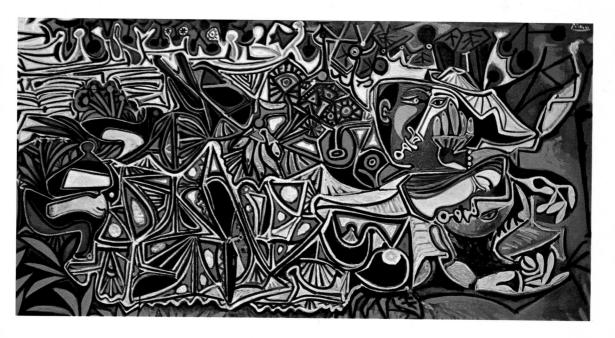

significance than a human head," he said, and "the acute angle of a triangle meeting a circle produces an effect that is no less powerful than the finger of God touching Adam's finger in Michelangelo."

Born in Moscow, Kandinsky first wanted to be a musician, and the kind of painting he ultimately discovered, following his initial Expressionism, was to be both expressive and without precedent, almost musical. At first, abstraction appeared as the best means at hand to express this fervor as well as a kind of lyricism that figurative and anecdotal Expressionism could only indirectly and incompletely convey. In this abstract vein are the *Compositions* of 1911 and 1913 and the *Painting with Red Spot* of 1914.

In Weimar, Germany, in 1922 Kandinsky joined the staff of the Bauhaus at the invitation of its founder, the architect Walter Gropius. The Bauhaus aimed at drawing up and teaching a grammar of all the plastic arts, creating a repertory of the simplest and most expressive relationships between forms. For Kandinsky, this resulted in a kind of abstraction very different from what he had started with. It called for avoiding the whims of improvisation, for seeking rules and laws, culminating in a well-ordered, geometric kind of painting. He divested his structure of its expressive impact (even though theoretically each geometric element and each color had special meaning).

From 1933 until his death in 1944, Kandinsky worked in great solitude in Paris, and dissociated and purified forms found new life in his

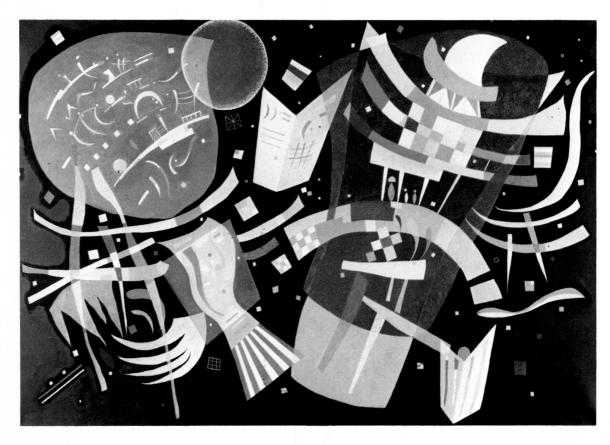

Wassily Kandinsky was trained in the law and did not take up art until he was thirty. With a turn of mind receptive to abstraction, he moved logically toward nonobjective painting. His artistic theories and his desire to bring the viewer right into such paintings as Composition X (left) were to have profound implications, especially for the Abstract Expressionists. Kandinsky worked in close association with Paul Klee, whose own approach to abstraction is evident in Houses in the Night (above).

work. This life does not emanate from a recognizable nature but from an organic unity of forms that exist nowhere in nature and evoke the fauna and flora of an imaginary landscape: varieties of butterflies and multicolored caterpillars as gaudy as the masks and lanterns of an Oriental carnival, all simply floating in space as in *Sky Blue* (1940) or swept along on the revolving movement of a planetary constellation as in *Composition X* or climbing the rungs of a ladder recalling the geometrics of the Bauhaus, though much more dynamic. A little later, in such works as *Brown Impetus* (1943) and *Tempered Elan* (1944), more muted tones appear along with insects, dragons, and spiders.

Kandinsky's colleague during his Bauhaus years, Paul Klee, went through a realist, then a Fauve, and even a Cubist period (as indicated by his *Homage to Picasso*, 1914), and belonged to the *Blaue Reiter* as well as the Bauhaus, but his work can never really be identified with any collective group. From the start, at least in graphics, he was master of a personal world; comparing the completely realistic portrait of his sister (1905) to a fantastic drawing, *Menacing Head*, of the same year reveals that he is already a visionary draftsman resembling no one. The influence of Delaunay and a trip to Tunisia in 1914 opened his eyes to the possibilities of using color as freely and personally as drawing—and from then on he had found his vocation. World War I only added confirmation to a vision that combined the anguish of the times with an inventive play that it liberated. Yet several tendencies almost always run concurrently in his work: Klee is at the same time a creator of beings in a state of exaltation—in dreams or fairy tales—a colorist of

subtle mosaics and skillful arrangements, and an architect of fragile banks of cubes in complex perspectives. The inverse of Kandinsky, his evolution seems to proceed from living beings and objects to signs—signs with titles so meaningful and charged with poetry that they can only be deciphered gradually; they are primarily the letters of a new alphabet, the notes of some unknown music. Such final canvases as La Belle Jardinière (1939), Wood Louse in Enclosure (1940), and Death and Fire (1940) succeed in fusing sign with fantastic form.

In England Ben Nicholson constituted a cross between Cubism and abstraction. In the wake of Mondrian, the Bauhaus, and some of Picasso's collages, he executed subtle, decorative paintings that are actually shallow reliefs in which visual depth, instead of being suggested by color, is reinforced by uneven levels. In France Jacques Villon also achieved a sense of depth without resorting to perspectival illusion, often by using double vanishing points—one receding into the distance, the other advancing toward the spectator, producing a delicate shimmering effect. Closer to Nicholson was Paul Nash, whose early World War I battle scenes show a Cubist influence suffused with a traditionally English love of nature—in this case nature ravaged by war. Nash, too, moved toward abstraction, founding in 1933 the short-lived Unit One, a group formed to promote "a truly contemporary spirit" in the arts. His search for a personal symbolism, however, ultimately led him to Surrealism.

Marc Chagall, an intimate of Soutine, Léger, and Modigliani, never called himself a Surrealist, but had affinities to the movement and is the most important of the painters who imparted a lyrical reverie to their

work while still remaining faithful to recognizable form. In Paris before World War I, in Russia from 1914 to 1922, then permanently in France, he always painted the same world—his native village—with imaginary folklore and the precision of an icon painter (as in the background of the *Double Portrait with Wine Glass*, 1917). But later the Eiffel Tower, the Gallic rooster, and the flowers of southern France mingle with the Oriental domes, Russian log cabins, tramps, and strolling musicians that are ever present in his dream world. Giving the appearance of being entirely spontaneous, as if made on waking

the appearance of being entirely spontaneous, as if made on waking from a dream, his paintings were often left unfinished and taken up again years later. For example *The Falling Angel*, begun in 1923 and returned to in 1933, was not completed until 1947; his paintings depend on the vacillation of his humor, the ebb and flow of life, and also on

technical experiment, primarily with color. After violent masses of red and blues in sharp contrast a more restrained, more iridescent palette follows, the red becoming gooseberry and the violet mauve, with

bunches of flowers tending to replace bodies in levitation.

Joan Miró was regarded by the poet André Breton as the most Surrealistic of painters, meaning the most spontaneous. But Miró resembles no one. When he said that painting "must be assassinated," he did not mean to remove all justification for painting but to do away with individualistic easel painting for a more comprehensive, universal art that speaks to everyone, as, for example, mural decoration. With ceramic he was ultimately to realize his desire for art as serviceable object; with murals he did for the Terrace Hilton Hotel in Cincinnati, Harvard

Although Paul Klee took a highly disciplined and theoretical approach to his work, he believed that art should convey the same feeling as "a vacation in the country." Consequently such paintings as The Runner at the Goal (left) convey both infectious wit and a sense of, in his words, "impish laughter." They also display his appreciation of children's painting, as the work of Jean Dubuffet was to do later in the century.

University, and the UNESCO building in Paris, he realized his desire for public works. In early canvases, such as Nude with Mirror and The Farmer's Wife, he came close to Cubism but only briefly; he soon declared he had "smashed the Cubist guitar." His concern was not in depicting an object in a new way but in reaching its essence more powerfully, more directly. Miró was not satisfied with guitars; he dreamed of stars and suns. Between 1925 and 1927 he painted Surrealist paintings, but, like Tanguy, he objected to representing real objects in bizarre surroundings. He created instead a world of unknown forms. His art was to consist chiefly of discovering for each fundamental element of the cosmos a sign that would immediately evoke it and at the same time be an expression of the artist. A ladder is often placed on the horizon separating the sky from the earth: Miró wants both to keep his feet on the ground and to fly away; he wants to leave his imprint on everything and to possess everything magically. After his canvases of 1940, in his series of Constellations, space tends to take over more and more, until finally the sign, like a sun, shines in all its splendor in space. The anguish of events is not absent from his work: like his fellow Catalan, Picasso, Miró dedicated a political work, The Reaper (1937), to the Spanish Republic. There is something disturbing about the swarm of

Much of the work of Marc Chagall is an art of celebration. In Homage to Apollinaire (left) he commemorates a meeting with that French poet in an allegory of Adam and Eve-in part inhabiting the same body-holding the forbidden fruit. According to an addition the artist made to the painting's lower left, it was also dedicated to Riciotto Canudo, the editor of an avant-garde periodical, to poet Blaise Cendrars, and to the German critic Herwarth Walden. In the joyful Double Portrait with Wine Glass (right) Chagall celebrated his love for Bella, at that time his wife of two years' standing.

In seeking the "sources of human feeling," Joan Miró developed his own pictorial language in The Passage of the Divine Bird (left) and his Painting (below).

Overleaf: Impressed by the vast skyscrapers of New York, Georgia O'Keeffe resolved to paint small objects—such as flowers—large so that people "would have to look," as in her Black Iris (left). From a base of German Expressionism modified by Cubism and Bauhaus teaching, Lyonel Feininger executed semiabstract paintings of such monuments as the Barfüsser Church at Erfurt, Germany (right).

entrancing imps, spiders, amoebas, and snails that populate the picture. Yet it is full of joy and pure enchantment.

In America, the influence of European painting effected a ferment that prepared the country for the major role it was to play from 1940 on. First, however, that influence had to be integrated with the American environment and tradition in painting, an operation that was not immediate. The Armory Show of 1913 revealed the new painting to American audiences, but assimilation of it and competition with it stemmed mostly from the 291 group, a gathering of artists named for the Fifth Avenue address of the Photo-Secession Gallery of photographer Alfred Stieglitz, where the group exhibited their work. The 291 group was receptive—as the Ashcan School had not been—to new developments, although the desire for a purely American style, close to nature and to the realities of urban society, was common to all. This is evident in the work of such artists as Marsden Hartley, whose sojourn in Germany left a deep mark; Georgia O'Keeffe, whose Black Cross (1929) transcribes Indian influence and the open spaces of New Mexico; and Arthur Dove, who had been practicing abstraction since 1908 without any awareness of what was happening in Europe. In a painting such as *Fog Horns* he was even seeking the visual equivalent of sounds. But the most important painter of the 291 group is without question John Marin, whose delicate iridescent watercolor images of sky and water and depictions of towering architecture are full of a sense of reflected light and movement. His View of Fifth Avenue (1932) is an unstable, tottering forest.

The realist tradition persisted. It ranged from the simplified, photographic realism of Andrew Wyeth to the proletarian academicism of Jack Levine and Philip Evergood. Thomas Hart Benton's emphatic figuration accented by modeling and perspective yields a reactionary rather than progressive feeling so evident in The Harvest (1938). It is an art for all, which he aims to make traditional and regional while denouncing the "esthetic colonialism" of cosmopolite and decadent art. By contrast, the realism of Grant Wood's American Gothic has an irony to the point of the fantastic, which turns the commonplace into a complete anomaly. The same glitter of the anomalous is channeled to greater purpose in the powerful work of Edward Hopper in a realism of empty houses, abandoned places, deserted filling stations, and aging couples with vacant eyes-all projecting an immobilized world reflecting the still more poignant alienation of impassive lives. Isabel Bishop and notably Ben Shahn are inspired by a more anecdotal realism of utterly destitute Bowery tramps and wives of miners, and this realism is carried to the fantastic, almost to the level of Surrealism, by Peter Blume and Ivan Albright.

But on the whole, under European influence, abstraction became the pole of major activity. In 1935, the Whitney Museum held an exhibition of abstract art; in 1937, the Guggenheim Foundation started a museum of nonobjective art around its Kandinsky collection; in 1936, Lyonel Feininger returned to the United States and structured his dreams according to the teachings of the Bauhaus. He was followed by two refugees from Europe, Hans Hofmann and Josef Albers, the latter working and teaching at Black Mountain College in North Carolina. Stuart Davis was to apply the lesson of the abstract to American con-

Early Sunday Morning (above) is an example of the stark realism that Edward Hopper sought in his lonely gas stations, desolate buildings, and barren cityscapes. Ben Shahn, better known for his social protest, also produced gentle works of great charm, of which Peter and the Wolf (right, above) is an example. And John Marin, in Lower Manhattan (right, below), compressed half a city into a single canvas.

The gap between the 1913 Armory Show (at which he exhibited five watercolors) and the painters of the 1950s-and even of Pop Art-was bridged by the resolutely American painter Stuart Davis, who relied on American idioms (such as jazz music) in such works as International Surface #1 (left). In Mexico, a different concept was developing, an art of murals accessible to everyone, with bold colors and an aggressive realism often bound up with left-wing politics and proletarian protest, as in David Siqueiros's Self Portrait (above).

tent. As early as 1921—in *Lucky Strike*—he introduced numbers and letters in a painting by depicting a package of cigarettes, thereby anticipating Pop Art; and in *Swing Landscape* (1938) he revealed jazz music as one of his main sources of inspiration. Milton Avery was a link between Matisse and Rothko—the pure color in his paintings is like open country and light.

On those who were to become the major artists of the next two decades—Arshile Gorky, Willem de Kooning, and Jackson Pollock—the mural painting of the Mexican school undoubtedly had an influence (and American canvases were almost always to have large dimensions). There was indeed an important school of fresco painting in Mexico, following the Revolution of 1911, by which art was to be put at the service of the people struggling for emancipation, but the approach was different from that of Social Realism. Diego Rivera, David Alfaro Siqueiros, José Orozco, and Rufino Tamayo all had a feeling for painting on walls and the dramatic impact of monumental form; and in the mosaics with which they sheathed such architectural forms as fountains, they prepared the artist to turn from easel painting and two dimensions and apply himself to the open spaces of functional art.

Action Painting and Beyond

The period from World War II to the present is characterized by a series of important innovations more numerous but perhaps less inventive than the century had already seen and by a geographical redistribution of creative energies coupled with decisive sociological changes. Previously St. Petersburg and Munich had been important art centers and Paris had been both the principal focus and the only great center never to lapse into inactivity. But the coming of the Soviets to Russia and the Nazis to Germany had effaced St. Petersburg and Munich in the 1920s and 1930s. And in the 1940s Paris, for the first time in a century, was finally to lose its primacy. For some time the United States had been assimilating the new art of the twentieth century and making experiments of its own, and New York in particular had become the American art world's lodestar. New York naturally became a haven for artists fleeing European dictatorships and others fleeing the war.

With the downfall of the Nazis and with America won over to modern art, new trends emerged from a quasi-furtive status to become, in a sense, the official art of the postwar world. Modern art became the art sought by museums and collectors and, with the return of prosperity, began to fetch extravagant prices. Conscious of the breathless rise of such originally unrecognized figures as Cézanne and Van Gogh, postwar buyers tended to credit almost any new approach with the same promise, all the more so if it was shocking or unintelligible. The innovating, iconoclastic painter was no longer the outcast; the robe of the disinherited fell upon the traditional artist. Never have such daring works found such immediate and universal channels of diffusion as in

the past thirty years.

The sudden, massive, and dramatic entry of American painting in a direction counter to traditional realism came in the form of Abstract Expressionism, an art in which the identity of natural objects is absent but a suggestion of their elements can be recognized; it is also an art that arouses some powerful feeling, even if that feeling cannot be named. It is an art of forms and colors connected with the turmoil of life, the legacy of Kandinsky not of Mondrian. The new art had its first major patron in Peggy Guggenheim, who exhibited it at the Art of This Century Gallery, which she founded and financed in the 1940s.

An early exponent of Abstract Expressionism was Arshile Gorky, an Armenian emigré to the United States. His fluid, supple forms

The predominant style of painting following World War II was called Abstract Expressionism. One of its founders and foremost exponents was the American Jackson Pollock, whose Autumn Rhythm (detail at left) shows the knotted whorls and skeins of paint that typify his work.

Arshile Gorky, in paintings such as Landscape Table (left), provided a bridge between the Surrealists and the new painting of Pollock and his followers. The style of Pollock's Night Mist (below) was called Action Painting by critic Harold Rosenberg, partly for the strenuous nature of the creative process, and partly to stress that such paintings insist upon being experienced directly, almost as one responds to a physical event.

served equally well to recall the paradisiacal garden of his childhood and to translate his erotic obsessions (sexual organs and breasts can be recognized in the signs of his *Betrothal* of 1947). But whatever his originality, his art is still somewhat eclectic and shows the influence of Kandinsky, to which he added Jean Arp's biomorphism and elements from Surrealism. The first totally original member of this school, who followed no one but had many followers, was Jackson Pollock, the developer of Action Painting in which bodily motion plays a major role.

Pollock was initially attracted to mural and monumental decoration, chiefly through the baroque fresco art of Mexico but also through Guernica, then to spontaneity of motion and the automatism of violent draftsmanship such as he found in Masson's paintings. Although his first experiments with webs of color are in small-scale canvases, he ultimately moved to canvases of enormous size—Blue Poles (1953) measures 7 by 16 feet—for their powerful decorative impact. In his work the network of endless arabesques and interlacings and the repetition of motifs all affirm a feeling for wall painting rather than easel painting. His canvases are filled with oscillating labyrinths that convey the effect of physical motion rather than of carefully meditated composition, precisely because they are the result of motion. Pollock discovered his world in his technique: he was the first painter to make Action Painting the governing principle of his work, instead of merely a fortuitous encounter as in Ernst's frottages or Masson's sprinkles of sand.

Pollock worked not on a canvas placed on an easel but on one laid upon the floor; he didn't use brushes but let the paint drip from holes in a tin can or ooze directly from the tube (for which he was ironically called "Jack the Dripper"); nor did he paint standing still but wheeling around like a dervish, as if following the motions of a dance, using not only his hand but his arm and body as well to guide his motions. He put down veins and marbled splashes and streaks of blue, black, white, and red. His was the first entirely physical painting, the first to preserve spontaneity of impulse free from any intervention by the

mind. The solution of a recurrent problem was simultaneously reached in this maelstrom of dripping color: by literally drawing with paint, Pollock obliterated the time-honored distinction between the linear and the painterly, between the painter as draftsman and the painter as colorist. At the same time, the process erased all distinction between the plane of the canvas and matter in space, between surface and ground. Attempting to thread one's way through this whirlwind of knotted skeins is a journey for the eye that no longer relates to reading or identifying forms.

Pollock's influence on American painting was decisive (like Cézanne's on French painting), not only in his approach but even more because it led to open, all-over composition. Painting is no longer centrally focused, no longer organized within the space of its physical dimensions. There are certainly details in a Pollock canvas on which the eye can rest, a microcosm within the whole, but once a sector engages the attention, it leads on to a trail beyond the physical limits of the picture. Here, for the first time, is a homogeneous universe into which the onlooker plunges rather than simply standing aside and observing—a pictorial field vaster than the field of vision.

The internal agitation of Pollock's painting is related to that of Willem de Kooning, whose series on Women (1951) and Excavation (1950) are dramatic canvases, often evoking recognizable forms and containing elements fused together suggesting human organs and demolition sites. Similarly related to Pollock is Robert Motherwell, whose Elegy to the Spanish Republic (1953–54) uses intersecting bands of black as powerful evocations of tragic events. Another is Franz Kline whose black structures against white grounds—suggesting the girders of elevated trains or skyscrapers under construction—evoke the same somber violence. Close to Pollock's gestural signs, and equally mobile, is the so-called "white writing" of Mark Tobey, who moved to Seattle from the Midwest. But Tobey's painting attains the serenity of Far Eastern wisdom, a charm of refinement rather than strength.

Pollock also influenced other painters, who came to be called the New York School. Their accent was on dramatic violence, but this soon turned toward greater sensibility, as can be seen in the work of

Postwar Abstract Expressionism ranged from the strong, vividly harsh strokes of Franz Kline's Mycenae (far left) and the similar technique of Pierre Soulage's Painting (left) to the vigorous if unlikely combination of violence and grace in such works as De Kooning's Woman I (1950-52) (right) and the serenity of Mark Tobey's Agate World (below).

Sam Francis and Helen Frankenthaler, both of whom employed a post-Impressionist *tachisme* (spotting of color). A common denominator of this period, and especially of the New York School, is the enormous size of the canvases, reflecting the artists' intent to place the spectator within the picture. Another aspect of their work is the search for innovation in technical processes: instead of the fine-point brushes used by Gorky and De Kooning, Franz Kline and Frank Stella used house painters' brushes, Adolph Gottlieb a kitchen sponge, Jules Olitski a spray can, and Helen Frankenthaler dyes.

During the same period Europe witnessed the simultaneous diffusion and elaboration of an expressionist, lyrical, or informal abstraction in which many degrees and varieties of approach can be recognized, including texturism, colorism, and *tachisme*. The exhibitions mingled all these varieties, but it is nonetheless necessary to make distinctions. For example, in the work of such painters as Jean Bazaine, Roger Bissière, and Vieira da Silva—all artists who resent being called abstractionists—nature is never far away. Their painting is a poetic transposition of at least an impression of natural form, light, and space; their quasi-abstract

European abstraction included the calligraphic vehemence of Hans Hartung's T. 1951/I (right) and landscapes such as Le Lanvandou (left) by Nicolas de Staël. Concurrently, Henri Michaux, often under the influence of hallucinogenic drugs, was producing a series of fantastically conceived heads (above, right).

style sometimes has an almost Neo-Impressionist refinement. The somewhat disquieting forms in the work of Jean Atlan are often close to the rhythms of African art; Pierre Soulages's powerful blue-and-black frameworks suggest abstract constructions; and Bram van Velde displays a sort of dispersal or dilution of form-blood-red clots and slashes suggest life defeated by time. In the frankly greater abstraction of Serge Poliakoff and Maurice Estève, color is the controlling factor, but substance counts most in the paintings of the Canadian Jean-Paul Riopelle and Jean Fautrier, whose pinkish impasto in the center of his Hostage (1948) suffices to evoke a feeling of tragedy. Substance is also the controlling interest in the work of Antoni Tapies, who resorts to an admixture of plaster, sand, and glue to effect a play of hollows and lumps, and in Alberto Burri, whose assemblages of gunny sack, string, and rags anticipate Pop Art. But the greatest artist of this group is Nicolas de Staël, whose heavily impastoed canvases, built up with a palette knife, have a remarkable density and vividness.

Action Painting was reflected, in a sense, in the work of Hans Hartung, an expatriated German who fought on the French side in World War II. Tufts of grass and tangled reeds bundled in sheaves, drawn with the delicacy and rapidity of an Oriental calligrapher, are characteristic of his work, but he is also a distinguished colorist. Henri Michaux, perhaps better known for fantastic heads and automatic drawings executed under the influence of mescaline, also inscribed small ideograms with

simple spots of India ink, filling whole pages with extraordinary tension and movement. But the best representative in France of Action Painting is Georges Mathieu, whose spontaneity and utilization of pure color directly as it comes from the tube lend challenge to the speed of his execution. (In Tokyo he painted a forty-foot canvas in public in twenty minutes.) His calligraphy is more decorative than Pollock's and more ostentatious, incorporating the golds of a baroque theater. The titles he gives to his canvases (*Battle of Bouvines*, for example) often allude to great events in French history, revealing the nostalgic dreams of an otherwise thoroughly modern painter.

Mathieu drew not only on Pollock but also on Wols (Wolfgang Schulze). Wols was an exceptional personality whose influence was to grow by degrees; his life sheds great light on his work. He left Ger-

many in 1932, leading thereafter a nomadic and adventurous existence. A musician of sorts, interested in photography, he never claimed to be a professional painter; whatever drawing or watercolor he indulged in he did only to relieve his anxieties. He drew clowns, men pinned to the floor, crustacea, caterpillars, and roots; then later, latticed spaces, which reflect his internment in 1939–40. It was not until 1945, pressured by a shrewd picture dealer, René Drouin, that he reluctantly had an exhibition in Paris. He then moved from small sketchbooks of drawings to canvases and obsessional images with abstract scrawls not unlike Pollock's (although Wols had never heard of him). But almost always at the center of these networks of scrawls is an apparition with violent colors. The Blue Phantom (1951) is a vision that lies between Odilon Redon and Pollock.

"Tachisme, action painting, the so-called lyrical abstraction seem to me so many samples of the same thing, disorder," wrote Victor Vasarely in 1959. Against this disorder, geometric abstraction had for a long time been a reaction, but between 1940 and 1950 geometric art became sidetracked.

Vasarely played an important role in reviving it. In Budapest, where he was born in 1908, he took a course in Bauhaus teaching. In 1930 he moved to Paris; after a few experiments in trompe l'oeil, he freed himself more and more from the object and turned toward optical and mathematical researches. In the unity of his color relationships one color advances and another recedes, which creates the illusion of motion and continuity. His Homage to Malevich (1958) shows a square placed obliquely, making it a lozenge that seems to be pivoting on an axis and giving the impression of three dimensions. First with black and white, later rediscovering color, he created mirror-images that functioned like optical illusions whose reversibility keeps them from immobility.

A purely optical art of this kind, dividing the canvas into verticals, horizontals, squares, rectangles, and circles rather than focusing on a center, developed a wide appeal in the United States. An art totally emancipated from the object and also from the restricted dimensions of easel painting (virtually looking more like an image projected on a wall

Although Wols knew nothing of Jackson Pollock and owed nothing to his work, his own creations, such as God's Eye (above), show an uncanny similarity to that of the American Action Painter. More influenced by Pollock's style, although not derived from it, was Georges Mathieu, perhaps France's foremost exponent of Abstract Expressionism, whose Capetians Everywhere is at right.

or a vast screen), an art that tends toward a certain mathematical impersonality and also toward industrial colors, which are more susceptible than others to optical alternation, is called Hard Edge. It is a specifically American art of color fields with vivid metallic colors and rigid forms. Some of its chief exponents are Frank Stella, Ellsworth Kelly, Al Held, and Kenneth Noland. In the work of Morris Louis the forms are more tractable, with bands of color often having the effect of drapery. But this painting totally devoid of objective reference, which came into being in the 1960s, is after all only a variant of geometric art.

Optical design still represents a kind of composition and can even perpetuate objectivity to the extent that the elements composing the picture create an ensemble. Entirely different is the kind of painting that can only be apprehended in the aggregate, that cannot be broken down into elements with some sort of relationship with each other. Distinguishable elements remain, perhaps, in the canvases of Clyfford Still, where a black mass that looks cut out and torn appears among ragged yellow or reddish trails, or in Adolph Gottlieb's *Counterweight* (1962), where a black sun counterpoises a large splash on brown ground, or in the work of Mark Rothko, where reddish surfaces are caught between somewhat cloudy brown and white bands. But it would be a mistake to pick out these elements, because they are part of a whole, functioning to achieve a homogeneous effect. These canvases are really without

Victor Vasarely's Composition (left) is an example of the geometrical abstraction verging on Kinetic Art that characterizes much of his work. Other examples of this Optical Art are Bridget Riley's Current (above) and Frank Stella's Sinjerli Variation (right). At a distant remove from this sort of painting is the mystic luminescence of Mark Rothko's Black, Pink, and Yellow on Orange (far right).

composition and lead to an art where the virtual disappearance of any element is sought. Rothko's last canvases tend in this direction as do Barnett Newman's and Jules Olitski's. Whatever remains of composition is only the potential of form or of light, a layer of air appearing and disappearing. Nothing gives a better impression of light at daybreak than the masterpieces of Rothko.

Ad Reinhardt's monochromes, with blacks that are practically indistinguishable, are the earliest examples of Minimal Art, to which Hard Edge logically leads. Minimal Art pushes to the utmost limits the tendency to employ only primary structures to attain works that comprise neither images, nor signs, nor symbols, nor any meaning whatsoever—simply the totally neutral presence of figurations repeated at periodic intervals or in series within a colored area. Most of the Minimalists rejected the limits imposed by the easel; they eschewed the canvas to set up three-dimensional rods, tubes, and cubes. These are not closed forms but rather a species of scaffoldings giving form to the space contained and creating an environment. Donald Judd, Robert Morris, and Carl André produced works that still retain the suggestion of an integral

structure; but Dan Flavin created environments chiefly by placing neon tubes in a given space, a style called Conceptual Art.

The urge to give an account of the visual impressions that come to us from the outside world is ineradicable; but it appears less at the level of collective currents than at the level of individual works with a strong personal touch. It requires courage and talent to ignore the preoccupations of the day and risk approaching banal figuration. Although there is an elongation of form both in the paintings and the sculptures of Alberto Giacometti that can be interpreted as an expressionist element, the obsession to create a likeness—primarily of the human face—is a dominant factor in his work. While painting his portrait of Jean Genet he revealed the problem and its difficulties, declaring: "There must be resemblance but it is also necessary to paint a picture." Similarly the painter who calls himself Balthus (Balthasar Klossowski de Rola) paints imaginary, dream-haunted pictures charged with hidden drama, but in his dream subjects he retains sensation just as much as in his landscapes

Among the painters who retained the traditional configuration and depiction of objects is the enigmatic Balthus, whose The Game of Patience (left) nonetheless projects an air of unreality. At the same time a group called Cobra attempted to fuse traditional Expressionism with Action Painting with results such as Pierre Alechinsky's Central Park (below, left) and Karel Appel's The Red Horseman (right).

and nudes. He remains faithful to the idea that there exists a relationship between the beauty of things and the perfection of painting.

Every politically oriented revolutionary art naturally respects figurative resemblance, since such art wants to be understood by everyone and concerns itself with people and their status. In Europe after the war, notably in Italy, Social Realism experienced a certain vitality. In 1950 Renato Guttuso exhibited a manifesto-painting, Occupation of Farm Lands in Sicily, and published an important essay in which he stated: "A work of art must be understood by everyone, at least in part. . . . The part that must be clear to everyone is the subject. A Raphael or a Bellini madonna is before anything else a madonna with a child in her arms." That is the lesson of the Mexican fresco painters, as well as such artists as Edouard Pignon in France and the painters of East Germany. Conversely in the U.S.S.R.—where Social Realism is the only officially tolerated approach—an avant-garde art has come into being as a reaction, but it is subject to a clandestine existence.

The currents that can be classified with figuration do not all fall into such narrow interpretations; both Surrealism and the Dutch movement Cobra basically use the figure as one element among others. Among the last of the Surrealists were Victor Brauner, a master of fantastic and ironic art, Wilfredo Lam, and Matta (Sebastian Echaurren). Lam's stinging vegetal world partakes of something akin to Picasso; and Matta is the author not only of dream and erotic canvases swarming with geometric or anthropomorphic forms in a sort of science-fiction style but also of politically oriented, more readable canvases protesting the wars in Algeria and Vietnam.

Cobra is the only movement whose cohesion recalls Surrealism. It was formed in 1948 by a group of Dutch-based experimentalists but did not last much beyond 1955. The name is formed by the initial letters of

Ireland's Francis Bacon and France's Jean Dubuffet are totally dissimilar artists-not only from each other but from everyone else as well-who are dominant figures on the artistic scene. Bacon's agonized figures, such as his Man in Blue (left) depict humanity alone in a hostile world. Dubuffet proclaimed his preference for "Raw Art," the works of children and the insane, and produced an individualistic oeuvre of extraordinary variety, including Business in Town (above, right) and Garden of Pousse-Mousse (right).

the cities from which its founders came: Copenhagen, Brussels, and Amsterdam. The group included the Dane Asger Jorn, the Belgian Pierre Alechinsky, and the Dutch Karel Appel, Constant (C. A. Nieuwenhuis), Corneille (Cornélis van Beverloo), and Lucebert (Van Swaanswijk). Like Surrealism, Cobra protested against painting that has contact neither with the human element nor with other means of expression, especially poetry. Its manifesto condemned both the sterility of abstraction and what it called "Surrealist pessimism." Yet Cobra itself has affinities with abstraction—Jorn called it "an abstract art that does not believe in abstraction"—and also with an expressionism linked to the earth, not to dreams, and marked by joy and anguish—violent feelings emanating from an intensely lived existence. Its common denominator is powerful color and impetuous violence.

The originality of Francis Bacon and Jean Dubuffet appears to place them outside of every trend, yet each employs a figuration that under the shock of its internal violence explodes and is distorted, and both artists denounced abstract art. Francis Bacon (born in Dublin of English parents) began painting with a series of *Crucifixions* around 1933 but met with little success. Difficult to classify, he was rejected for the Surrealist exhibition of 1936; he did not have a one-man show until he exhibited his series of *Heads* in 1949. But in 1954, the year of his *Man in Blue*, he represented Great Britain at the Venice Biennale and since then has commanded international attention. The essence of his subject matter—portraits, crucifixions, bullfights—is the human figure and to a certain extent animals, for he is interested only in life. But his grimacing images are blurred as if they were reflected in a quickly revolving glass drum. The flesh is open and bleeding; violence is always present. Bacon said that he would like to paint a smile but could

only paint a scream. And yet, it is a healthy art; blood, sex, and death are the things that give life its intensity.

Dubuffet is today's most original artist. He aims to exclude from his world all reference to culture and to proceed exclusively from art brut-raw art-the art of self-taught artists, of the insane, and of recluses. The extraordinary variety of his work is in sharp contrast to the uniformity of style of most expressionist painters. Born in 1901, Dubuffet tried several styles, all of which he soon abandoned as too influenced by current tendencies. He finally found what he was looking for: an art with no resemblance to anything except perhaps children's drawings and wall graffiti, a rudimentary art that could be practiced by anyone but that he was to develop with a prodigious power of invention. In such pictures as Charred Nude and Body of a Lady he practices a brutal art, deliberately aggressive, in which the human figure and notably the female nude is perfectly recognizable but clearly ravaged. On the other hand, he also produces what he calls an art of celebration, retrieving mean, condemned substances such as mud and dust and depicting soil, vegetables, or sky in canvases or lithographs that are perfectly concrete but give the appearance of abstraction.

Between 1943 and 1962 Dubuffet's work was characterized by swings and alternations, but in 1962 he seemed to converge on a systematic unity in *L'Hourloupe* (a word he invented). It is a system of elementary colors (blue and red, black and white) and of figures uniformly striped and caught in a meandering network, a closed world that carries the artist's signature, the syntax of which he alone has the key.

The object in art has been recently rediscovered on new foundations, following experiments common to a large number of artists, of which Pop Art is the most significant manifestation. Pop Art was born in England between 1954 and 1955, the inspiration of a group including Richard Hamilton, Patrick Caulfield, and Peter Blake. Also in the group were Allen Jones and R. B. Kitaj, who was originally a photographer. His work includes blowups of two men reading books and giant effigies of movie stars and Che Guevara. Jones painted legs sheathed in nylon above high-heeled shoes. Their aim was to create an image as close as possible to a given environment, to scrutinize an object more closely than art ever had, thereby heightening its presence. The movement was given its name by the critic Lawrence Alloway, who called Pop culture the culture of the mass media, of photographs and posters, and by Richard Hamilton who asserted that Pop must be "popular, transitory, exuberant, witty, sexy."

Pop Art was, however, both preceded and accompanied by a number of experiments that do not fall under its label. Duchamp's "ready-mades," Man Ray's photographs, the kind of superpresence that Surrealism confers on the object: all opened the way to Pop. The tendency in the United States is exemplified by Larry Rivers's paintings of highly magnified bank notes and Jasper Johns's abstractly painted American flags and targets. These not only give the illusion but also heighten the effect of the object, purposely creating an ambiguous space and making it hard to tell whether one is looking at the real thing or its representation.

The subject matter of Pop Art is derivative—depicting something that has already been published or produced, including comic strips. One Pop artist particularly known for his use of comic strips is Roy Lichtenstein, whose Pow! appears above.

Between 1955 and 1960, Johns shared a studio with Robert Rauschenberg, who was awarded the Grand Prize at the Venice Biennale of 1964. The work of Rauschenberg is combine painting, consisting of the retrieval of trash added to pictures of daily life, making Pop appear like an art of secondary importance, consisting of what is already an image. To these raw materials, Rauschenberg added traditional techniques, resulting in touched-up paintings and even the most literal simulation of tachiste processes. The aim is to bring art as close as possible to daily life, to create a zone of ambiguity between the two.

Most American Pop artists come from a field outside of painting, specifically the mass media. James Rosenquist was first a poster designer, Roy Lichtenstein had worked in window display, Andy Warhol did newspaper publicity, and Tom Wesselmann was a caricaturist. Although aiming at an impersonal art, each has his favorite themes; but in choosing a given object, they proceed to strip it of all inherent meaning. Rosenquist remarked that, confronted with abstraction, one feels obliged to find some meaning but that "no one would make a crucifixion out of spaghetti." This is the kind of glaring absurdity, of irresponsiveness toward the object, that Andy Warhol gives utterance to in presenting a bottle of Coca Cola, a portrait of Marilyn Monroe, or an electric chair; and it is in the same cool style that Jim Dine presents articles of clothing, a shower, or a lawn mower; Lichtenstein, blowups of comic strips; Wesselmann, still lifes and nudes; and Oldenburg, hamburgers.

Claes Oldenburg explained his approach by remarking that, confronting his hamburgers, the public will say either "This is not art, these are hamburgers" or "These are not hamburgers, this is art." He provokes a switching back and forth between the art object and the real object. The difference between Pop image-objects and Duchamp's ready-mades is that the former, by taking a common object out of its context, instead of refuting that object, attempts to show that it deserves to be looked at. The Pop artist is an optimist, unprejudiced in his choice of subject. But he sometimes has aggressive intentions too, which have been seized upon and accentuated by the Hyper-realists. By such effects as Andy Warhol's endlessly repeated face of Marilyn Monroe or Lichtenstein's crowding, spotting, and dividing, the image fades and flickers in a sort of optical quiver; by blowups the viewer moves from image to space.

Simultaneously in France a New Realism was displayed in an exhibition given by the critic Pierre Restany under that name in 1960. In it were included widely divergent works that all possess one common denominator: the need to expand into space. For these artists, the attainment of the object merely by painting has become inadequate; there is a need to reach out, for space itself to become a work of art.

One of the most influential of the New Realists, despite the shortness of his life, was Yves Klein. In 1946 on a beach in the south of France he had a revelation of the cosmic energy of space, choosing for his inheritance a sky of cloudless blue. The colors of his monochrome canvases—blue, rose, gold—are the fundamental colors of his cosmos. On canvases smeared with these colors, he made *Anthropométries* by

having nude models roll to leave their imprint; he employed "the language of fire" in various singeing and burning operations; and he used the action of nature, setting a prepared canvas out in the rain.

Also emerging at the same time has been kinetic art, which aims at being an art of space-time. It is art related to motion, whether of actual motion brought about by motors or other mechanical means, the motion of lights or reflection, or the feeling of motion psychologically induced by optical effects. In each case, such optical art is created in the mind of the observer and subsists there even after the optical contact has been broken. Among kinetic artists are the painter Vasarely, Alexander Calder, with his mobile sculpture, and Nicolas Schöffer, who animates rooms with reflections from revolving disks.

But during all this time, there has been a return to the painted image in Narrative Painting, which had its first exhibit in Paris in July, 1964, under the title "Daily Mythologies." Like Pop, Narrative Painting utilizes the imagery of mass media, not to give the object its literal presence so much as to have it act like a word in a story that can be read, somewhat like comic strips and photographic novels. The pictures may be juxtaposed on one canvas or in polyptychs or may appear as an

The nihilism of Dada resurfaced in the works of Neo-Dadaists such as Robert Rauschenberg, Jasper Johns, and the French New Realist Yves Klein. In such works as his untitled painting below, Rauschenberg sought to remove all personal sensibility from his art. By the banal repetition of the commonplace, Johns, in his Three Flags (far right), made the point that the painting really has no point. Klein smeared nude models with paint for his Anthropométries (below, right). But Neo-Dada lacked much of the spirit of the original, as one old Dadaist uttered in his cryptic statement: "Dada fell like a raindrop from Heaven. The Neo-Dadaists have learned to imitate the fall, but not the raindrop."

episode in a series. The story is perfectly legible, and more often than not the subject is political—almost always a denunciation of society. But if the aim is more aesthetic, the story is presented in scattered elements that have to be reconstituted, like a puzzle that can be construed as one pleases.

Narrative Painting depends less on exactitude of pictorial representation than on utilizing the image as a sort of simplified writing. In contrast to it is Hyper-realism, which resorts to an imagery that is virtually photographic. The exhibitions of "22 Realists" and "Cool Realism" in New York in 1970 and Chicago in 1971 started the movement that has Jasper Johns and Oldenburg as precursors. There are in fact relationships between this movement, Pop, Narrative Painting, and all forms of realism. But Hyper-realism is distinguished essentially by its photographic source of inspiration and the fact that it usually depicts either a general effect, such as a wide landscape or a drugstore window, or some scene of action, such as a cocktail party or people in a car. Rather than telling a story or suggesting the animation of a gathering, the Hyper-realist canvas registers a static existence—revealing both despairing emptiness and unreality as soon as one confronts it.

From these various scattered trends it can be seen that modern painting, which began coherently and progressively at the start of the nineteenth century, seems to have lost its unity. It communicates the sensation of having reached a dead end, forcing it to retrace its steps. Its freedom from the thralldom of both the object and of color—the ability to explore every potentiality—seemed a guarantee of unity and progress. But modern painting has gone the whole length of what Cézanne spoke of as "the logic of color," only to renounce it, as in Minimal Art and Hyper-realism, or to demand a great deal more, as in kinetic art. It also went to the end of objectivity and is now seeking to rediscover the object, either simply to reinstate it, to magnify it, as in the optimism of Pop Art, or to disparage it, as in Hyper-realism. The contradictions of all these tendencies give an impression of vitality, but at the same time they reveal disquiet and anxiety. Modern painting, as is perhaps to be expected, is a reflection of a world in crisis.

mpbells.	Campbells	Campbells	Campbell)	Gampbells	Gampbells.	Campbells	Campbells	Campbells	Camp
BEEF OODLE SOUE	BEEF NOODLE SOUP	NOODLE SOUP	BEEF NOODLE SOULE	BEEF NOODLE SOUP	SOUP NOODLE	SOUP NOODLE	SOUP SOUP	NOODLE SOUP	S O S O
mpbells	Campbells	Campbells.	Campbells	Campbells	Campbells.	Campbells.	Campbells.	Campbells	Cany
BEEF NOODLE BOWP	NOODLE SOUF	SO UP	BEEF NOODLE SOUP	NOODLE	SOUP SOUP	NOODLE SOUP	BEEF NOODLE SOUP	NOODLE SOUP	BE NOC SO
inpbells	Campbells	Campbells	Campbelli	Campbells.	Campbells.	Campbells.	Campbells.	Campbells	Camp
BEEF CODILE	NOODLE SOUP	BEEF NOODLE SOUP	SOUP SOUP	BEEF	NOODLE	BEEF	BEEF NOODLE SOUP	BEEF NOODLE SOUP	SO.
mpsells	Campbells	Campbells	Campbells	Campbells.	Campbells	Campbells	Gampbells	Campbells	Camp
BEEF NOODLE NOODLE	BEEF NOODLI SOUE	BEEF NOODLE SOUP	SOUP	NOODLE SOUP	BEEF	SOUP	SOUP	SOUP SOUP	8 E
mpbells	Campbells.	Gampbells	Campbells	Campbells	Complete	Sampbell	Gampbell	Gampbells	Cam
BEEF	SEEF NOODLE SOUP	NOODLE SOUE	BEEF NOODLE SOUP	BEEF NOODLE SOUP	SOUP SOUP	NOODLE SOUP	BEEF	BEEF NOODLE SOUP	BE NOC
mpbells	Campbells	Gampbells	Gampbells	Campbell	Campbell	Samphel	Lampbell	Campbells	Camp
NOODLE	SO UT	BEEF NOODLE SOUP	SOUP NOODLE	SOUP SOUP	SOUP NOODLE	BEEF NOODLE SOUP	SO WE	NOODLE SOUP	S S S S S S S S S S S S S S S S S S S
unpbelli		Campbells	Campbells	Campbells	Campbell	Gumphel	Campbel	Campbells	Camp
BEEF SOUP	BFEF NOODLE SOUP	NOODLE SOUP	BEEF NOODLE SOUP	BFE F NOODLE	SOUP NOODLE	NOODLE S. J. U.S.	NOOD	SC OF	BOOK OF
nphells	Campbells.	Campbells	Campbells.	Campbell	Campbel	Sampher	Sumple Compenses	Ils Campbell	Camp
BEEF	BEEF NOODLE SOUP	BEEF	BEEF NOODLE	NOODLE SOUP	BEEF NOODLE SOUP	BEEF	NOODLE SOUF	NOODLE SOUF	N CE
mpBells	Campbelli.	Campbells	Campbells	Campbell	Campbe	lls Campbel	Campbel	ls Campbell	Gam
BEEF NOODLE	BEEF NOODLE	BEEF NOODLE	SOUP NOODLE	BEEF NOODLE SOUP	SOUP SOUP	SOUE SOUE	SOUP SOUP	SOUP	600 0000
mpbells	Compbells Congenser		Campbells	Campbell CONDENSED	Campbe	lls Campbel	Lampbel CONDENSED	ls Campbell	Gam
BEEF	BEEF	NOODLE	NOODLE NOODLE	BEEF	BEEF NOODLE SOUP	BEEF	Soup Soup	BEEF NOODLE SOUP	BCS

THE PAINTER'S VISION

Opposite: Andy Warhol's One Hundred Campbell's Soup Cans.

Nineteenth-century English landscape painting produced two men of unmistakable genius: J.M.W. Turner and John Constable. Deeply moved by the physical beauty and harmony of the English countryside, Constable found within the relatively small area of the Stour River and its embankments an abundant source of inspiration and challenge, as he explained in a letter to his lifelong confidant, Archdeacon John Fisher.

Hampstead, October 23rd, 1821.

My dear Fisher, . . . I am most anxious to get into my London painting-room, for I do not consider myself at work unless I am before a six-foot canvas. I have done a good deal of skying, for I am determined to conquer all difficulties, and that among the rest. And now talking of skies, it is amusing to us to see how admirably you fight my battles; you certainly take the best possible ground for getting your friend out of a scrape (the example of the old masters). That landscape painter who does not make his skies a very material part of his composition, neglects to avail himself of one of his greatest aids. Sir Joshua Reynolds, speaking of the landscapes of Titian, of Salvator, and of Claude, says: 'Even their skies seem to sympathize with their subjects.' I have often been advised to consider my sky as 'a white sheet thrown behind the objects.' Certainly, if the sky is obtrusive, as mine are, it is bad; but if it is evaded, as mine are not, it is worse; it must and always shall with me make an effectual part of the composition. It will be difficult to name a class of landscape in which the sky is not the key note, the standard of scale, and the chief organ of sentiment. You may conceive, then, what a 'white sheet' would do for me, impressed as I am with these notions, and they cannot be erroneous. The sky is the source of light in nature, and governs everything; even our common observations on the weather of every day are altogether suggested by it. The difficulty of skies in painting is very great, both as to composition and execution; because, with all their brilliancy, they ought not to come forward, or, indeed, be hardly thought of any more than extreme distances are; but this does not apply to phenomena or accidental effects of sky, because they always attract particularly. I may say all this to you, though you do not want to be told that I know very well what I am about, and that my skies have not been neglected, though they have often failed in execution, no doubt, from an over-anxiety about them, which will alone destroy that easy appearance which nature always has in all her movements.

How much I wish I had been with you on your fishing excursion in the New Forest! What river can it be? But the sound of water escaping from mill-dams, &c. willows, old rotten planks, slimy posts, and brickwork, I love such things. Shakespeare could make everything poetical; he tells us of poor Tom's haunts among 'sheep cotes and mills.' As long as I do paint, I shall never cease to paint such places. They have always been my delight, and I should indeed have been delighted in seeing what you describe, and in your company, 'in the company of a man to whom nature does not spread her volume in vain.' Still I should paint

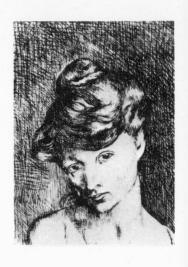

The extraordinary range and flexibility of Picasso's work is well demonstrated by his graphics, which include the print of a woman shown above as well as those illustrated on the following pages.

my own places best; painting is with me but another word for feeling, and I associate 'my careless boyhood' with all that lies on the banks of the Stour; those scenes made me a painter, and I am grateful; that is, I had often thought of pictures of them before I ever touched a pencil, and your picture is the strongest instance of it I can recollect; but I will say no more, for I am a great egotist in whatever relates to painting. Does not the Cathedral look beautiful among the golden foliage? Its solitary grey must sparkle in it.

JOHN CONSTABLE Letters, 1821

French landscape painter Camille Corot led a sharply cloistered existence. Except for winter months spent in Paris, Corot lived alone in the northern countryside where he undoubtedly passed most of his days in the manner delightfully described in the following letter.

Gruyères, 1857

You know, a landscape painter's day is delightful. You get up early, at three o'clock in the morning, before sunrise; you go and sit under a tree; you watch and wait. At first there is nothing much to be seen. Nature looks like a whitish canvas with a few broad outlines faintly sketched in; all is misty, everything quivers in the cool dawn breeze. The sky lights up. The sun has not yet burst through the gauze veil that hides the meadow, the little valley, the hills on the horizon. The nocturnal vapours are still creeping in silvery flakes over the frozen green of the grass. Ah! a first ray of sunshine! The tiny flowers seem to wake up happily. Each has its tremulous dewdrop. The leaves shiver with cold in the morning breeze. Invisible birds are singing beneath the leaves. It seems as though the flowers were saying their prayers. Little butterfly-winged cupids frolic over the meadow, making the tall grass ripple. One sees nothing. Everything is there! The whole landscape lies behind the transparent gauze of the fog that now rises, drawn upwards by the sun, and, as it rises, reveals the silver-spangled river, the fields, the trees, the cottages, the further scene. . . .

The sun is up! There is a peasant at the end of the field, with his waggon drawn by a yoke of oxen. You can hear the little bell round the neck of the ram, the leader of the flock. Everything is bursting into life, sparkling in the full light—light which as yet is still soft and golden. The background, simple in line and harmonious in colour, melts into the infinite expanse of sky, through the bluish, misty atmosphere. The flowers raise their heads, the birds flutter hither and thither. A countryman on a white horse rides away down the steep-banked lane. The little rounded willows on the bank of the stream look like birds spreading their tails. It's adorable! and one paints! and paints!

Camille Corot Letters, 1857

For most of his career Paul Cézanne worked in relative obscurity in his native city of Aix-en-Provence. Following the success of his one-man show at Paris in 1895, however, many younger artists sought Cézanne's counsel on their work, and the letters of his last years contain much sage advice for a new generation of painters. Two of Cézanne's frequent correspondents were his son Paul and the artist Émile Bernard.

Aix, 1905, Friday

My dear Bernard,

I am replying briefly to some of the paragraphs of your last letter. As you write, I think I really have made some slight progress in the last studies that you saw at my house. It is, however, very painful to have to register that the improvement produced in the comprehension of nature from the point of view of the form of the picture and the development of the means of expression should be accompanied by old age and a weakening of the body.

If the official Salons remain so inferior it is because they only employ more or less widely known methods of production. It would be better to bring more personal feeling, observation and character.

The Louvre is the book in which we learn to read. We must not, however, be satisfied with retaining the beautiful formulas of our illustrious predecessors. Let us go forth to study beautiful nature, let us try to free our minds from them, let us strive to express ourselves according to our personal temperaments. Time and reflection, moreover, modify little by little our vision, and at last comprehension comes to us.

It is impossible in this rainy weather to practise out of doors these theories which are yet so right. But perseverance leads us to understand interiors like everything else. It is only the old duffers who clog our intelligence, which needs spurring on.

Aix, 8th September, 1906

My dear Paul,

To-day (it is nearly eleven o'clock) a startling return of the heat. The air is overheated, not a breath of air. This temperature can be good for nothing but the expansion of metals, it must help the sale of drinks and bring joy to the beer merchants, an industry which seems to be assuming a fair size in Aix, and it expands the pretentions of the intellectuals in my country, a pack of ignorants, of cretins and fools.

The exceptions, there may be some, do not make themselves known. Modesty is always unaware of itself. Finally I must tell you that as a painter I am becoming more clear-sighted in front of nature, but that with me the realization of my sensations is always very difficult. I cannot attain the intensity that is unfolded before my senses. I have not the magnificent richness of colouring that animates nature. Here on the edge of the river, the motifs are very plentiful, the same subject seen from a different angle gives a subject for study of the highest interest and so varied that I think I could be occupied for months without

My dear Paul, in conclusion I must tell you that I have the greatest faith in your feelings, which dictate to your mind the necessary measures to guard our interests, that is to say that I have the greatest faith in your direction of our affairs.

It is with a most patriotic satisfaction that I learn of the impending visit with which the statesman who presides over the political destinies of France is about to honour our country; it will make our southern population of Aix tremble. Jo [Joachim Gasquet, a friend and neighbor], where will you be? Is it the artificial and conventional things that succeed best in this world and in our lives or do a series of lucky coincidences crown our efforts with success?

Paul Cézanne Letters, 1905–6

Paul Gauguin's decision to leave Europe for the wilds of Polynesia had a profound impact on his fellow artists in the late nineteenth century and continues to stir the imagination of the public today. In 1893, after his first stay in Tahiti, Gauguin recorded his experiences in a journal called Noa Noa, a Maori expression meaning perfume.

I was truly alone there. . . . After two days I had exhausted my provisions, I had imagined that with money I would find all that is necessary for nourishment. The food is there, certainly, on the trees, on the mountain-slopes, in the sea, but one has to be able to climb a high tree, to go up the mountain and come back laden with heavy burdens; to be able to catch fish [or] dive and tear from the sea-bottom the shells firmly attached to the rocks. So there I was, a civilised man, for the time being definitely inferior to the savage, and as, on an empty stomach, I was pondering sadly on my situation, a native made signs to me and shouted, in his language, "come and eat." I understood. But I was ashamed and, shaking my head, refused. A few minutes later a child silently laid at the side of my door some food cleanly done up in freshly picked leaves, then withdrew. I was hungry, so silently I accepted. A little later the man went by and with a kindly expression, without stopping, said to me a single word: "Paia." I understood vaguely. "Are you satisfied?"

On the ground under some clusters of broad pumpkin leaves I caught sight of a small dark head with quiet eyes.

A little child was examining me, then made off timorously when its eyes met mine. . . . These black people, these cannibal teeth, brought the word "savages" into my mouth.

For them, too, I was the savage. Rightly perhaps.

I began to work—notes, sketches of all kinds. Everything in the landscape blinded me, dazzled me. Coming from Europe I was constantly uncertain of some colour [and kept] beating about the bush:

and yet it was so simple to put naturally on to my canvas a red and a blue. In the brooks, forms of gold enchanted me—Why did I hesitate to pour that gold and all that rejoicing of the sunshine on to my canvas? Old habits from Europe, probably,—all this timidity of expression [characteristic] of our bastardised races—

To initiate myself properly into the character of a Tahitian face, into all the charm of a Maori smile, I had long wanted to make a portrait of a woman who lived close by, who was of true Tahitian descent.

I asked her permission one day when she had plucked up the courage to come into my hut and look at some photographs of paintings. While she was examining with a great deal of interest some religious pictures by the Italian primitives, I tried to sketch some of her features, especially that enigmatic smile of hers. She made a nasty grimace, went away-then she came back. Was it an inner struggle, or caprice (a very Maori trait), or even an impulse of coquetry that will surrender only after resistance? I realised that in my painter's scrutiny there was a sort of tacit demand for surrender, surrender for ever without any chance to withdraw, a perspicacious probing of what was within. [She was,] in fact, not pretty by European standards: Beautiful all the same -all her features had a raphaelesque harmony in their meeting curves, while her mouth, modelled by a sculptor, spoke all the tongues of speech and of the kiss, of joy and suffering; that melancholy of the bitterness that mingles with pleasure, of passivity dwelling within domination. An entire fear of the unknown.

I worked fast, with passion. It was a portrait resembling what my eyes *veiled by my heart* perceived. I believe it was chiefly faithful to what was within. That sturdy fire from a contained strength.

Paul Gauguin Noa Noa, 1893

For Claude Monet the hostility shown his first exhibited paintings by art patrons and critics echoed the skepticism and derision he often heard from his family and teachers. But, as Monet recalls in an interview published in 1900 by the Parisian newspaper Le Temps, even as a young man he possessed an unshakable belief in his own artistic vision.

I fell ill at the end of two years [of military service], and quite seriously. They sent me home to recuperate. Six months of convalescence was spent in drawing and painting with redoubled energy. Seeing me thus persisting, worn as I was by fever, my father became convinced that no will could curb me, that no ordeal would get the better of so determined a vocation, and as much from lassitude as from fear of losing me, for the Doctor had led him to expect this, should I return to Africa, he decided, towards the end of my furlough to buy me out.

"But it is well understood," he said to me, "that this time you are going to work in dead earnest. I wish to see you in an atelier, under the

discipline of a well-known master. If you resume your independence, I will stop your allowance without more ado. It is a bargain?" This arrangement did not more than half suit me, but I felt that it was necessary not to oppose my father when he for once entered my plans. I accepted. It was agreed that I should have at Paris and in the person of the painter Toulmouche . . . an artistic tutor, who would guide me and furnish regular reports of my labors.

I landed one fine morning at Toulmouche's with a stock of studies which he declared pleased him very much. "You have a future," he said, "but you must direct your efforts in some given channel. You will enter the studio of Gleyre. He is the staid and wise master that you need." And grumbling I placed my easel in the studio full of pupils, over which presided the celebrated artist. The first week I worked there most conscientiously, and made with as much application as spirit a study of a nude from the living model, that Gleyre corrected on Mondays. The following week, when he came to me, he sat down, and solidly planted on my chair, looked attentively at my production. Then -I can see him yet-he turned round, and leaning his grave head to one side with a satisfied air, said to me: "Not bad! not bad at all, that thing there, but it is too much in the character of the model-you have before you a short thickset man, you paint him short and thickset—he has enormous feet, you render them as they are. All that is very ugly. I want you to remember, young man, that when one executes a figure, one should always think of the antique. Nature, my friend, is all right as an element of study, but it offers no interest. Style, you see, style is everything."

I saw it all. Truth, life, nature, all that moved me, all that which constituted in my eyes the very essence, the only *raison d'être* of art, did not exist for this man. I no longer wished to remain under him....

I nevertheless waited several weeks. In order not to exasperate my family, I continued to appear regularly at the studio, remaining only just long enough to execute a rough sketch from the model, and to be present at inspection, then I skipped. Moreover I had found in the studio congenial companions, natures far from commonplace. They were Renoir and Sisley, whom I was never thereafter to lose sight of—and Bazille, who immediately became my chum, and who would have become noted had he lived. None of them manifested . . . the least enthusiasm for a mode of teaching that antagonized both their logic and their temperament. The exodus being decided on, we left, Bazille and I taking a studio in common.

Later in the interview Monet described the spirit of camaraderie that sustained him and his fellow Impressionists in the days before their public acclaim.

It was in 1869 only that I saw him [Manet] again, but then we at once became fast friends. At our first meeting he invited me to join him

every evening in a cafe of the Batignolles, where he and his friends gathered after working hours, to talk. There I met Fantin-Latour and Cézanne, Degas, who soon after arrived from Italy, the art critic Duranty, Emile Zola, who was then making his début in literature, and several others. For my part I took there Sisley, Bazille and Renoir. Nothing could be more interesting than these causeries with their perpetual clash of opinion. They kept our wits sharpened, they encouraged us in sincere and disinterested research, they provided us with stores of enthusiasm that for weeks and weeks kept us up, until the final shaping of the idea was accomplished. From them we emerged tempered more highly, with a firmer will, with our thoughts clearer and more distinct.

Mr. Durand-Ruel for us was a savior. During fifteen years and more, my paintings and those of Renoir, Sisley and Pissarro had no other outlet but through him. The day came when he was compelled to restrict his orders, make his purchases less frequent. We thought ruin stared us in the face: but it was the advent of success. Offered to Petit, to the Boussods, our works found buyers in them. The public began to find them less bad. At Durand-Ruel's the collectors would have none of them. Seeing them in the hands of other dealers they grew more confident. They began to buy. The momentum was given. To-day nearly everyone appreciates us in some degree.

CLAUDE MONET Interview, 1900

So you must not think that I disavow things—I am rather faithful in my unfaithfulness and, though changed, I am the same; my only anxiety is, How can I be of use in the world? Can't I serve some purpose and be of any good? How can I learn more and study certain subjects profoundly? You see, that is what preoccupies me constantly; and then I feel imprisoned by poverty, excluded from participating in certain work, and certain necessities are beyond my reach. That is one reason for being somewhat melancholy. And then one feels an emptiness where there might be friendship and strong and serious affections, and one feels a terrible discouragement gnawing at one's very moral energy, and fate seems to put a barrier to the instincts of affection, and a choking flood of disgust envelops one. And one exclaims, "How long, my God!"

Well, what shall I say? Do our inner thoughts ever show out-

wardly? There may be a great fire in our soul, yet no one ever comes to warm himself at it, and the passers-by see only a wisp of smoke coming through the chimney, and go along their way. Look here, now, what must be done? Must one tend that inner fire, have salt in oneself, wait patiently yet with how much impatience for the hour when somebody will come and sit down near it—maybe to stay? Let him who believes in God wait for the hour that will come sooner or later.

For the moment it seems that things are going very badly with me, and it has already been so for a considerable time and may continue awhile in the future; but after everything has seemed to go wrong, perhaps a time will come when things will go right. I don't count on it, perhaps it will never happen; but if there is a change for the better, I should consider it so much gain, I should be contented, I should say, At last! you see there was something after all!...

I write something at random whatever comes to my pen. I should be very glad if you could see in me something more than an idle fellow. Because there are two kinds of idleness, which are a great contrast to each other. There is the man who is idle from laziness and from lack of character, from the baseness of his nature. If you like, you may take me for such a one.

On the other hand, there is the idle man who is idle in spite of himself, who is inwardly consumed by a great longing for action but does nothing, because it is impossible for him to do anything, because he seems to be imprisoned in some cage, because he does not possess what he needs to become productive, because circumstances bring him inevitably to that point. Such a man does not always know what he could do, but he instinctively feels, I am good for something, my life has a purpose after all, I know that I could be quite a different man! How can I be useful, of what service can I be? There is something inside of me, what can it be? This is quite a different kind of idle man; if you like, you may take me for such a one!

VINCENT VAN GOGH Letter to his brother Théo, July, 1880

The career of Henri Matisse spanned six decades from his student days in Paris in 1891 until his death in 1954. Although his curiosity about and desire to experiment with new mediums and techniques never flagged, the foundation of Matisse's work can be found in the ideas expressed in "Notes of a Painter," which he published in 1908.

It is expression I am after, more than anything. It has sometimes been admitted that I have a certain knowledge, while my ambition is said to be limited and goes no further than purely visual satisfaction produced by the sight of a picture. But the painter's idea should not be considered apart from his means, because it is only of value in so far as it is served by those means, which should be complete (and by complete I

do not mean complicated) according to the depth of his idea. I cannot distinguish between my feeling for life and the way I interpret it.

"Expression" does not to me reside in the passion which will light up a face or will be translated into violent gesture. It is in the whole arrangement of my picture: the place taken up by the bodies, the spaces round them, the proportions, all play their part. Composition is the art of arranging, in a decorative way, the various elements the painter has at his disposal to express his sentiments. Each element in a picture should be visible, and play its allotted part, of first or secondary importance. Whatever is useless in a picture is for that reason harmful. A work demands harmony of the whole; any unnecessary detail, in the eye of the spectator, will usurp the place of another, essential one.

Composition, which should aim at expression, is modified according to the surface to be covered. If I take a sheet of paper of given dimensions, I shall make a drawing necessarily related to its proportions. I should not repeat the same drawing on a sheet of paper differently proportioned, which was rectangular, for instance, instead of being square. And I should not be content to enlarge it if I had to reproduce it on a similar sheet, but ten times bigger. The drawing should have an expanding force which gives life to its surroundings. The artist who wants to transfer a composition from a small canvas to a large one should, to keep the expression of it, conceive it afresh, modify its appearance, not simply square it up. . . .

One can obtain most delightful effects with colours by stressing their relationship or their contrast. Often I start on a picture by noting fresh and superficial sensations. A few years ago, the result often satisfied me. If I left it at that today, now that I think I can see further, it would remain a vague picture. I should have recorded the fugitive sensations of the moment which did not entirely define what I felt, and which I should scarcely recognize the next day. I wish to reach that state of condensation of impressions which makes a picture. Were I to be content with a spontaneous painting of a picture, I should be bored with it later, and I would rather continue working on it so as to recognize something in it afterwards which represents my mind. At one time I never hung my pictures on the wall, because they reminded me of a state of over-excitement, and I didn't care to see them again when I was calm. Today I try to put calmness into them, and I work on them until I succeed.

I have to paint the body of a woman; first I give it grace, charm, and then I must give something more. I must condense the meaning of the body in finding its essential lines. The charm will be less evident at first glance, but it should be finally manifest in the new image I have obtained, which has greater, and more fully human meaning. The charm will be less obvious, not being the only characteristic, but it will be there none the less, in the general conception of my figure. . . .

Each relationship of tone, I have found, should produce a chord of living colours; a harmony like that of a musical composition.

To my mind composition is everything. So it is essential to have a clear vision of the whole from the outset. Look at a picture by Cézanne; everything is so well combined that, from no matter what distance, and however many the figures, you can distinguish them clearly, and understand to which among them every limb belongs. If there is great order and light in a picture, it is because that order and light existed from the beginning in the painter's mind, or that the painter realized their necessity. Limbs may be intertwined, mingled, but each one will remain, for the spectator, attached to the one body and expressing the idea of that body: all confusion has gone. . . .

What interests me most, is neither still life nor landscape, it is the figure. It is by the figure I can best express the almost religious feeling I have for life. I do not attempt to portray all the details of a face, to render them one by one in exact anatomy. If I have an Italian model who suggests to me at first sight a purely animal existence, I discover in him, none the less, essential features, I go into the lines of his face, and discover those which express the character of profound gravity persistent in all human beings. A work should carry its whole meaning in itself and impress it on the spectator even before he has understood the subject. When I see Giotto's frescoes in Padua, I do not trouble to find out which scene in the life of Christ is before me, but I understand at once the feeling of it, for it is in the lines, the composition, the colour, and the title would only confirm my impression. . . .

People like to distinguish between painters who work directly from nature, and those who work purely from imagination. I do not think, myself, one should praise one of the two methods of work to the exclusion of the other. It happens that both are used in turn by the same person, either because he needs actual objects from which to receive impressions and thereby stimulate his creative faculty, or because his impressions are already classified, and in either case he can arrive at a whole which makes a picture. . . . However, I believe one can judge of an artist's vitality and power when, once directly impressed by the spectacle of nature, he is capable of organizing his sensations and even returning to them, on several occasions and different days, continuing them in the same state of mind. Such a power implies a man sufficiently master of himself to obey his own discipline.

The simplest means are those which best allow an artist self-expression. If he is afraid of being commonplace, he will not avoid it by a strange exterior expression, in seeking bizarre drawing and eccentric colour. His means should derive almost essentially from his temperament. He should have the simplicity of mind which leads him to suppose he has only painted what he has seen.

I like what Chardin said, "I put on colour until it looks like the thing." And Cézanne, "I want to paint an image." And also Rodin, "Copy nature." Leonardo said "He who can copy can create." Those who use a deliberate style and depart from nature on purpose, are beside the truth. An artist should realize, when he reasons, that his

picture is artificial, but while painting he should have the impression that he is copying nature. And even when he gets away from it, he should still feel convinced that he does so in order to render it more completely.

HENRI MATISSE
"Notes of a Painter," 1908

As a result of his work with Picasso in developing Cubism, Georges Braque earned recognition as one of the most innovative spirits in modern painting. In reflecting on his own development, however, the artist takes a considerably more restrained and modest view of his goals and accomplishments.

I had no more thought of becoming a painter than of breathing. . . . It pleased me to paint and I worked hard . . . as for me I never had a goal in mind. "A goal is a servitude," wrote Nietzsche, I believe, and it is true. It is very bad when one notices that one is a painter . . . if I had had any intention it was to accomplish myself day by day. In accomplishing myself I found that what I did resembled a painting. Making my way I continued. So. . . . But as one never lives outside of circumstances, when, in 1907, the ten canvases that I exhibited at the Salon des Indépendents were sold, I said to myself that I could do nothing else.

My habit of keeping a notebook of designs began in 1918. Before I drew on scraps of paper which I lost. Then I said to myself that it was necessary to keep a notebook. Since I always have a notebook within reach, and I draw no matter what, I preserve everything that passes through my head. And I was aware that all that served me well. There are times when one has the desire to paint, but knows not what to paint. I don't know what is the cause of this but there are moments when one feels empty. There is a great appetite to work, and then my sketchbook serves me as a cookbook when I am hungry. I open it and the least of the sketches can offer me material for work.

I make the background of my canvases with the greatest care because it is the ground that supports the rest; it is like the foundations of a house. I am always very occupied and preoccupied with the material because there is as much sensibility in the technique as in the rest of the painting. I prepare my own colors, I do the pulverizing. . . . I work with the material, not the ideas.

In my painting I always return to the center. I am the contrary, therefore, to one I should call a "symphoniste." In a symphony the theme approaches the infinite; there are painters (Bonnard is an example) who develop their themes to the infinite. There is in their canvases something like diffuse light, while with me, on the contrary, I attempt to reach the core of intensity; I concentrate.

Georges Braque Remarks, 1954

Long life, great talent, and enormous productivity combined to make Pablo Picasso one of the most famous personalities of the twentieth century. One of his early friends and patrons was the American expatriate writer and art collector Gertrude Stein, who recorded some of the highlights of her association with Picasso in The Autobiography of Alice B. Toklas.

We went up the couple of steps and through the open door passing on our left the studio in which later Juan Gris was to live out his martyrdom but where then lived a certain Vaillant, a nondescript painter who was to lend his studio as a ladies dressing room at the famous banquet for Rousseau, and then we passed a steep flight of steps leading down where Max Jacob had a studio a little later, and we passed another steep little stairway which led to the studio where not long before a young fellow had committed suicide, Picasso painted one of the most wonderful of his early pictures of the friends gathered round the coffin, we passed all this to a larger door where Gertrude Stein knocked and Picasso opened the door and we went in.

He was dressed in what the french call the singe or monkey costume, overall made of blue jean or brown, I think his was blue and it is called a singe or monkey because being all of one piece with a belt, if the belt is not fastened, and it very often is not, it hangs down behind and so makes a monkey. His eyes were more wonderful than even I remembered, so full and so brown, and his hands so dark and delicate and alert. We went further in. There was a couch in one corner, a very small stove that did for cooking and heating in the other corner, some chairs, the large broken one Gertrude Stein sat in when she was painted and a general smell of dog and paint and there was a big dog there and Picasso moved her about from one place to another exactly as if the dog had been a large piece of furniture. He asked us to sit down but as all the chairs were full we all stood up and stood until we left. It was my first experience of standing but afterwards I found that they all stood that way for hours. Against the wall was an enormous picture, a strange picture of light and dark colours, that is all I can say, of a group, an enormous group and next to it another in a sort of a red brown, of three women, square and posturing, all of it rather frightening. Picasso and Gertrude Stein stood together talking, I stood back and looked. I cannot say I realized anything but I felt that there was something painful and beautiful there and oppressive but imprisoned. I heard Gertrude Stein say, and mine. Picasso thereupon brought out a smaller picture, a rather unfinished thing that [he] could not finish . . . pale almost white, two figures, they were all there but . . . unfinished and not finishable. Picasso said, but he will never accept it. Yes, I know, answered Gertrude Stein. But just the same it is the only one in which it is all there. Yes, I know, he replied and they fell silent. After that they continued a low toned conversation and then Miss Stein said, well we have to go, we are going to have tea with Fernande. Yes, I know, replied

Picasso. How often do you see her, she said, he got very red and looked sheepish. I have never been there, he said resentfully. She chuckled, well anyway we are going there, she said, and Miss Toklas is going to have lessons in french. Ah the Miss Toklas, he said, with small feet like a spanish woman and earrings like a gypsy and a father who is king of Poland like the Poniatowskis, of course she will take lessons. We all laughed and went to the door. There stood a very beautiful man, oh Agero, said Picasso, you know the ladies. He looks like a Greco, I said in english. Picasso caught the name, a false Greco, he said. Oh I forgot to give you these, said Gertrude Stein handing Picasso a package of newspapers, they will console you. He opened them up, they were the Sunday supplement of american papers, they were the Katzenjammer kids. Oh oui, Oh oui, he said, his face full of satisfaction, merci thanks Gertrude, and we left.

We left then and continued to climb higher up the hill. What did you think of what you saw, asked Miss Stein. Well I did see something. Sure you did, she said, but did you see what it had to do with those two pictures you sat in front of so long at the vernissage. Only that Picassos were rather awful and the others were not. Sure, she said, as Pablo once remarked, when you make a thing, it is so complicated making it that it is bound to be ugly, but those that do it after you they don't have to worry about making it and they can make it pretty, and so everybody can like it when the others make it....

It was only a very short time after this that Picasso began the portrait of Gertrude Stein, now so widely known, but just how that came about is a little vague in everybody's mind. I have heard Picasso and Gertrude Stein talk about it often and they neither of them can remember. They can remember the first time that Picasso dined at the rue de Fleurus and they can remember the first time Gertrude Stein posed for her portrait at rue Ravignan but in between there is a blank. How it came about they do not know. Picasso had never had anybody pose for him since he was sixteen years old, he was then twenty-four and Gertrude Stein had never thought of having her portrait painted, and they do not either of them know how it came about. Anyway it did and she posed to him for this portrait ninety times and a great deal happened during that time. To go back to all the first times.

Picasso and Fernande came to dinner, Picasso in those days was, what a dear friend and schoolmate of mine, Nellie Jacot, called, a good-looking bootblack. He was thin dark, alive with big pools of eyes and a violent but not a rough way. He was sitting next to Gertrude Stein at dinner and she took up a piece of bread. This, said Picasso, snatching it back with violence, this piece of bread is mine. She laughed and he looked sheepish. That was the beginning of their intimacy.

That evening Gertrude Stein's brother took out portfolio after portfolio of japanese prints to show Picasso, Gertrude Stein's brother was fond of japanese prints. Picasso solemnly and obediently looked at print after print and listened to the descriptions. He said under his

breath to Gertrude Stein, he is very nice, your brother, but like all americans, like Haviland, he shows you japanese prints. Moi j'aime pas ça, no I don't care for it. As I say Gertrude Stein and Pablo Picasso immediately understood each other.

Then there was the first time of posing. The atelier of Picasso I have already described. In those days there was even more disorder, more coming and going, more red-hot fire in the stove, more cooking and more interruptions. There was a large broken armchair where Gertrude Stein posed. There was a couch where everybody sat and slept. There was a little kitchen chair upon which Picasso sat to paint, there was a large easel and there were many very large canvases. It was at the height of the end of the Harlequin period when the canvases were enormous, the figures also, and the groups.

There was a little fox terrior there that had something the matter with it and had been and was again about to be taken to the veterinary. No frenchman or frenchwoman is so poor or so careless or so avaricious but that they can and do constantly take their pet to the vet.

Fernande was as always, very large, very beautiful and very gracious. She offered to read La Fontaine's stories aloud to amuse Gertrude Stein while Gertrude Stein posed. She took her pose, Picasso sat very tight on his chair and very close to his canvas and, on a very small palette which was of a uniform brown grey colour, mixed some more brown grey and the painting began. This was the first of some eighty or ninety sittings.

Toward the end of the afternoon Gertrude Stein's two brothers and her sister-in-law and Andrew Green came to see. They were all excited at the beauty of the sketch and Andrew Green begged and begged that it should be left as it was. But Picasso shook his head and said, non.

It is too bad but in those days no one thought of taking a photograph of the picture as it was then and of course no one of the group that saw it then remembers at all what it looked like any more than do Picasso or Gertrude Stein.

GERTRUDE STEIN
The Autobiography of Alice B. Toklas, 1933

An heir to the rich tradition of British landscape artists, Paul Nash brought an acutely sensitive eye to descriptions of the French country-side contained in a series of letters to his wife during his military service in World War I. Both the soldier and painter in Nash reacted with increasing horror as the implements of war destroyed the precious work of nature.

March 7th, 1917

They stopped post a day before we left, and it was impossible to write again till we got back to our old haunts. We are all sad to leave the quiet of that untroubled country, where such pleasant days have been

spent. We could not have hit upon a better time for we saw all the change of trees and fields and hills from bleakness to fresh green and warm lovely lights. I must return to these landscapes above the hills. Just before I left I came upon a bank where real French violets grew, you know those dark ones that have such an intoxicating smell. Alas I was with the Company at the time, and though I meant to hunt out the bank after and send some flowers to you I never had time. Flowers bloom everywhere and we have just come up to the trenches for a time and where I sit now in the reserve line the place is just joyous, the dandelions are bright gold over the parapet and nearby a lilac bush is breaking into bloom; in a wood passed through on our way up, a place with an evil name, pitted and pocked with shells and trees torn to shreds, often reeking with poison gas-a most desolate ruinous place two months back, to-day it was a vivid green; the most broken trees even had sprouted somewhere and in the midst, from the depth of the wood's bruised heart poured out the throbbing song of a nightingale. Ridiculous mad incongruity! One can't think which is the more absurd, the War or Nature; the former has become a habit so confirmed, inevitable, it has its grip on the world just as surely as spring or summer. Thus we poor beings are double enthralled. At the mercy of the old elements which we take pains to study, avoid, build and dress for we are now in the power of something far more pitiless, cruel and malignant, and so we must study further, build ten times as strong, dress cunningly and creep about like rats always overshadowed by this new terror. Of course we shall get used to it just as we are almost accustomed to the damnable climate of England. Already man has assumed an indifference quite extraordinary to shells, fire, mines and other horrors. It's just as well because it is going to be our daily bread for months and months to come.

I am rather pleased with myself just to-day because yesterday I sent off six unfinished sketches to you which after much labour I have managed to work up to a pitch of presentability. The C.O. has seen them and enclosed a note saying they are of no military importance and, as they are marked "drawings" on the outside and registered and stamped by the field censor, I shouldn't wonder if they arrived unmolested. . . .

. . . In a month or less I shall have another batch for you. Here in the back garden of the trenches it is amazingly beautiful—the mud is dried to a pinky colour and upon the parapet, and through sandbags even, the green grass pushes up and waves in the breeze, while clots of bright dandelions, clover, thistles and twenty other plants flourish luxuriantly, brilliant growths of bright green against the pink earth. Nearly all the better trees have come out, and the birds sing all day in spite of shells and shrapnel. I have made three more drawings all of these wonderful ruinous forms which excite me so much here. We are just by a tumbledown village, only heaps of bricks, toast-rackety roofs and halves of houses here and there among the bright trees and what remains of the orchards. This dug-out I am writing in must stand in

what was once a snug cottage garden in hillocky ground sloping down to the stream, the apple trees fat with bloom straggle about outside the door, one has been knocked by a shell but continues flowering on its head. A green garden gate, swung off its fence, leans up against the sandbags. I think it is the only significant landmark left. Our table inside is gay with a bunch of flowers-lilac, globe flowers, white narcissi found blooming near my trench, which is adjacent to the old village cottage gardens half a mile away. This place is the Mess, where I spend most of the time, though my actual responsibilities lie in "M" trench which is held by my platoon. I feel very happy these days, in fact, I believe I am happier in the trenches than anywhere out here. It sounds absurd, but life has a greater meaning here and a new zest, and beauty is more poignant. I never feel dull or careless, always alive to the significance of nature who, under these conditions, is full of surprises for me. I can't quite explain my state of mind, not having troubled to analyse my emotions about it. Last night there was a heavy shelling, in fact the line is not the place it was; the Boche is very restive and jumpy, and I am not surprised. The clouds roll up in these parts and their shadows already fall over us. I have no fear. I know there are numerous things I want to say to you, but my mind is wandering today-it's raining and the earth and trees and all green things exude a moist perfume and make the soul dream wearily. . . . In the New Statesman you sent me, there is a short notice upon Edward Thomas saying the best thing he did was the verse written while he was in the Artists. He wrote under the name of Edward Eastaway. If you can procure any of his poems, I should so much like to read them. Some of my surplus kit has been sent home and soon I am going to post back all my books and get you to send me a few ones which I will mention later. I read very little now, as a matter of fact between my drawing and writing letters my spare hours are pretty well full.

I have just returned, last night, from a visit to Brigade Headquarters up the line, and I shall not forget it as long as I live. I have seen the most frightful nightmare of a country more conceived by Dante or Poe than by nature, unspeakable, utterly indescribable. In the fifteen drawings I have made I may give you some vague idea of its horror, but only being in it and of it can ever make you sensible of its dreadful nature and of what our men in France have to face. We all have a vague notion of the terrors of a battle, and can conjure up with the aid of some of the more inspired war correspondents and the pictures in the Daily Mirror some vision of a battlefield; but no pen or drawing can convey this country—the normal setting of the battles taking place day and night, month after month. Evil and the incarnate fiend alone can be master of this war, and no glimmer of God's hand is seen anywhere. Sunset and sunrise are blasphemous, they are mockeries to man, only the black rain out of bruised and swollen clouds all through the bitter

black of night is fit atmosphere in such a land. The rain drives on, the stinking mud becomes more evilly yellow, the shell holes fill up with green-white water, the roads and tracks are covered in inches of slime, the black dying trees ooze and sweat and the shells never cease. They alone plunge overhead, tearing away the rotting tree stumps, breaking the plank roads, striking down horses and mules, annihilating, maiming, maddening, they plunge into the grave which is this land; one huge grave, and cast up on it the poor dead. It is unspeakable, godless, hopeless. I am no longer an artist interested and curious, I am a messenger who will bring back word from the men who are fighting to those who want the war to go on for ever. Feeble, inarticulate, will be my message, but it will have a bitter truth, and may it burn their lousy souls.

PAUL NASH Letters to his wife, 1917

The two most vital elements in modern painting are form and color. Freed from the necessity to portray reality, artists have investigated the possibility of creating an inner reality through the manipulation of these elements. Wassily Kandinsky established much of the groundwork for this experimentation in the essay "Concerning the Spiritual in Art," published in 1910. One of his principal interests was the effect of color upon the message a painting relates.

If you let your eye stray over a palette of colors, you experience two things. In the first place you receive a purely physical effect, namely the eye itself is enchanted by the beauty and other qualities of color. You experience satisfaction and delight, like a gourmet savoring a delicacy. Or the eye is stimulated as the tongue is titillated by a spicy dish. But then it grows calm and cool, like a finger after touching ice. These are physical sensations, limited in duration. They are superficial, too, and leave no lasting impression behind if the soul remains closed. Just as we feel at the touch of ice a sensation of cold, forgotten as soon as the finger becomes warm again, so the physical action of color is forgotten as soon as the eye turns away. On the other hand, as the physical coldness of ice, upon penetrating more deeply, arouses more complex feelings, and indeed a whole chain of psychological experiences, so may also the superficial impression of color develop into an experience.

On the average man, only impressions caused by familiar objects will be superficial. A first encounter with any new phenomenon exercises immediately an impression on the soul. This is the experience of the child discovering the world; every object is new to him. He sees a light, wishes to hold it, burns his finger and feels henceforth a proper respect for flame. But later he learns that light has a friendly side as well, that it drives away the darkness, makes the day longer, is essential to warmth and cooking, and affords a cheerful spectacle. From the accumulation of these experiences comes a knowledge of light, indeli-

Only with higher development does the circle of experience of different beings and objects grow wider. Only in the highest development do they acquire an internal meaning and an inner resonance. It is the same with color, which makes a momentary and superficial impression on a soul whose sensibility is slightly developed. But even this simplest effect varies in quality. The eye is strongly attracted by light, clear colors, and still more strongly by colors that are warm as well as clear: vermilion stimulates like flame, which has always fascinated human beings. Keen lemon-yellow hurts the eye as does a prolonged and shrill bugle note the ear, and one turns away for relief to blue or green.

But to a more sensitive soul the effect of colors is deeper and intensely moving. And so we come to the second result of looking at colors: *their psychological effect*. They produce a correspondent spiritual vibration, and it is only as a step toward this spiritual vibration that the physical impression is of importance.

Whether the psychological effect of color is direct, as these last few lines imply, or whether it is the outcome of association, is open to question. The soul being one with the body, it may well be possible that a psychological tremor generates a corresponding one through association. For example, red may cause a sensation analogous to that caused by flame, because red is the color of flame. A warm red will prove exciting, another shade of red will cause pain or disgust through association with running blood. In these cases color awakens a corresponding physical sensation, which . . . works poignantly upon the soul.

If this were always the case, it would be easy to define by association the physical effects of color, not only upon the eye but the other senses. One might say that bright yellow looks sour, because it recalls the taste of a lemon.

But such definitions are not universal. There are several correlations between taste and color which refuse to be classified. A Dresden doctor reported that one of his patients, whom he designated as an "exceptionally sensitive person," could not eat a certain sauce without tasting "blue," i.e., without "seeing blue." It would be possible to suggest, by way of explanation, that in highly sensitive people the approach to the soul is so direct, the soul itself so impressionable, that any impression of taste communicates itself immediately to the soul, and thence to the other organs of sense (in this case, the eyes). This would imply an echo or reverberation, such as occurs sometimes in musical instruments which, without being touched, sound in harmony with an instrument that is being played. Men of sensitivity are like good, much-played violins which vibrate at each touch of the bow.

But sight has been known to harmonize not only with the sense of taste but with the other senses. Many colors have been described as rough or prickly, others as smooth and velvety, so that one feels inclined to stroke them (e.g., dark ultramarine, chromoxide green, and madder-lake). Even the distinction between warm and cool colors is based upon this discrimination. Some colors appear soft (madder-lake), others hard (cobalt green, blue-green oxide), so that fresh from the tube they seem to be "dry."

The expression "perfumed colors" is frequently met with.

The sound of colors is so definite that it would be hard to find anyone who would express bright yellow with bass notes, or dark lake with the treble. The explanation in terms of association will not satisfy us, in many important cases. Those who have heard of chromotherapy know that colored light can influence the whole body. Attempts have been made with different colors to treat various nervous ailments. Red light stimulates and excites the heart, while blue light can cause temporary paralysis. If the effect of such action can be observed in animals and plants, as it has, then the association theory proves inadequate. In any event one must admit that the subject is at present unexplored, but that it is unquestionable that color can exercise enormous influence upon the body as a physical organism.

The theory of association is no more satisfactory in the psychological sphere. Generally speaking, color directly influences the soul. Color is the keyboard, the eyes are the hammers, the soul is the piano with many strings. The artist is the hand that plays, touching one key or another purposively, to cause vibrations in the soul.

It is evident therefore that color harmony must rest ultimately on purposive playing upon the human soul; this is one of the guiding principles of internal necessity.

Wassily Kandinsky
"Concerning the Spiritual in Art," 1910

Apart from his important essays about the theory of abstract painting Wassily Kandinsky made an enormous contribution to the literature of modern art through his autobiographical writings. The legendary story of his accidental discovery of the concept of nonobjective painting provides an unusual look into the mind of one of the giant figures of twentieth-century art.

It was the hour of approaching dusk. I returned home with my paint box after making a study, still dreaming and wrapped into the work completed, when suddenly I saw an indescribably beautiful picture, imbibed by an inner glow. First I hesitated, then I quickly approached this mysterious picture, on which I saw nothing but shapes and colors, and the contents of which I could not understand. I immediately found the key to the puzzle: it was a picture painted by me, leaning against

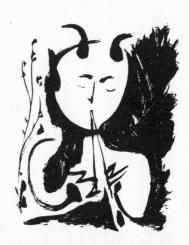

the wall, standing on its side. The next day, when there was daylight, I tried to get yesterday's impression of the painting. However, I only succeeded half-ways: on its side too, I constantly recognized the objects and the fine finish of dusk was lacking. I now knew fully well, that the object harms my paintings.

A frightening abyss, a responsible load of all kinds of questions confronted me. And the most important: What should replace the missing object? The danger of ornamentation stood clearly before me, the dead make-believe existence of schematical forms could only repulse me.

Only after many years of patient working, strenuous thinking, numerous careful attempts, constantly developing ability to purely and non-objectively feel artistic forms, to concentrate deeper and deeper into this endless depth, I arrived at the artistic forms, with which I am now working, at which I am now working and which, I hope, will develop much further.

It took very long before the question "What should replace the object?" received a proper reply from within me. Often I look back into my past and am desolate to think how much time I have lost in answering this question. I have only one consolation: I could never get myself to use a form which was created within me through the application of logic-not purely feeling. I could not think up forms and I am repulsed when I see such forms. All forms that I ever used came "of their own accord," they appeared in finished form before my eyes, and it was only up to me to copy them, or they already shaped themselves, while I was working, often surprising me. As the years went by, I have learned to somewhat control this ability of shaping. I have trained myself not to just let myself go, but to check and guide the force working within me. As the years went by I learned to understand that working with a quickly beating heart, with pressure on the chest (and thus later aching ribs) and tension of the entire body, cannot suffice. It can, however, only exhaust the artist, not his task. The horse carries the rider with strength and speed. But the rider leads the horse. Talent brings the artist to greater heights with power and speed.

The artist, however, guides his talent. That is the element of the "conscious," the "calculating" in his work, or what else you wish to call it. The artist must know his talent through and through and, like a smart businessman, not let the smallest part rest unused and forgotten. He must rather utilize, develop every single piece up to the maximum possibility existing for him. This training, development of talent, requires great ability to concentrate, which on the other hand tends to diminish other abilities. I observed this clearly on myself. I never had a so-called good memory: I was particularly always unable to memorize numbers, names and even poems. The tables of multiplication always offered me unsurmountable difficulties, which I have not overcome to this date and which got my teachers desperate. From the very start I had to utilize the optical memory. Then it went better. In the state examination in statistics I quoted an entire page of figures only because

in the excitement I saw this page in front of me. Thus, already as a boy, I was able to, at home, paint by heart paintings, which had particularly fascinated me in exhibits. . . . Later I often painted a landscape better "by heart" than from nature. . . .

As a thirteen or fourteen year old boy I bought a paint box with oil colors with money I had slowly saved up. The feeling I had at that time-or better: the experience of the color coming out of the tube, is with me to this day. One pressure of the fingers and cheering, solemn, meditating, dreaming, wrapped up in themselves, with deep seriousness, with bubbling roguishness, with a sigh of relief, with the deep sound of sorrow, with obstinate-power and resistance, with resilient softness and devotion, with tenacious self-control, with pathetic unstableness of balance, one after the other of these unique beings that we call colors, appeared-each alive within itself, independent, equipped with all kinds of qualities for further independent life. And willing at any moment, to submit to new combinations, to mix among themselves and create endless rows of new worlds. Some [lay] there as already exhausted, weakened, hardened, dead forces, living reminders of past possibilities, not decreed by fate. As in strife, as in battle fresh forces appear from the tube, replacing the old ones. In the center of the palette there is a unique world of remnants of colors already used, wandering far from this source to build the necessary creations on canvas. Here is a world which arose from the will, to create the pictures already painted and by coincidence, the obscure game with forces unknown to the artist. And I owe much to these coincidences: they have taught me more than any teacher or master. I studied them often with love and admiration. The palette (consisting of the elements mentioned and which in itself is a "creation," often more beautiful than any masterpiece) be praised for the pleasures which it grants. Often it appeared to me that the brush, which with unbending will power tore pieces from this living color creation, brought forth musical notes as it tore away the pieces. Sometimes I heard a hissing of the mixing colors. It was like an adventure that you could hear, in the secret kitchen of the mysterious alchemist.

Later I heard that a very famous artist had said (I do not remember who it was), "In painting one look at the canvas, half a look at the palette and ten at the model." It sounded very nice, but I soon found that in my case it would have to be the other way around: Ten looks at the canvas, one at the palette, half a look at nature. Thus I learned to fight with the canvas, to learn to know it as a creature resisting my wish (dream) and to forcefully submit it to my wish. First it stands there like a pure, chaste virgin with clear eye and with heavenly joy—this pure canvas which itself is as beautiful as a painting. And then comes the wishful brush conquering it here and there and finally with all its energy, like a European colonist penetrating the wild virgin nature which no one to date has touched, using the axe, spade, hammer and saw to shape her according to wishes. I gradually learned not to see the obstinate, white tone of the canvas, to notice it only as a matter of sec-

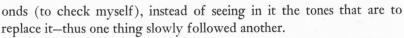

Painting is a thundering collision of different worlds intended to create the new world within and out of their strifes. This new world is the painting. Technically every masterpiece is created as the cosmos was—through catastrophies which in the end create a symphony, a symphony of spheres from the chaotic noise of the instruments. The creation of masterpieces is the creation of worlds.

Wassily Kandinsky Retrospects, 1913

The Swiss painter Paul Klee stands alongside Kandinsky, Matisse, and Picasso as a major contributor to the development of modern painting. A highly original thinker, Klee summarized his thoughts on the purpose of art in a publication entitled Creative Credo.

Art is a parable of Creation; it is an example, as the terrestrial is an example of the cosmos. But all these matters we have been speaking of are not yet art. The release of the elements, the grouping of them in subdivisions composed of parts, the articulation of the whole by building up several aspects simultaneously, pictorial polyphony, the achievement of equilibrium between the various movements, all higher and still higher questions of form, are vital factors in artistic communication; but they do not in themselves produce art of the highest level. For at that level, mystery begins and the intellect counts for nothing. At the highest level, imagination is guided by instinctual stimuli, and illusions are created which buoy us up and stir us more than do the familiar things of earth. In that realm are born the symbols which comfort the mind, which perceives that it need not be chained to the potentialities of terrestrial things. Up there, ethical seriousness reigns, and along with it impish laughter at the learned apparatus of scholars and parsons.

Neither higher potentiality nor reality can be of any avail to us. Away with everyday things and away with the occult sciences—they are barking up the wrong tree. Art goes beyond both the real and the imaginary object. Art plays an unknowing game with things. Just as a child at play imitates us, so we at play imitate the forces which created and are creating the world.

Art should be at home everywhere, like a fairy tale; and it should know how to deal in good and evil, like the Almighty. To man art should be like a vacation in the country, an opportunity for him to change his point of view and see himself transplanted into a world of diversions which offers only pleasant things, and from which he returns, strengthened, to the routine of daily life. Still more, it should help him put off his shell, to imagine himself God for a few moments, and, remembering the possibility of repeating such a transformation, to look forward to evening after work when the soul sits down at table to

nourish its famished nerves and replenish its weary organs with fresh juices. All art should lead to this, both the broad rivers and charming, aphoristic, many-branched rivulet of graphic art.

PAUL KLEE Creative Credo, 1920

Through the geometrically nonobjective style of painting he helped develop, the Dutch painter Piet Mondrian hoped to provide a new means of experiencing the world. In his view, the function of art is no less than the discovery of "a clear vision of reality." As can be seen from an essay written two years before his death in 1944, the evolution of Mondrian's manner of painting involved a constant attempt to reach a purer means of expressing that reality.

I began to paint at an early age. My first teachers were my father, an amateur, and my uncle, a professional painter. I preferred to paint land-scape and houses seen in grey, dark weather or in very strong sunlight, when the density of atmosphere obscures the details and accentuates the large outlines of objects. I often sketched by moonlight—cows resting or standing immovable on flat Dutch meadows, or houses with dead, blank windows. I never painted these things romantically; but from the very beginning, I was always a realist.

Even at this time, I disliked particular movement, such as people in action. I enjoyed painting flowers, not bouquets, but a single flower at a time, in order that I might better express its plastic structure. My environment conditioned me to paint the objects of ordinary vision; even at times to make portraits with likeness. For this reason, much of this early work has no permanent value. At the time, I was earning my living by teaching and commercial drawing.

After several years, my work unconsciously began to deviate more and more from the natural aspects of reality. Experience was my only teacher; I knew little of the modern art movement. When I first saw the work of the Impressionists, van Gogh, van Dongen, and the Fauves, I admired it. But I had to seek the true way alone.

The first thing to change in my painting was the color. I forsook natural color for pure color. I had come to feel that the colors of nature cannot be reproduced on canvas. Instinctively, I felt that painting had to find a new way to express the beauty of nature....

During [my] period of research in Paris, I made many abstract paintings of trees, houses, plants and other objects. They were exhibited at the Salon des Indépendents. Shortly before the outbreak of the first World War, I went back to Holland on a visit. I remained there for the duration of the war, continuing my work of abstraction in a series of church facades, trees, houses, etc. But I felt that I still worked as an Impressionist and was continuing to express particular feelings, not pure reality. Although I was thoroughly conscious that we can

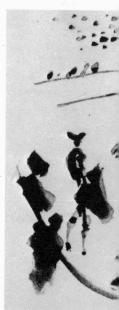

never be absolutely "objective," I felt that one can become less and less subjective, until the subjective no longer predominates in one's work. . . .

.... In my early pictures, space was still a background. I began to determine forms: verticals and horizontals became rectangles. They still appeared as detached forms against a background; their color was still impure.

Feeling the lack of unity, I brought the rectangles together: space became white, black or grey; form became red, blue or yellow. Uniting the rectangles was equivalent to continuing the verticals and horizontals of the former period over the entire composition. It was evident that rectangles, like all particular forms, obtrude themselves and must be neutralized through the composition. In fact, rectangles are never an aim in themselves but a logical consequence of their determining lines, which are continuous in space; they appear spontaneously through the crossing of horizontal and vertical lines. Moreover, when rectangles are used alone without any other forms, they never appear as particular forms, because it is contrast with other forms that occasions particular distinction.

Later, in order to abolish the manifestation of planes as rectangles, I reduced my color and accentuated the limiting lines, crossing them one over the other. Thus the planes were not only cut and abolished, but their relationships became more active. The result was a far more dynamic expression. Here again I tested the value of destroying particularities of form and thus opening the way to a much more universal construction.

PIET MONDRIAN
"Towards the True Vision of Reality," 1942

Despite his tragic death in an automobile accident in 1956, Jackson Pollock has become the most widely recognized artist of the Abstract Expressionist style that flourished in New York City after World War II. The phrase "action painting" was coined to describe Pollock's technique, which he himself set forth during the latter part of his career.

My painting does not come from the easel. I hardly ever stretch my canvas before painting. I prefer to tack the unstretched canvas to the hard wall or the floor. I need the resistance of a hard surface. On the floor I am more at ease. I feel nearer, more a part of the painting, since this way I can walk around it, work from the four sides and literally be in the painting. This is akin to the method of the Indian sand painters of the West.

I continue to get further away from the usual painter's tools such as easel, palette, brushes, etc. I prefer sticks, trowels, knives, and dripping paint or a heavy impasto with sand, broken glass, and other foreign matter added.

When I am in my painting, I'm not aware of what I'm doing. It is

only after a sort of "get acquainted" period that I see what I have been about. I have no fears about making changes, destroying the image, etc., because the painting has a life of its own. I try to let it come through. It is only when I lose contact with the painting that the result is a mess. Otherwise there is pure harmony, an easy give and take, and the painting comes out well. . . .

I don't work from drawings or color sketches. My painting is direct.... The method of painting is the natural growth out of a need. I want to express my feelings rather than illustrate them. Technique is just a means of arriving at a statement. When I am painting I have a general notion as to what I am about. I can control the flow of paint: there is no accident, just as there is no beginning and no end.

JACKSON POLLOCK
Three Statements, 1944–51

Debate over the precise meaning of the term abstract art has occurred in art circles throughout the twentieth century. The Dutch-born painter Willem de Kooning, one of the most highly regarded members of the post-World War II New York School, eloquently outlined his views on the subject for a symposium held in 1951 at the Museum of Modern Art.

The first man who began to speak, whoever he was, must have intended it. For surely it is talking that has put "Art" into painting. Nothing is positive about art except that it is a word. Right from there to here all art became literary. We are not yet living in a world where everything is self-evident. It is very interesting to notice that a lot of people who want to take the talking out of painting, for instance, do nothing else but talk about it. That is no contradiction, however. The art in it is the forever mute part you can talk about forever.

For me, only one point comes into my field of vision. This narrow, biased point gets very clear sometimes. I didn't invent it. It was already here. Everything that passes me I can see only a little of, but I am always looking. And I see an awful lot sometimes.

The word "abstract" comes from the light-tower of the philosophers, and it seems to be one of their spotlights that they have particularly focussed on "Art." So the artist is always lighted up by it. As soon as it—I mean the "abstract"—comes into painting, it ceases to be what it is as it is written. It changes into a feeling which could be explained by some other words, probably. But one day, some painter used "Abstraction" as a title for one of his paintings. It was still life. And it was a very tricky title. And it wasn't really a very good one. From then on the idea of abstraction became something extra. Immediately it gave some people the idea that they could free art from itself. Until then, Art meant everything that was in it—not what you could take out of it. There was only one thing you could take out of it sometime

when you were in the right mood-that abstract and indefinable sensation, the esthetic part-and still leave it where it was. For the painter to come to the "abstract" or the "nothing," he needed many things. Those things were always things in life-a horse, a flower, a milkmaid, the light in a room through a window made of diamond shapes maybe, tables, chairs, and so forth. The painter, it is true, was not always completely free. The things were not always of his own choice, but because of that he often got some new ideas. Some painters liked to paint things already chosen by others, and after being abstract about them, were called Classicists. Others wanted to select the things themselves and, after being abstract about them, were called Romanticists. Of course, they got mixed up with one another a lot too. Anyhow, at that time, they were not abstract about something which was already abstract. They freed the shapes, the light, the color, the space, by putting them into concrete things in a given situation. They did think about the possibility that the things-the horse, the chair, the man-were abstractions, but they let that go, because if they kept thinking about it, they would have been led to give up painting altogether....

Spiritually I am wherever my spirit allows me to be, and that is not necessarily in the future. I have no nostalgia, however. If I am confronted with one of those small Mesopotamian figures, I have no nostalgia for it but, instead, I may get into a state of anxiety. Art never seems to make me peaceful or pure. I always seem to be wrapped in the melodrama of vulgarity. I do not think of inside or outside-or of art in general-as a situation of comfort. I know there is a terrific idea there somewhere, but whenever I want to get into it, I get a feeling of apathy and want to lie down and go to sleep. Some painters, including myself, do not care what chair they are sitting on. It does not even have to be a comfortable one. They are too nervous to find out where they ought to sit. They do not want to "sit in style." Rather, they have found that painting-any kind of painting, any style of painting-to be painting at all, in fact-is a way of living today, a style of living so to speak. That is where the form of it lies. It is exactly in its uselessness that it is free....

Personally, I do not need a movement. What was given to me, I take for granted. Of all movements, I like Cubism most. It had that wonderful unsure atmosphere of reflection—a poetic frame where something could be possible, where an artist could practise his intuition. It didn't want to get rid of what went before. Instead it added something to it. The parts that I can appreciate in other movements came out of Cubism. Cubism *became* a movement, it didn't set out to be one. It has force in it, but it was no "force-movement." And then there is that one-man movement, Marcel Duchamp—for me a truly modern movement because it implies that each artist can do what he thinks he ought to—a movement for each person and open for everybody.

A Chronology of Modern Painting

Johann Joachim Winckelmann's History of Ancient Art introduces Neoclassicism; Giovanni Piranesi's prints acquaint a wide audience with the monu- ments of Rome	1764	James Hargreaves invents the spinning jenny; Horace Walpole's The Castle of Otranto
ments of Rome	1776	American Declaration of Independence signed; James Watt invents the steam engine; Adam Smith's <i>The Wealth of Nations</i> published
Jacques Louis David's Oath of the Horatii depicts an event in Roman history	1784	
	1789	Parisians storm the Bastille; Declaration of the Rights of Man proclaimed
David's Marat Assassinated has a completely con- temporary subject	1793	Louis XVI executed; First Coalition against France
The Louvre begins assembling the spoils of war, including ancient art and works of the Italian Renaissance; Charles Willson Peale's The Staircase Group utilizes trompe l'oeil	1795	Third French Republic; French Convention is dissolved; French Directory installed
Francisco de Goya's series of etchings, the Capri- chos, are published	1799	Napoleon Bonaparte made First Consul
Jean Auguste Ingres wins the Prix de Rome	1801	Thomas Jefferson becomes President of the United States
The Watercolour Society is formed in England; it introduces the use of clear color	1804	Johann Friedrich von Schiller finishes the drama William Tell
J. M. W. Turner's <i>Hannibal Crossing the Alps</i> has a historical subject but emphasizes the theme of man versus the forces of nature	1812	War of 1812 between Great Britain and the United States
	1815	Napoleon defeated at Waterloo
German romantic landscape painting is represented by Caspar David Friedrich's <i>The Chalk Cliffs of</i> <i>Rügen</i>	1818	
Théodore Géricault presents the Raft of the Medusa at the Paris Salon where the general public discovers Romanticism	1819	Singapore occupied by the British; Sir Walter Scott writes <i>Ivanhoe</i>
	1823	Beethoven completes his Ninth Symphony
Works by Jean Ingres and Eugène Delacroix share popularity at the Salon with John Constable's <i>The Hay Wain</i>	1824	First trade union formed in England
William Blake paints Beatrice Speaking to Dante, one of a series of illustrations for the Divine Comedy	1825	Robert Owen establishes a communal experiment at New Harmony, Indiana; Erie Canal opened
Delacroix completes <i>Death of Sardanapalus</i> , a painting representing the essence of Romanticism	1827	Georg S. Ohm formulates his law of electricity
	1830	Beginning of the French occupation of Algeria; Auguste Comte writes Positive Philosophy
Honoré Daumier's satirical print <i>Gargantua</i> (a caricature of Louis Philippe) costs him six months' imprisonment	1832	Goethe completes the second part of Faust
	1837	Accession of Queen Victoria in England
Fur Traders Descending the Missouri by George Caleb Bingham represents the new American frontier painting	1845	Richard Wagner composes Tannhäuser; Emily Brontë writes Wuthering Heights
Théodore Rousseau settles at Barbizon, in the Forest of Fontainebleau, and with François Millet and Diaz de la Peña founds the Barbizon School	1846	
Dante Gabriel Rossetti, together with W. Holman Hunt and J. Everett Millais, founds the Pre-Raph- aelite Brotherhood	1848	William Makepeace Thackeray writes Vanity Fair; Karl Marx and Friedrich Engels issue the Com- munist Manifesto; abdication of Louis Philippe and proclamation of the Second Republic

Gustave Courbet paints <i>The Stone Breakers</i> , which was destroyed during the bombing of Dresden in 1945	1849	Giuseppe Garibaldi retreats from Rome
	1854	The United States concludes the first treaty by a Western power with Japan
Courbet completes <i>The Artist's Studio</i> ; he opens his own exhibition, the "Pavilion of Realism" during the International Exhibition in Paris	1855	Aluminum is produced on a commercial scale; Walt Whitman's <i>Leaves of Grass</i> published
Japanese woodcuts begin to attract attention Millet paints <i>The Gleaners</i> , a prime example of the Realist style	1856 1857	Louis Pasteur develops process for the pasteuriza- tion of milk
Giovanni Fattori, representative of the Macchiaioli School, initiates a series of paintings on the Italian war of independence	1859	Gustav Kirchhoff and Robert W. Bunsen discover the method of spectrum analysis of light; Ferdi- nand de Lesseps begins construction of the Suez Canal; Charles Darwin publishes <i>Origin of Species</i>
Édouard Manet's Déjeuner sur l'Herbe causes a scan- dal at the Salon des Refusés, which also exhibits James McNeill Whistler's The White Girl; Manet completes Olympia; Rossetti paints Beata Beatrix, inspired by the death of his wife	1863	Confederates are defeated by Federal troops at Gettysburg
Émile Zola is obliged to resign from his post as news- paper editor for having defended Manet; Nikolai Chernyshevski proclaims in Russia that art must serve the people	1865	Assassination of Abraham Lincoln; Joseph Lister introduces method of surgical asepsis
Claude Monet paints Camille, the main work of his realist period	1866	Alfred Nobel invents dynamite; Dostoyevsky writes Crime and Punishment
Courbet joins the uprising of the Paris Commune; Whistler paints The Artist's Mother	1871	German Empire proclaimed; Otto von Bismarck be- comes German chancellor; Heinrich Schliemann identifies and excavates the site of ancient Troy; proclamation of the Third Republic in France
First major exhibition of Impressionist paintings at the Paris studio of photographer Nadar (Gaspard Félix Tournachon); works by Edgar Degas, Ca- mille Pissarro, and Alfred Sisley are included as well as Monet's Impression, Sunrise	1874	Notorious and powerful Whisky Ring exposed in the U.S. through the efforts of Secretary of State Benjamin Bristow
Thomas Eakin's The Gross Clinic completed	1875	
Auguste Renoir paints the <i>Moulin de la Galette</i> , one of the most representative works of Impressionism; Degas produces <i>Absinthe</i>	1876	Alexander Graham Bell invents the telephone; Tchaikovsky composes Swan Lake
Manet finishes Bar at the Folies Bergère	1882	Wagner composes his last work, Parsifal
Paul Gauguin deserts his family to devote himself entirely to painting	1883	The Fabian Society is founded in England
Georges Seurat develops pointillism, a system of optical painting, in his first major work, Bathing at Asnières	1884	Elie Metchnikoff introduces the theory of phago- cytosis, demonstrating the antibacterial function of white blood cells
Vincent van Gogh paints <i>The Potato Eaters</i> , the last work of his formative, realist period	1885	The Berlin Conference; Karl Benz and Gottlieb Daimler build the first automobile powered by an internal combustion engine
Seurat's A Sunday Afternoon on the Island of La Grande Jatte, shown at the last Impressionist exhibition, is one of the first Neo-Impressionist masterpieces	1886	Robert Louis Stevenson completes The Strange Case of Doctor Jekyll and Mr. Hyde
Père Tanguy by Van Gogh represents the brighter palette of his Paris period	1887	Emile Berliner invents the gramophone and a method for duplicating disk records
Henri de Toulouse-Lautrec introduces the theme of the circus with At the Circus Fernando: The Equestrienne; Van Gogh quarrels with Gauguin and early the next year paints his Self-Portrait with Bandaged Ear	1888	Wilhelm II is proclaimed emperor of Germany and king of Prussia; Richard Strauss composes <i>Don Juan</i> ; John Boyd Dunlop invents the pneumatic tire
Degas paints The Blue Dancers; Van Gogh, shortly before committing suicide, finishes Wheat Field with Crows; William Harnett's still life, The Faithful Colt, completed	1890	William James writes <i>The Principles of Psychology</i> ; Henrik Ibsen completes his feminist drama, <i>Hedda Gabler</i>
Gauguin arrives in Tahiti	1891	
Toulouse-Lautrec paints At the Moulin Rouge; Cézanne completes The Cardplayers	1892	The first diesel engine is constructed
Toulouse-Lautrec designs Jane Avril au Jardin de Paris, one of his best-known posters	1893	An antidiphtheria serum is discovered

At the exhibition of his works organized in Paris by Ambroise Vollard, Cézanne obtains his first recognition from the critics	1895	Wilhelm Roentgen discovers X rays; H. G. Wells writes <i>The Time Machine</i> ; The Lumière brothers invent the cinematograph; Freud's <i>Studies on Hysteria</i> marks the beginning of psychoanalysis
Henri Matisse evokes Impressionism in The Dinner Table; Gauguin paints Where Do We Come From? What Are We? Where Are We Going?	1897	
Paul Signac publishes From Eugène Delacroix to Neo-Impressionism, a definitive essay on pointillism	1899	U.S. Senate ratifies the Treaty of Paris ending the Spanish-American War
Pablo Picasso makes his first trip to Paris; Maurice Denis's <i>Homage to Cézanne</i> assembles the Nabis in one painting	1900	Founding of the Labour Party in Great Britain; Boxer Rebellion is crushed in China
Picasso's first exhibition in Paris, his Blue Period begins	1901	Peter Hewitt invents the mercury vapor lamp
	1903	Orville and Wilbur Wright fly their first airplane
This year's Salon d'Automne marks the beginning of Fauvism; the group called <i>Die Brücke</i> is formed in Dresden and exhibits the next year	1905	
	1905-16	Einstein formulates his special and general theories of relativity
A posthumous exhibition of Cézanne's paintings at the Salon d'Automne establishes his triumph; Pi- casso shows <i>Les Demoiselles d'Avignon</i> to critics and friends	1907	John Millington Synge's The Playboy of the West- ern World is produced
Georges Braque exhibits the first Cubist paintings at D. H. Kahnweiler's gallery; the Ashcan School exhibits in New York; Kandinsky's studio dis- covery marks the beginning of abstract art	1908	French physicist Gabriel Lippmann awarded Nobel Prize for his development of color photography
The Italian poet F. T. Marinetti publishes the first manifesto of Futurism in <i>Le Figaro</i>	1909	
Amedeo Modigliani exhibits at the Salon des Indé- pendents; a watercolor by Kandinsky is the first abstract painting	1910	The Mexican revolution begins; Union of South Africa is formed
Kandinsky and Franz Marc found <i>Der Blaue Reiter</i> ; the Futurists Umberto Boccioni and Carlo Carra visit Paris and are introduced to Cubism	1911	Bartok composes the opera Bluebeard's Castle
Picasso and Braque first use papier collé; Cubism evolves from its Analytical to its Synthetic phase; first exhibition of the Section d'Or; Wilhelm Worringer's Formproblem der Gothik discusses German Expressionism	1912	War in the Balkans; Chinese republic is proclaimed; discovery of vitamins by Casimir Funk
The Armory Show in New York introduces European works and the latest American trends; Giullaume Apollinaire elaborates the principles of Cubism in <i>Les Peintres Cubistes</i> ; Duchamp exhibits his first "ready-made," <i>Bicycle Wheel</i>	1913	Stravinsky composes The Rites of Spring
	1913-28	Marcel Proust's multivolume masterpiece Remem- brance of Things Past is published
Braque goes to war, and his artistic association with Picasso is dissolved; Fernand Léger's Contrasting Forms excludes all objective references.	1914	World War I begins; Panama Canal opens
Kasimir Malevich exhibits his first Suprematist paint- ings; Juan Gris paints Still Life Before an Open Window: Place Ravignan	1915	A German submarine sinks the <i>Lusitania</i> ; Franz Kafka writes <i>The Metamorphosis</i>
The Dada group is formed in Zurich; Francis Picabia publishes its periodical 391; Amedeo Modigliani paints a portrait of Paul Guillaume	1916	Allied and German forces suffer enormous casualties at Verdun and the Somme
George Grosz paints Metropolis; Piet Mondrian explains the theoretical principles of Neoplasticism, a kind of abstract painting; Georges Rouault paints Three Clowns; De Chirico, Hector and Andromache	1917	The United States enters the war; beginning of the Russian Revolution
Joan Miró's paintings are first exhibited in Bar- celona	1918	Republic proclaimed in Germany; Communist revolt in Hungary organized by Bela Kun
The Bauhaus is founded by Walter Gropius; Max Ernst collaborates with Jean Arp in the series of Fatagaga collages; Giorgio Morandi, who began in the Metaphysical school, paints Still Life	1919	Treaty of Versailles ends World War I; Robert Wiene's film <i>The Cabinet of Dr. Caligari</i> is produced in Germany

Duchamp exhibits L.H.O.O.Q., the Mona Lisa with beard and moustache; Picasso's Neoclassical period begins. Paul Klee is appointed to the staff of the Bauhaus	1920	Warren G. Harding elected President of the United States
Lucky Strike by Stuart Davis anticipates Pop Art; in Mexico, David Alfaro Sigueiros publishes a manifesto advocating a public art—mural rather than easel painting	1921	Austrian philosopher Ludwig Wittgenstein publishes the <i>Tractatus Logico-philosophicus</i>
Kandinsky is appointed to the staff of the Bauhaus	1922 1923	Establishment of the Irish Free State Hitler's "beer-hall putsch" defeated in Munich;
André Breton publishes first manifesto of Surrealism	1924	George Gershwin composes Rhapsody in Blue
First Surrealist exhibition of Miró's work is held at the Pierre Gallery in Paris; Max Ernst perfects the technique of <i>frottage</i> ; André Masson uses auto- matic drawing	1925	Death of Sun Yat-sen, the father of the Republic of China
René Magritte joins the Surrealist movement; Claude Monet completes his last painting on the theme of <i>Water Lilies</i>	1926	Paul Hindemith composes Cardillac
Masson begins using sand on his canvases; Ernst's The Kiss is completed	1927	Charles Lindbergh makes first solo, nonstop trans- atlantic flight from New York to Paris in <i>The</i> Spirit of St. Louis
Miró paints three <i>Dutch Interiors</i> ; Breton publishes Surrealism and Painting	1928	Sir Alexander Fleming discovers penicillin; Bertolt Brecht and Kurt Weill collaborate on <i>The Three-</i> penny Opera
Salvador Dali's first exhibition takes place in Paris; the second manifesto of Surrealism is published	1929	Stock market crash on Wall Street leads to world- wide economic depression
Dali joins the Surrealist movement	1930	
Founding of the Abstraction—Création group, dedi- cated to nonobjective principles, marks the zenith of abstract art in Paris; Siqueiros begins frescoes for the Plaza Art Center in Los Angeles; John Marin completes <i>View of Fifth Avenue</i>	1932	Construction of the first cyclotron; James Chadwick discovers the neutron; Carl D. Anderson, the positron
Paul Nash and others start the heterogeneous group of English painters called Unit One; Dali finishes <i>The Persistence of Memory</i> , one of the most characteristic images of Surrealism	1933	Adolf Hitler becomes chancellor of Germany; André Malraux writes <i>La Condition Humaine</i>
René Magritte paints <i>Perpetual Motion</i> ; Miró begins the period of his "wild paintings which make monsters arise"	1934	Arnold J. Toynbee begins his ten-volume work, A Study of History
	1936	Beginning of Spanish Civil War; three years later, forces led by General Franco emerge victorious
Picasso paints Guernica and illustrates The Dream and Lie of Franco; Miró dedicates The Reaper to the Spanish Republic; the art of Kokoschka, Kandinsky and others is condemned by the Nazis at an exhibition of "Degenerate Art"; The Guggenheim Foundation starts a museum of nonobjective painting around its Kandinsky collection	1937	English aeronautical engineer Frank Whittle constructs the first jet engines; Margaret Mitchell's Gone with the Wind wins the Pulitzer Prize in fiction writing
The International Exhibition of Surrealism opens in Paris; Thomas Hart Benton paints <i>The Harvest</i> ; Stuart Davis's <i>Swing Landscape</i> draws on jazz for its inspiration	1938	Russian cinema director Sergei Eisenstein produces his first sound film, <i>Aleksandr Nevsky</i> ; the Munich Pact permits Hitler immediate occupation of The Sudetenland
José Clemente Orozco finishes a masterpiece: the fresco at the Cabañas Orphanage at Guadalajara	1939	German invasion of Poland marks the beginning of World War II
Ernst elaborates the technique of decalcomania, transferring thin layers of paint to the canvas from a stereotype plate	1940	The German army occupies Paris; Ernest Heming- way writes For Whom the Bell Tolls
Picasso is forbidden by the Nazis to exhibit his work	1941	The Japanese attack Pearl Harbor; the United States enters the war
Publication of the third and last manifesto of Sur- realism; Breton reads Dali out of the Surrealist group	1942	Enrico Fermi creates the first self-sustaining nuclear chain reaction; the battle of Midway marks a de- cisive American victory in the war
Picasso joins the French Communist Party	1944	Allied landing in Normandy
Abstract Expressionism becomes the dominant trend in American art; it is represented by Arshile Gorky, Willem de Kooning, Mark Rothko, and Jackson Pollock	1945	Allies defeat Hitler's Germany; the first atomic bombs are used against Japan to end World War II in the Pacific; United Nations organized; the first television sets reach the public market

Victor Brauner paints The Surrealist; Pierre Bonnard produces Still Life	1947	India attains independence from Great Britain; do- minion of Pakistan created
Matisse starts designing the Dominican Chapel at Vence, a culmination of his art; the experimentalist group Cobra is founded; Rothko exhibits at the Art of This Century Gallery	1948	Creation of the state of Israel
Picasso's lithograph of a dove of peace is used on posters for the Communist Party's World Congress	1949	People's Republic of China proclaimed
Renato Guttoso shows Occupation of Farm Lands in Sicily, an example of Socialist Realism	1950	Korean War begins
Nicolas de Staël paints Figure by the Sea; War and Peace painted by Picasso for the Chapel at Vallauris; Adolph Gottlieb's Frozen Sounds, Number 2 completed	1952	Gamal Abdal Nasser leads army coup to overthrow Egyptian monarchy
Francis Bacon completes Study after Velázquez: Pope Innocent X; Pollock paints Blue Poles; Mark Tobey's Edge of August is an example of his "white writing"	1953	Death of Stalin; armistice is signed in Korea
Bacon attains international renown through Man in Blue, as he represents Great Britain at the Venice Biennale	1954	Launching of the U.S.S. Nautilus, the first American nuclear-powered submarine
Birth of Pop Art in England reflects the culture of the mass media	1955	Pulitzer Prize for musical composition awarded to Gian-Carlo Menotti for his Saint of Bleeker Street
Chagall is commissioned by Ambroise Vollard to illustrate the Bible	1956	Suez Canal crises; Russia crushes anti-Communist uprising in Hungary
Ben Nicholson paints April '57; Robert Rauschenberg exhibits examples of his combine painting, Factum I and Factum II; Antonio Tàpies' Red Painting X completed	1957	Sputnik I, the first artificial satellite, is launched by the Soviet Union
Siqueiros completes the mural painting Future Victory of Medicine over Cancer; Miró designs a tiled wall for the UNESCO building in Paris; Rothko paints Slate Blue on Violet Brown; Victor Vasarely paints Homage to Malevich	1958	National Aeronatics and Space Administration (NASA) created to study the problems of space travel
Retrospective show of Max Ernst's works at the Musée d'Art Moderne in Paris; opening of the Solomon R. Guggenheim Museum in New York	1959	Charles de Gaulle inaugurated as president of the new Fifth Republic in France
Paris hosts the New Realism exhibition; the begin- ning of Pop Art in the United States along with the Neo-Dada movement is represented by Rob- ert Rauschenberg and Jasper Johns	1960	John F. Kennedy defeats Richard M. Nixon for President of the United States
	1961	Soviet astronaut Yuri Gagarin becomes the first man in space; Berlin Wall built
Dubuffet's L'Hourloupe establishes his personal style; the Tate Gallery holds a large retrospective exhibition of Kokoschka paintings; the Movement group is created in Moscow; Claes Oldenburg ex-	1962	Cuban missile crisis; Pope John XXIII opens the Second Vatican Council
hibits Ice Cream Cone Oldenburg completes French Fried Potatoes	1963	Assassination of President John F. Kennedy
Systematic Painting exhibition at the Guggenheim is represented by Al Held, Larry Poons, Frank Stella, Kenneth Noland, and Ellsworth Kelly; a group of young painters in Chicago create the Hairy Who	1966	Mao Tse-tung launches "cultural revolution" in China
Magritte paints Le Dernier Cri	1967	Arab-Israeli Six-Day War; first heart transplan performed by Dr. Christiaan Barnard
Frottage by Rauschenberg completed; the Kinetic Art movement creates whole environments as works of art	1968	Russian troops invade Czechoslovakia to stifle libera regime of Alexander Dubcek; Richard Nixon elect ed President of the United States
	1969	American astronauts are first men to walk on the moon
Two exhibitions of the Hyper-realists take place in New York	1970	Biafra surrenders, ending the thirty-one month civi war in Nigeria

1973

1974

The Yom Kippur War between Israel and Arab states; agreement signed to end the Vietnam War

President Nixon, facing impeachment over Water-gate scandal, resigns

Picasso dies in his country home near Mougins in

Mark Tobey retrospective at the National Gallery, Washington, D.C.

Selected Bibliography

- Barr, Alfred H., Jr., ed. Cubism and Abstract Art. New York: Museum of Modern Art, 1936.
- ----. Fantastic Art, Dada, Surrealism. new ed. New York: Museum of Modern Art, 1936.
- Chipp, Herschel B. Theories of Modern Art. Berkeley and Los Angeles: University of California Press, 1969.
- Friedlaender, Walter F. From David to Delacroix. Cambridge: Harvard University Press, 1952.
- Gray, C. The Great Experiment: Russian Art, 1863-1922. London: Thames & Hudson, 1962.
- Green, Samuel M. American Art, A Historical Survey. New York: The Ronald Press Company, 1966.
- Haftmann, Werner. *Painting in the Twentieth Century*. 2 vols. New York: Frederick A. Praeger, Inc., Publishers, 1965.
- Hamilton, George Heard. 19th and 20th Century Art. New York: Harry N. Abrams, Inc. Publishers, 1970.
- ---. Painting and Sculpture in Europe 1880–1940. The Pelican History of Art series. Baltimore: Penguin Books, 1967.
- Leymarie, Jean. Impressionism. Translated by James Emmons. 2 vols. New York: Skira, 1955.
- McLanathan, Richard. The American Tradition in the Arts. New York: Harcourt, Brace & World, Inc., 1968.
- Myers, Bernard S. The German Expressionists: A Generation in Revolt. New York: Frederick A. Praeger, 1957.
- Novak, Barbara. American Painting of the Nineteenth Century. New York: Praeger Publishers, Inc., 1969.
- Novotny, F. Painting and Sculpture in Europe, 1780 to 1880. The Pelican History of Art series. Baltimore: Penguin Books, 1960.
- Porzio, Domenico, and Marco Valsecchi. *Understanding Picasso*. New York: Newsweek Books, 1973.
- Praeger World of Art Profiles: Late Modern, The Visual Arts Since 1945, Edward Lucie-Smith, 1969; Matisse, Jean Guichard-Meili, 1967; Mondrian, Frank Elgar, 1968; Surrealist Art, Sarane Alexandrian, 1970; Toulouse-Lautrec, André Fermigier, 1969; Van Gogh, Frank Elgar, 1958. New York: Frederick A. Praeger, Inc., Publishers.
- Robb, David M. The Harper History of Painting. New York: Harper & Brothers, 1951.
- Sloane, Joseph C. French Painting Between the Past and the Present. Princeton: Princeton University Press, 1951.
- Sutter, Jean, ed. The Neo-Impressionists. Greenwich, Conn.: New York Graphic Society, Ltd., 1970.
- Time-Life Library of Art: The World of Cézanne, Copley, Delacroix, Duchamp, Goya, Homer, Manet, Matisse, Picasso, Turner, Van Gogh. American Painting, 1900–1970. New York: Time-Life Books, 1966–1973.

Picture Credits

HALF TITLE Jay J. Smith Studio FRONTISPIECE Richard Doetsch-Benziger Collection, Basel (Mercurio)

CHAPTER 1 6 Louvre (Giraudon) 8 Musées Royaux des Beaux-Arts, Brussels (Scala) 9 Louvre (Scala) 10–11 Louvre (Musées Nationaux, Paris) 12 Louvre (Scala) 13 Louvre (Scala) 14 National Gallery, London 15 Courtesy of the Trustees of the Tate Gallery, London 16 Top: Museum of Fine Arts, Boston (Kodansha) Bottom: National Gallery, Washington (Kodansha) 17 Philadelphia Museum of Art (A. J. Wyatt) 18–19 Prado, Madrid (Scala) 20 Prado, Madrid (Giraudon) 21 Prado, Madrid (Scala)

CHAPTER 2 22 Louvre (Scala) 24 Victoria and Albert Museum, London 25 National Gallery, London 26 National Gallery, London 27 Tate Gallery, London 28 Louvre (Musées Nationaux, Paris) 29 Top: Musée des Beaux-Arts, Béziers (Lauros-Giraudon) Bottom: Louvre (Musées Nationaux, Paris) 30–31 Louvre (Scala) 32 Louvre (Musées Nationaux, Paris) 33 Louvre (Giraudon) 34 Both: Louvre (Musées Nationaux, Paris) 35 Louvre (Kodansha) 36 Louvre (Giraudon) 37 Top: Louvre (Scala) Bottom: Kunsthalle, Hamburg

CHAPTER 3 38 Louvre (Kodansha) 40–41 Louvre (Musées Nationaux, Paris) 42–43 Louvre (Scala) 44 Top: Louvre (Musées Nationaux, Paris) Bottom: National Gallery, Washington 45 National Gallery, London 46 Tretyakov Gallery (Novosti) 47 Louvre (Kodansha) 48 Louvre (Musées Nationaux, Paris) 49 Louvre (Musées Nationaux, Paris) 50 Louvre (Mercurio) 51 Top: Tate Gallery (Photo Archives AME) Bottom: Collection of Mrs. Patrick Gibson (Purnell and Sons) 52 Top: Art Institute of Chicago Bottom: New-York Historical Society, New York 53 New-York Historical Society, New York.

CHAPTER 4 54 Louvre (Giraudon) 56 Louvre (Musées Nationaux, Paris) 56–57 Art Institute of Chicago, Potter Palmer Collection 58–59 Louvre (Scala) 60 National Gallery, Washington 61 Louvre (Musées Nationaux, Paris) 62 Louvre (Scala) 63 Louvre (Kodansha) 64 Louvre (Scala) 65 Both: Louvre (Scala) 66-67 Louvre (Scala) 67 Courtauld Collection, London (Scala) 68 Top: Musée D'Albi (Musées Nationaux, Paris) Bottom: Art Institute of Chicago 69 Louvre (Musée Nationaux, Paris) 70 National Gallery, Washington (Kodansha) 71 Top: Brooklyn Museum, Carll H. DeSilver Fund Bottom: Louvre, Cabinet des Dessins (Mercurio)

CHAPTER 5 72 National Gallery of Art, Washington, Chester Dale Collection 74 Louvre (Musées Nationaux, Paris) 75 Bridgestone Museum, Tokyo 76 Top: National Gallery, London (Kodansha) Bottom: Louvre (Mercurio) 77 Louvre (Photo Archives AME) 78 Courtauld Collection 79 Louvre (Held-Ziolo) 80 Albright-Knox Art Gallery, Buffalo 80–81 Museum of Fine Arts, Boston (Kodansha) 83 Top: Giuseppe Sprovieri Collection, Galleria d'Arte Moderna, Turin (Rampazzi) Bottom: Bayerische Staatgemäldesammlungen, Munich (Blauel) 84 Museum of Fine Arts, Lausanne (Held) 85 Top: National Museum of Modern Art, Paris (Held) Bottom: Private Collection, Geneva (Held) 86 Top: Zurich Museum (Giraudon) Bottom: Wallraf-Richartz Museum, Cologne (Scala) 87 National Gallery, Oslo (Photo Archives AME) 88 Top: Wolfgang Gurlitt Collection, Munich (Arborio Mella) Bottom: Museum of Fine Arts, Anversa (Giraudon) 89 Städtische Galerie im Lenbachhaus, Munich (Rampazzi)

CHAPTER 6 90 Museum of Modern Art, New York (Scala) 92 Collection of Jean Dalsace, Paris (Held) 93 Pushkin Museum, Moscow (Giraudon) 94 Right: Museum of Modern Art, Paris (D. René) Left: Art Institute of Chicago, Gift of Leigh B. Block 95 Museum of Modern Art, New York, Lillie B. Bliss Bequest 97 Philadelphia Museum of Art 98 Kunstmuseum, Basel (Musées Nationaux, Paris) 99 Albright-Knox Art Gallery, Buffalo, Georges F. Goodyear and the Buffalo Fine Arts Academy (Greenberg-May Prod. Inc.) 100 Stuttgart Staatsgalerie 101 Top: Carnegie Institute, Pittsburgh (Held) Bottom: Museum of Modern Art, Paris (Photo Archives AME) 102 Mr. and Mrs. Burton Tremaine Collection, Meriden, Connecticut (Kodansha) 103 Stedelijk Museum, Amsterdam (Mercurio) 104 Gianni Mattioli Foundation, Milan (Mercurio) 105 Museum of Modern Art, New York (Scala) 106 National Museum of Modern Art, Paris (Musées Nationaux, Paris) 106–107 Museum of Modern Art, New York 107 Museum of Modern Art, New York

CHAPTER 7 108 Royal Museum of Fine Arts, Copenhagen 110 Top: Private Collection, Paris (Mercurio) Bottom: Madame G. C. Signac Collection, Paris (Musées Nationaux, Paris) 111 State Hermitage Museum, Leningrad (Novosti) 112–113 Baltimore Museum of Art 114–115 Museum of Modern Art, New York 116 Museum of Modern Art, New York (Hinz-Ziolo) 117 Oeffentliche Kunstsam-

mlung, Basel (Giraudon) 118 Madame Nina Kandinsky Collection, Neuilly-sur-Seine 119 Gianni Mattioli Foundation, Milan (Mercurio) 120 (Kodansha) 122 Eindhoven Stedelijk Van-Abbe Museum (Mercurio) 123 National Museum of Modern Art, Paris (Mercurio) 124 (Mercurio) 125 Museum of Modern Art, New York 126 Metropolitan Museum of Art, The Alfred Stieglitz Collection, New York 127 Staatsgalerie, Stuttgart 128 Whitney Museum of American Art, New York 129 Top: Private Collection, New Haven (Scala) Bottom: Museum of Modern Art, New York, Lillie B. Bliss Bequest 130 Private Collection (Mercurio) 131 National Museum of Fine Arts, Mexico (Arborio Mella)

CHAPTER 8 132 Metropolitan Museum, New York 134 Museum of Modern Art, New York (Mercurio) 134-135 Private Collection (Mercurio) 136 Right: Private Collection Left: Private Collection (Georges Fall) 137 Top: Museum of Modern Art, New York Bottom: Seattle Museum (Georges Fall) 138 National Museum of Modern Art, Paris (Mercurio) 139 Top: National Museum of Modern Art, Paris (Kodansha) Bottom: Private Collection (Mercurio) 140-141 Gilbert Halbers Collection (Mercurio) 141 National Museum of Modern Art, Paris (Kodansha) 142 Top: Museum of Modern Art, New York (Kodansha) Bottom: Private Collection (Mercurio) 143 Top: William S. Rubin Collection, New York (Kodansha) Bottom: Mr. and Mrs. Burton Tremaine Collection, Meriden, Connecticut (Kodansha) 144 Top: Private Collection (Mercurio) Bottom: Private Collection (Mercurio) 145 Private Collection (Mercurio) 146 Private Collection (Mercurio) 147 Top: The Artist's Collection (Mercurio) Bottom: Cardazzo Collection, Venice (Mercurio) 149 Neue Galerie, Aachen (Kodansha) 150 Jasper Johns Collection, New York (Kodansha) 151 Top: The Artist's Collection (Kodansha) Bottom: Blu Gallery, Milan (Mercurio) 152 (Kodansha)

Index

Absinthe (Degas), 64 Abstract art (abstraction), 89, 117 ff. in America, 128 ff. birth of, 102-4 Cubism and, 94, 96, 98-99 De Kooning on, 178–79 geometric, 141-42 photography and, 69 Abstract Expressionism, 133 ff., 177-Académie des Beaux Arts, 55, 70 Action Painting, 134 ff., 177-78 Advice to a Young Artist (Daumier), Agate World (Tobey), 137 Albers, Josef, 128 Albright, Ivan, 128 Alechinsky, Pierre, 145, 146 Alloway, Lawrence, 148 American Gothic (Wood), 128 André, Carl, 143 Animated Landscapes (Léger), 98 Anthropométries (Klein), 149, 150 Antiquity Neoclassicism and, 8 Romanticism and, 32 Apollinaire, Guillaume, 91, 96 Apparition (Moreau), 51 Appel, Karel, 145, 146 Aragon, Louis, 92 Arles, 80 Armory Show (1913), 83, 100, 125, Arp, Jean, 101, 106, 134 Art brut, 148 Artist's Mother (Whistler), 68, 69 Artist's Studio (Courbet), 39, 41 Art nouveau, 82 Art of This Century Gallery, 133 Ashcan School, 83, 125 Asparagus (Manet), 57 Atelier, The (Corot), 48 Atlan, Jean, 139 Audubon, John James, 53 Autobiography of Alice B. Toklas (Stein), 165-67 Autumn Rhythm (Pollock), 133 Auvers-sur-Oise, 80 Avery, Milton, 131 Avril, Jane, 67, 69

Bacon, Francis, 146, 147–48
Balcony, The (Manet), 57
Ball, Hugo, 101
Balla, Giacomo, 99
Balthus (Balthasar Klossowski de Rola), 144, 145
Bara, Joseph, 10, 11
Barbizon School, 45
Barfüsser Church at Erfurt (Feininger), 125

Bargaining for a Horse (Mount), 53 Bateau-Lavoir group, 91 Battlefield of Eylau (Gros), 11 Baudelaire, 21, 23, 32, 33, 39, 41 Bauhaus, 118, 119 Bazaine, Jean, 137 Beata Beatrix (Rossetti), 51, 52 Beauty Cubism and, 91 Ingres and, 35 Neoclassicism and, 7, 8 Pre-Raphaelites and, 49 Bedroom at Arles (Van Gogh), 77, 80 Belfry of Douai (Corot), 48 Bellows, George, 83 Benton, Thomas Hart, 128 Bernard, Emile, 81, 156 Bierstadt, Albert, 27 Bingham, George Caleb, 52 Bishop, Isabel, 128 Bissière, Roger, 137 Black Clock (Cézanne), 75 Black Iris (O'Keeffe), 125 Blake, Peter, 148 Blake, William, 15-16 Blakelock, Ralph Albert, 52 Blaue Reiter (Blue Rider), 89, 119 Blue Phantom (Wols), 141 Blue Poles (Pollock), 134 Blume, Peter, 128 Boats under the Cliffs (Braque), 96 Boccioni, Umberto, 99 Böcklin, Arnold, 83 Bonnard, Pierre, 84 Boucher, François, 10 Boudin, Eugène, 60 Boulevard des Italiens (Pissarro), 60 Bourgeois art, 39-40, 46 Braque, Georges, 84, 89, 91, 93, 96, 99, 164 Brauner, Victor, 145 Breton, André, 105, 106, 121 Bride Stripped Bare . . . (Duchamp), Bridge at Mantes (Corot), 48, 49 Bridge of Narni (Corot), 47 Brittany, 81, 82 (Mon-Broadway Boogie-Woogie drian), 103 Brown, Ford Madox, 49 Brücke, Die (The Bridge), 86, 89 Burial at Ornans (Courbet), 41 Burne-Jones, Edward Coley, 52 Burri, Alberto, 139 Business in the City (Dubuffet), 146

Cagnes, 84
Calder, Alexander, 150
Campbell's Soup Cans (Warhol), 152
Canéphore (Braque), 96
Canova, 23
Capetians Everywhere (Mathieu), 141
Caprichos (Goya), 17
Cardplayers, The (Cézanne), 77
Carlyle, Thomas, 68
Carrà, Carlo, 99, 105
Cartoons, Realism and, 44

Cassatt, Mary, 69, 71 Catlin, George, 53 Caulfield, Patrick, 148 Central Park (Alechinsky), 145 Cézanne, Paul, 57, 60, 73 ff., 156-57 Chagall, Marc, 121, 122 Charivari, Le (Daumier), 44 Charles IV, 16, 20 Charles X, 32 Charon (Füssli), 15 Chase, William Merritt, 69 Chassériau, Théodore, 37 Château Noir (Cézanne), 74, 76 Chernyshevski, Nikolai, 45 Chirico, Giorgio de, 104, 105-6 Christ in the House of His Parents (Millais), 49 Christ in Limbo (Cézanne), 75 Church, Frederick Edwin, 27 Church at Auvers (Van Gogh), 78, Circus (Seurat), 77, 78 Classicism Impressionist period and, 71 Neoclassicism and, 10, 14, 15 Romantic period and, 23, 34 Cloisonnism, 81 Clothed Maja (Goya), 20 Cobra, 145-46 Cole, Thomas, 27 Collage, 92-94, 106 Collecting at Mortefontaine (Corot), 46, 48 Color abstraction and, 103 Cubism and, 94-95, 96 Impressionism and, 60-62, 66 Kandinsky on, 170-72 Neoclassicism and, 11, 17 Neo-Impressionism and, 74, 75-76, 78, 81, 82 Orphism and, 96 Romantic period and, 26, 27, 32-33, Composition 1921 (Mondrian), 100 Composition X (Kandinsky), 119 Composition with Three Figures (Léger), 98 Conceptual Art, 144 Constable, John, 24-26, 154-55 Constant (C. A. Nieuwenhuis), 146 Constellations (Miró), 122 Constructivism, 105 Contrasting Forms (Léger), 96 Copley, John Singleton, 16-17 Corneille (Cornélis van Beverloo), 146 Cornelius, Peter von, 37 Corner of the Table (Fantin-Latour), Coronation of Napoleon (David), 8, Corot, Jean Baptiste Camille, 46-48, 49, 155

Cortona, Pietro da, 13

Counterweight (Gottlieb), 142

Country Concert (Giorgione), 55

Cour des Comptes, 37 Course of Empire (Cole), 27 Creation of Adam (Blake), 15 Creative Credo (Klee), 175-76 Crome, John, 24 Cubism, 91 ff., 109, 122 Cézanne and, 76–77 Cubisme, Du, 96 Current (Riley), 142

Dada, 96, 100, 101-2 Dali, Salvador, 104, 106 Dance (Matisse), 109, 111 Dance of Life (Munch), 86, 88 Dans le Rêve (Redon), 83 Daumier, Honoré, 40, 44, 45 David, Jacques Louis, 7, 8, 10-11, 13, 34 Davis, Stuart, 128, 131 Death of General Wolfe (West), 16

ley), 17 Death on a Pale Horse (Ryder), 69 Death of a Pig (Millet), 44 Death of Sardanapalus (Delacroix), 32, 34

Death of Major Pierson . . . (Cop-

Degas, Edgar, 57, 64-65, 69 Déjeuner sur l'Herbe (Manet), 55, 57 on abstract art, 178-79

Delacroix, Eugène, 8, 13, 23-24, 28, 32-34, 41, 75 Delaunay, Robert, 91, 96, 119

Delvaux, Paul, 106 Demoiselles d'Avignon (Picasso), 91 Demoiselles des bords de la Seine (Picasso), 117

Demon, The (Vrubel), 83 Denis, Maurice, 84 Derain, André, 84, 86, 87 Dernier Cri (Magritte), 107

Désossé, Valentin le, 67 Destruction of Sodom (Martin), 14 Diaghilev, Sergei, 111

Dickens, Charles, 49 Dine, Jim, 149 Disasters of War (Goya), 21 Disquieting Muses (De Chirico), 104, 106

Divine Justice and Vengeance Pursuing Crime (Prud'hon), 13

Dix, Otto, 89 Dog on Leash (Balla), 98 Domain of Arnheim (Magritte), 107

Don Quixote Attacking the Windmills (Daumier), 45 Douanier, 87

Double Ascension (Kandinsky), (frontispiece) Double Portrait with Wine Glass

(Chagall), 121, 122 Doughty, Thomas, 27 Dove, Arthur, 125

Dream (Picasso), 114 Dream and Lie of Franco (Picasso), 115

Drouin, René, 141 Dubuffet, Jean, 121, 146, 147-48 Duchamp, Marcel, 96, 100-101, 148,

Duchamp-Villon, Raymond, 96 Dufy, Raoul, 84, 86 Durand-Ruel, 160

Dutch movement Cobra, 145-46

Eakins, Thomas, 69 Earl, Ralph, 17 Morning (Hopper), Early Sunday 128 Easel (Marquet), 86 Eight Red Rectangles (Malevich), 103 Elegy to the Spanish Republic (Motherwell), 136

Elgin Marbles, 23 Empress Josephine (Prud'hon), 13

England abstraction in, 121 landscape painting in, 24 ff. Neoclassicism in, 13 ff. Pop Art in, 148 Pre-Raphaelitism in, 49 ff. Romanticism, 24 ff. Vorticism in, 100

Ensor, James, 89 Entry of Christ into Brussels (Ensor),

Epsom Derby (Géricault), 28, 32 Ernst, Max, 101, 106, 107 Estève, Maurice, 139

Evergood, Philip, 128 Experimental-conventional dichotomy,

Expressionism, 87–89, 110–11 Abstract, 133 ff., 177-78

Faithful Colt (Harnett), 53 Falling Angel (Chagall), 121 False Mirror (Magritte), 106 Family of Charles IV (Goya), 16, 20 Fantin-Latour, Théodore, 60 Farewell at Fontainebleau (Vernet),

13 Farewell to Louis XVIII (Gros), 11 Fattori, Giovanni, 53

Fautrier, Jean, 139 Fauvism, 84 ff., 109

precursors of, 81, 82 Feininger, Lyonel, 125, 128 Ferrara, 105

Fifer, The (Manet), 57 Fisher, John, 154 Flavin, Dan, 144

Flaxman, John, 14 Flood, The (Martin), 14 Fontainebleau, School of, 13

Formalism, Ingres and, 36 Formproblem der Gothik (Worringer), 88

France abstraction in, 121 Action Painting in, 139-40 Cubism in, 91 ff.

Fauvism in, 84 ff. Impressionism in, 55 ff., 70-71 Nabis in, 84

Neoclassicism in, 10 ff. Neo-Impressionism in, 73 ff. New Realism in, 149–50 Realism in, 40 ff. Romanticism in, 23-24, 27 ff. Symbolist painting in, 83 Francis, Sam, 137 Frankenthaler, Helen, 137 Fresnaye, Roger de la, 96 Freud, Sigmund, 106 Friedrich, Caspar David, 37 Friesz, Emile Othon, 84, 86 From Eugène Delacroix to Neo-Impressionism (Signac), 78 Frottage, 106 Fualdès, 28, 29

Fugitives (Daumier), 44 Füssli, Johann Heinrich, 14-15, 26 Futurism, 99, 100

Gabo, Naum, 105 Gachet, Paul, 80 Game of Patience (Balthus), 145 Garden of Pousse-Mousse (Dubuffet), Gauguin, Paul, 57, 78, 80, 81-83, 157-

Gauguin's Armchair (Van Gogh), 81 Genet, Jean, 144 Geometric abstraction, 141-42

Géricault, Théodore, 27 ff. Germ, The, 49

Germany, 70 Bauhaus in, 118, 119 Dada in, 101 Expressionism in, 87–89

Realism in, 44-45 Romantic period in, 37 symbolic painting in, 83 Giacometri, Alberto, 144

Giorgione, 55 Girls on the Seashore (Puvis), 71 Glackens, William, 83 Gleaners (Millet), 44, 45

Gleizes, Albert, 91, 96 Gleyre, 159 God's Eye (Wols), 141

Golden Age (Ingres), 36 Gorky, Arshile, 131, 133-34 Gothic transcendentalism, 88 Gottlieb, Adolph, 137, 142

Goya, Francisco de, 8, 10, 17 ff. Grandes Baigneuses (Cézanne), 77

Grapes (Gris), 96 Great Day of His Anger (Martin), 14 Green, Andrew, 167

Greuze, Jean-Baptiste, 8 Gris, Juan, 91, 93, 95-96, 165 Gropius, Walter, 118

Gros, Antoine Jean, 10, 11-13 Gross Clinic (Eakins), 69 Grosz, George, 89

Guernica (Picasso), 114, 115 Guggenheim, Peggy, 133 Gulf of Marseilles . . . (Cézanne), 74 Guttuso, Renato, 145

Guys, Constantin, 23

Gypsy Woman (Matisse), 87

Hamilton, Richard, 148 Hannibal Crossing the Alps (Turner), Happy Mother (Prud'hon), 13 Hard Edge, 142 Harnett, William M., 53 Hartley, Marsden, 125 Hartung, Hans, 138, 139 Harvest, The (Benton), 128 Hassam, Childe, 69 Hay Wain (Constable), 24 Heade, Martin Johnson, 53 Held, Al, 142 Henri, Robert, 83 Herbin, August, 91 Hermitage, 20 Hesperides, The (Marées), 83 Hicks, Edward, 27 Historical painting landscape and, 49 Neoclassicism and, 8-10 Romantic period and, 27 History of Ancient Art (Winckelmann), 7 Hobbema, Meindert, 24 Hofer, Karl, 89 Hofmann, Hans, 128 Homage to Apollinaire (Chagall), 122 Homage to Cézanne (Denis), 84 Homage to Malevich (Vasarely), 141 Homer, Winslow, 68-69, 70 Hopper, Edward, 128 Hostage (Fautrier), 139 House of the Hanged Man (Cézanne), 76 Houses in the Night (Klee), 119 Hudson River School, 27, 52 Hunt, William Holman, 49, 51 Hyper-realism, 151

Idealism, symbolic, 48-49 Impression, Sunrise (Monet), 57, 62 Impressionism, 34, 55 ff., 111 Neo-Impressionism and, 73-74 precursors of, 46, 53 Improvisation 9 (Kandinsky), 100 Ingres, Jean Dominique Auguste, 13, 28, 34-36, 37, 69 Inness, George, 52, 53 International Surface #1 (Davis), 131 Interrupted Reading (Corot), 48 Irving, Henry, 68 Italy Macchiaioli School of, 53 Neoclassicism in, 10, 11 in Romantic period, 27 Social Realism in, 145

Jacob, Max, 91

Jane Avril au Jardin de Paris (Toulouse-Lautrec), 69

Japanese prints, 62, 64, 78, 82

Jawlensky, Alexis von, 84, 88, 89, 109

Jockeys Before the Grandstand (Degas), 64

Johns, Jasper, 148—49, 150, 151 Jones, Allen, 148 Jongkind, Johan Barthold, 46, 55, 60, 67 Jorn, Asger, 146 Joseph Bara (David), 10 Judd, Donald, 143 Jugendstil, 82

Kandinsky, Wassily, (frontispiece), 84, 88, 89, 100, 102, 117–19 writings by, 170 ff.
Kelly, Ellsworth, 142
Kensett, John Frederick, 53
Kinetic art, 142, 150
Kirchner, Ernst Ludwig, 84, 86, 88, 89
Kitaj, R. B., 148
Klee, Paul, 84, 89, 119–21, 175–76
Klein, Yves, 149–50
Klimt, Gustav, 88
Kline, Franz, 136, 137
Kokoschka, Oscar, 89
Kooning, Willem de, 131, 136, 137
Kubin, Alfred, 89

Lady with a Harp (Sully), 17 Lady with a Pearl (Corot), 49 Lam, Wilfredo, 145 Landscape painting, 23, 24 ff. American, 27 Barbizon School and, 45 Corot and, 46-48 in England, 24 ff. Impressionism and, 60, 64, 65, 69 literature on, 154-55, 167 ff. Realism and, 41, 46-48 Romanticism and, 46 Landscape Table (Gorky), 134 Lane, Fitz Hugh, 53 Last Judgment (Martin), 14 Last Supper (Dali), 106 Laurencin, Marie, 91 Lanvandou, Le (Hartung), 138 Lavater, Johann, 14 Léger, Fernand, 91, 96-98 Leibl, Wilhelm, 44 Lenoir, Alexandre, 7 Levine, Jack, 128 Lewis, Wyndham, 100 L'Hourloupe, 148 Liberty Leading the People (Delacroix), 32 Lichtenstein, Roy, 149 Lictors Bringing to Brutus the Bodies of His Sons (David), 10 Lime Kiln (Géricault), 32 Literature on painting, 154 ff. Littérature, 105 L'Oeuvre (Zola), 73 Loge, The (Renoir), 65 Lorrain, Claude, 14, 27, 47 Loti, Pierre, 86 Louis, Morris, 142 Louvre, 7 Lower Manhattan (Marin), 128

Lucebert (Van Swaanswijk), 146

Luks, George, 83

Luxe, Calme et Volupté (Matisse), 109, 111 Luxembourg Gardens (David), 11 Lyrical abstraction, 141

Macchiaioli School, 53 Macke, August, 88, 89 Madame Matisse (Matisse), 109 Madame Récamier (David), 7 Madame Rivière (Ingres), 36 Magritte, René, 106, 107 Male Nude (Matisse), 87 Malevich, Kazimir, 103-4, 105 Mallarmé, Stéphane, 55 Man in Blue (Bacon), 146, 147 Man with Guitar (Braque), 95 Man with the Hoe (Millet), 39 Man with Pipe (Picasso), 92 Manet, Edouard, 55, 57, 60, 64, 75, 159 - 60Mannerism, 13 Marat Assassinated (David), 8, 10, 11 Marc, Franz, 88, 89 Marcoussis, Louis, 96 Marées, Hans von, 83 Marin, John, 125, 128 Marinetti, F. T., 99 Marquet, Albert, 84 Mars Disarmed by Venus and the Graces (David), 11 Martin, John, 14 Masaccio, 34 Massacre at Chios (Delacroix), 28, 32 Mass media, 148, 150 Masson, André, 106-7, 134 Mathieu, Georges, 140, 141 Matisse, Henri, 77, 86-87, 109-10, 111, 161 ff. Matta (Sebastian Echaurren), 145 Mengs, Anton Raphael, 17 Menzel, Adolph von, 44 Metaphysical painting, 105-6 Metzinger, Jean, 91, 96 Mexican murals, 131, 145 Michaux, Henri, 138, 139-40 Michelangelo, 14 Milkmaid of Bordeaux (Goya), 20 Millais, John Everett, 49, 51 Millet, Jean François, 39, 40, 41, 44, 45 Minimal Art, 143-44 Miró, Joan, 106, 121-22, 125 Mirror of Venus (Burne-Jones), 52 Modern Style, 82 Modigliani, Amedeo, 111 Mondrian, Piet, 88, 100, 102-3, 117, Monet Claude, 57, 60-62, 158-60 Montagne Sainte-Victoire and Château Noir (Cézanne), 75 Moreau, Gustave, 48-49, 51 Morisot, Berthe, 60 Morris, Robert, 143 Mother and Child (Cassatt), 71 Motherwell, Robert, 136

Mother and Child (Cassatt), 71 Motherwell, Robert, 136 Motion, kinetic, 150 Moulin de la Galette (Renoir), 66 Moulin Rouge, 67, 69 Mount, William Sidney, 52, 53 Mountains in Silesia (Friedrich), 37 Munch, Edvard, 88-89 Munich, 84, 87, 89, 102, 133 Murals by Léger, 98 Mexican, 131, 145 Musée des Petits Augustins, 7 Musician (Braque), 96 Mycenae (Kline), 137

Nabis, 84 Naked Maja (Goya), 20, 21 Napoleon (Bonaparte), 11, 20, 24 Napoleon Among the Plague-stricken at Iaffe (Gros), 10, 11 Napoleon at the Battle of Arcole (Gros), 11, 13 Napoleon III, 55 Narrative Painting, 150-51 Nash, Paul, 121, 167 ff. Naturalism, Audubon's, 53 Nature, Neo-Impressionism and, 74-Neoclassicism, 7 ff. Classicism and, 10, 14, 15 in England, 13 ff. in France, 10 ff. history and, 8-10 Neo-Impressionism, 73 ff. New Artists Federation, 89 Newman, Barnett, 143 New painting, 55-56 New Realism, 149-50 New York School, 136, 178 Nicholson, Ben, 121 Nightmare (Füssli), 14 Night Mist (Pollock), 134 Nihilism, 105 Noa Noa, 157-58 Noland, Kenneth, 142 Nolde, Emil, 89

champ), 96, 100 Nude Listening to a Harpsichordist (Füssli), 14-15 Nudes in Romantic period, 29, 35, 36, Oath of the Army after Distribution of Eagles (David), 11

Nude Descending a Staircase (Du-

Nonobjective art, 102, See also Ab-

stract art.

literature on, 172 ff.

November Group, 89

Nude (Braque), 96

Nordic Expressionism, 88-89

Oath of the Horatii (David), 10 Occupation of Farm Lands in Sicily (Guttuso), 145 Odalisque (Ingres), 35, 37 O'Keeffe, Georgia, 125 Oldenburg, Claes, 149, 151 Olitski, Jules, 137, 143 Olympia (Manet), 55 Ophelia (Millais), 51 Optical art, 150

Optical design, 141-42 Orientalism, 11, 34 Orozco, José, 131 Orphism, 95, 96

Painter and His Model (Braque), 96 Painting (Miró), 125 Palace of Windowed Rocks (Tanguy), 106 Papier collé, 92-94, 106 Paranoiac-critical activity, 106 Paris Salons, 27-28, 55, 57, 68, 84 Passage of the Divine Bird (Miró), 125 Peale, Charles Willson, 16, 17 Pechstein, Max, 89 Permeke, Constant, 88

Persistence of Memory (Dali), 104, Peter and the Wolf (Hopper), 128 Pevsner, Antoine, 105

Phantom of a Flea (Blake), 15 Photography, 69-70 Picabia, Francis, 91, 102 Picasso, Pablo, 109, 111 ff., 114 Cubism and, 91-92, 99

Fauvism and, 84 New Artists Federation and, 89 portrait of, 95 Stein on, 165-67

Pierrot (Gris), 96 Pignon, Edouard, 145 Pink Nude (Matisse), 109, 111 Piranesi, Giovanni, 7, 14 Pissarro, Camille, 57, 60 Plein-air painting, 47, 52 Pointillism, 26, 111 Poliakoff, Serge, 139

Pollock, Jackson, 131, 133, 134 ff., 177-78

Pont-Aven 81, Poor Fisherman (Puvis), 71 Pop Art, 131, 148-49

Portrait of Jeanne Hebuterne (Modigliani), 111

Portraiture American, 16-17 by Goya, 16, 17, 20

Impressionist period and, 60, 68 by Matisse, 109

Realism and, 41, 45, 48 Romantic period and, 32, 36 Potato Eaters (Van Gogh), 78 Pound, Ezra, 100

Poussin, 27, 41, 47, 74 Pow! (Lichtenstein), 149 Premonition of Civil War (Dali), 106

Prendergast, Maurice, 83

Pre-Raphaelitism, 49 ff. Pretty Lambs (Brown), 49 Prisoners at Exercise (Van Gogh), 80 Procession (Repin), 46

Proudhon, Pierre Joseph, 40, 41 Prud'hon, Pierre-Paul, 13

Puvis de Chavannes, Pierre, 71

Quinta del Sordo, 21

Race of the Barberi Horses (Géricault), 28 Race Horses at Longchamp (Degas),

Races at Longchamp (Manet), 57 Raft of the Medusa (Géricault), 28 Rain, Steam, and Speed (Turner), 27 Rauschenberg, Robert, 149, 150

Raw art, 148 Ray, Man, 148

Ready-mades, 101, 148, 149 Realism, 39 ff.

in America, 52-53, 128 in France, 40 ff. in Germany, 44-45 Hyper-realism and, 151

New, 149-50 Pre-Raphaelites and, 49 Romanticism and, 34

in Russia, 45, 46 Social, 145 Reality

Cubism and, 93 Impressionism and, 55, 57 Mondrian on, 176-77

Neo-Impressionism and, 74–75 Reaper, The (Miró), 122, 125 Red Horseman (Appel), 145 Redon, Odilon, 83, 84 Reinhardt, Ad, 143 Remington, Frederick, 53

Renoir, Pierre-Auguste, 57, 65-66 Repin, Ilya, 46 Rethel, Alfred, 37 Revere, Paul, portrait of, 16 Reynolds, Joshua, 16 Riders on the Beach (Gauguin), 82

Right and Left (Homer), 69, 70 Riley, Bridget, 142

Riopelle, Jean-Paul, 139 Rivera, Diego, 131 Rivers, Larry, 148

Rococo Armchair (Matisse), 109–10 Rodchenko, Alexander, 104-5

Romanticism, 23 ff. in England, 24 ff. in France, 23-24, 27 ff.

in Germany, 37 landscape and, 46

Neoclassicism combined with, 13 in United States, 27

Rosenberg, Harold, 134 Rosenquist, James, 149 Rossetti, Dante Gabriel, 49, 51-52 Rothko, Mark, 142, 143

Rouault, Georges, 84, 89, 110-11 Rouen Cathedral in Full Sunlight

(Monet), 62 Rousseau, Henri, 86, 87 Rousseau, Théodore, 45 Roussel, Albert, 84 Runner at the Goal (Klee), 121

Ruskin, John, 49, 51, 56 Russia

Constructivism in, 105 in Neo-Impressionist period, 83 Realism in, 45, 46

BOWMAN LIBRARY

MENLO SCHOOL AND COLLEGE

Social Realism, 145 Suprematism in, 103, 104 Russolo, Luigi, 99 Ryder, Albert Pinkham, 69

Saint-Just, 13 Saint-Lazare Station (Monet), 62 Saint-Sulpice, 32 Salon d'Automne, 84 Salon des Refusés, 55, 57, 68 Sargent, John Singer, 68 Satyr and Nymph (Géricault), 32 Schmidt-Rottluff, Karl, 89 Schöffer, Nicolas, 150 Schwitters, Kurt, 101, 102 Sculpture, Classical, 10, 23 Sea (Mondrian), 102 Seated Woman (Picasso), 114 Section d'Or, 96, 104 Seine River at Nanterres (Vlaminck), Self-Portrait (Picasso), 84 Self-Portrait (Siqueiros), 131 Self-Portrait with Bandaged Ear (Van Gogh), 78, 80 Seurat, Georges, 77. Severini, Gino, 99, 100 Shahn, Ben, 128 Shoes, The (Van Gogh), 78 Sideshow (Seurat), 77, 78 Signac, Paul, 34, 78 Silva, Vieira da, 137 Sinjerli Variation (Stella), 142 Siqueiros, David Alfaro, 131 Sisley, Alfred, 57, 60 Sketch, 23 Sky Blue (Kandinsky), 119 Sleigh, The (Rousseau), 87 Sloan, John, 83 Sluice on the Stour (Constable), 25 Snake Charmer (Rousseau), 87 Snowstorm (Turner), 27 Social Realism in, 145 Sorrow (Cézanne), 75 Soulages, Pierre, 137, 139 Soupault, Philippe, 105 Source of the Arveiron (Towne), 24 Soutine, Chaïm, 89 Spengler, Oswald, 70 Spring (Millet), 41 Staël, Nicolas de, 138, 139 Staircase Group (Peale), 16, 17 Starry Night (Van Gogh), 80 Stein, Gertrude, 91, 165-67

Sully, Thomas, 17
Sunday Afternoon on La Grande
Jatte (Seurat), 77
Sunflowers (Van Gogh), 80
Suprematism, 103-4
Surrealism, 105-7, 121-22
Cobra and, 145-46
Swing Landscape (Davis), 131
Symbolic idealism, 48-49
Symbolism, 81, 83, 84
prelude to, 71
Pre-Raphaelitism and, 52
Synthetism, 81-82

Tachisme, 53, 137, 141 Tahiti, 82, 157-58 Tamayo, Rufino, 131 Tanguy, Yves, 106 Tàpies, Antoni, 139 Tatlin, Vladimir, 104, 105 Tempest, The (Kokoschka), 89 Temptation of St. Anthony (Redon), Third of May, 1808 (Goya), 20, 21 Three Dancers (Picasso), 114 Three Flags (Johns), 150 Three Musicians (Picasso), 111 Titania, Bottom and the Fairies (Füssli), 15 Titian, 15 Tobey, Mark, 136, 137 Toulmouche, 159 Toulouse-Lautrec, Henri de, 66-67, 69 Towne, Francis, 24 Tragedy of Man (Kokoschka), 89 Transcendentalism, Gothic, 88 Transfiguration (Raphael), 49 Tree (Mondrian), 100, 102 Trellis, The (Courbet), 41 Trouville, 84 Trumbull, John, 17 Tub, The (Degas), 64 Turkish Bath (Ingres), 36 Turner, J. M. W., 8, 26-27 Two Children Are Threatened by a Nightingale (Ernst), 107 291 group, 125 Two Sisters (Chassériau), 37 Two Sisters (Inness), 53 Tzara, Tristan, 101, 105

Ulysses Deriding Polyphemus (Turner), 27 Umbrellas (Renoir), 66 United States abstract art in, 128 ff. Abstract Expressionism in, 133 ff. in Impressionist period, 68–69 landscape painting in, 27 Minimalism in, 143-44 Neo-Impressionism in, 83 Pop Art in, 148-49 portraiture in, 16-17 post-World War II development in, 133 ff. Realism in, 52-53, 128 291 group in, 125

Urizen Creating the World (Blake), 15 Utrillo, Maurice, 111

Van Gogh, Vincent, 44, 77, 78 ff.,

Vallotton, Félix, 84

160-61

Vasarely, Victor, 141, 142, 150 Velde, Bram van, 139 Vernet, Horace, 13 Vien, Joseph-Marie, 10 Villon, Jacques (Gaston Duchamp), 96, 121 Violin (Dufy), 86 Vita Somnium Breve (Böcklin), 83 Vlaminck, Maurice de, 84, 86, 87 Vollard, Ambroise, 76 Vorticism, 100 Vrubel, Mikhail, 83 Vuillard, Edouard, 84

Wanderers, 45, 46 Warhol, Andy, 149, 152 Watercolor abstract, 102 landscapes in, 24 Realist trend and, 46 Watercolour Society, 24 Watson and the Shark (Copley), 16-Weaver, The (Van Gogh), 78 Wesselmann, Tom, 149 West, Benjamin, 16 Wheat Field with Crows (Van Gogh), 80 Where Do Come From? . . . (Gauguin), 81, 82 Whistler, James McNeill, 55, 67-68, White Girl (Whistler), 55, 68 White writing, 136 Winckelmann, Johann Joachim, 7, 8 Wols (Wolfgang Schulze), 140-41 Woman I (De Kooning), 137 Woman with Guitar (Picasso), 92 Woman with a Hat (Matisse), 87 Woman in Her Prime (Picasso), 117 Woman with a Mandolin (Braque), Woman with Orange (Picasso), 117 Woman Seated in an Armchair (Picasso), 117

Yates, Mrs. Richard, 16 Yellow Christ (Gauguin), 81 Young Woman Dressing (Corot), 48 Young Women on the Banks of the Seine (Courbet), 41

Women of Algiers (Delacroix), 23, 33

Women in the Garden (Monet), 60

Wreck of the Hope (Friedrich), 37

Worringer, Wilhelm, 84, 88

Zola, Emile, 55, 57, 73 Zulma (Matisse), 110

Wood, Grant, 128

Wyeth, Andrew, 128

32

Stella, Frank, 137, 142

Stieglitz, Alfred, 125 Still, Clyfford, 142

(Cézanne), 72

Stuart, Gilbert, 16, 17

casso), 92

Still Life with Chair Caning (Pi-

Still Life with Lobsters (Delacroix),

Still Life on Pedestal Table (Braque),

Still Life with Peppermint Bottle

Stone Breakers (Courbet), 40

ND 189 .P513 Picon, Ga etan. Modern painting, from 1800 to the present

DAIL DUL

CHECK TO BE A SECURE OF THE SECURE	MANUSCHOOL ROOM ESTRO	ekmijasunkmusipaektie	profitime di entre animanta co
DEC 1A	1990		
MAY 1	32		
NOV 2	92		
WC125"	3 1995	1.5	
MAR 1 1			
0.000	ESIL		
v			